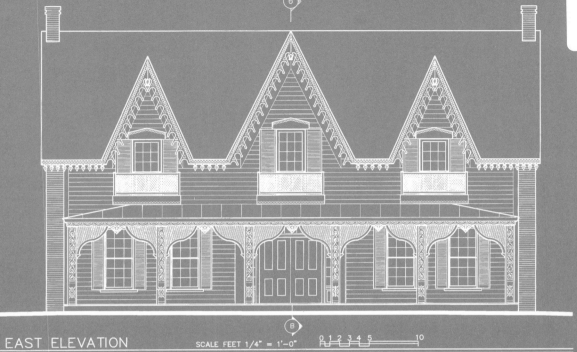

EAST ELEVATION

SCALE FEET 1/4" = 1'-0"

METERS 1:48

0 1 2 3 4 5 10

0 1 2 3

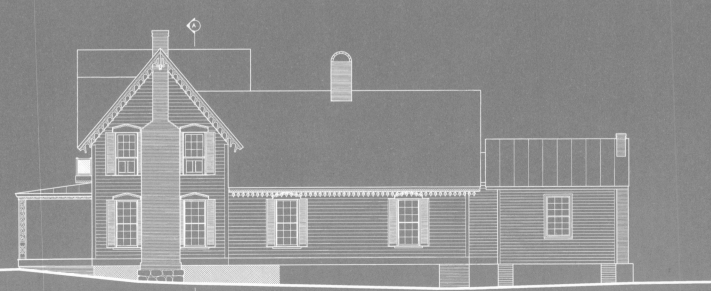

NORTH ELEVATION

MATERIALS:
FOUNDATION: ASHLAR/BRICK/STONE
WALL: TOUNGE & GROOVE
ROOF: PRESSED TIN/STANDING SEAM METAL

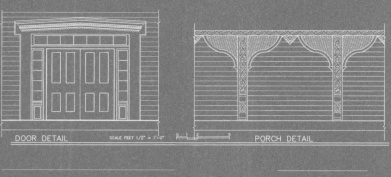

DOOR DETAIL SCALE FEET 1/2" = 1'-0" PORCH DETAIL

TRIM DETAILS SCALE FEET 1" = 1'-0"

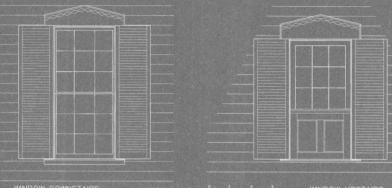

WINDOW DOWNSTAIRS SCALE FEET 1" = 1'-0" WINDOW UPSTAIRS

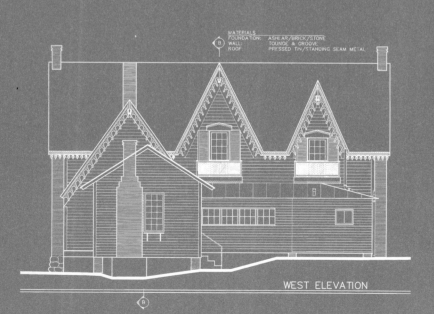

MATERIALS
FOUNDATION: ASHLAR/BRICK/STONE
WALL: TOUNGE & GROOVE
ROOF: PRESSED TIN/STANDING SEAM METAL

WEST ELEVATION

BEDROOM
17'-3"x17'-1"

TOILET
5'- 7 1/2"X9'-11"

BEDROOM
17'-3"x17'-1"

MATERIALS
WALLS - PLASTER
CEILING - PLASTER
FLOOR - WOOD

SECOND FLOOR PLAN SCALE FEET 1/4" = 1'-0"
METERS 1:48

Storybook Cottages

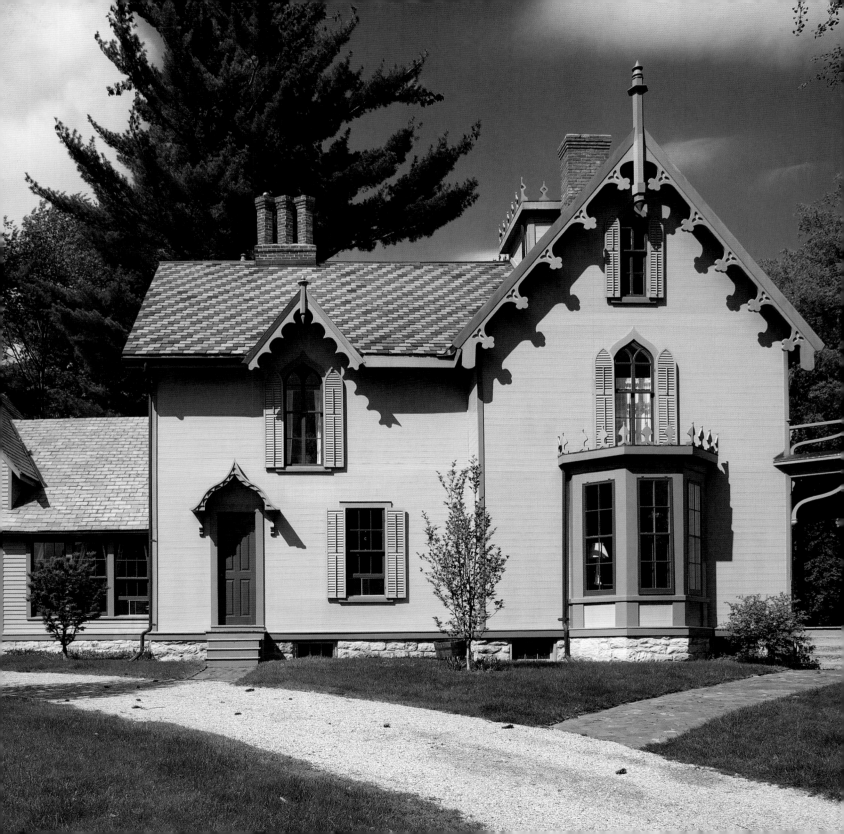

Storybook Cottages

AMERICA'S CARPENTER GOTHIC STYLE

GLADYS MONTGOMERY

RIZZOLI
NEW YORK

New York · Paris · London · Milan

First published in the United States of America in 2011
by Rizzoli International Publications, Inc.
300 Park Avenue South
New York, NY 10010
www.rizzoliusa.com

2011 2012 2013 2014 / 10 9 8 7 6 5 4 3 2 1

Distributed in the U.S. trade by Random House, New York

Printed in China

Designed by Lynne Yeamans

ISBN: 978-0-8478-3619-2

PREVIOUS PAGE: Chadbourne-Bascom house in Williamstown, Massachusetts

Contents

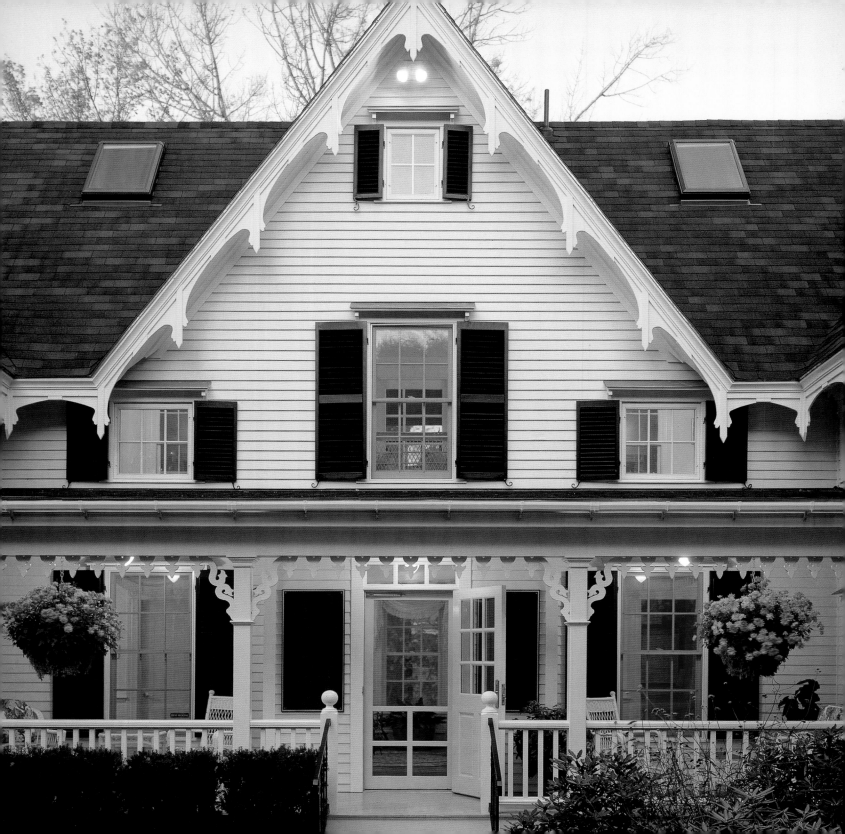

Introduction

[A]rchitecture has been up to the fifteenth century the principal register of humanity; that during all this time there has not been a single thought that was at all intricate, but has expressed itself in an ediface.

—Victor Hugo, *The Hunchback of Notre Dame*, 1831

[I]t often happens that some modest cottage, all chaste and simple and expressive, but in strictly correct taste and good keeping, awakens in our minds a far higher pleasure than the most costly saloon, bright with gilding, and rich with satin and velvet, where we only discover magnificence and expense without taste or propriety. We feel that there is some living spark of genius in the former, however simple and unpretending its manifestation, but in the latter—only unlimited credit at the banker's.

—Andrew Jackson Downing, *The Architecture of Country Houses*, 1850

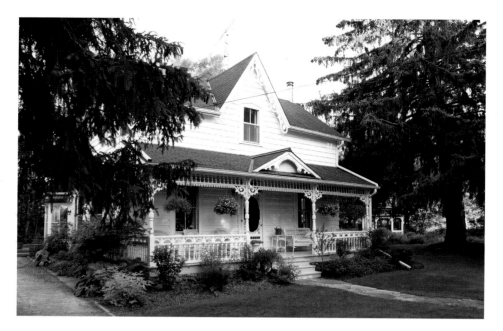

PREVIOUS, THIS PAGE, OPPOSITE: *Carpenter Gothic cottages display character-filled detailing: steep gables, scrollwork trim, diamond-paned and pointed windows, board-and-batten siding, and porches.*

The storybook Carpenter Gothic cottage, embellished with what we fondly call "gingerbread" trim, has a long lineage. The most visually playful and lively of all American architectural styles, Carpenter Gothic traces its beginnings to the great Gothic cathedrals of medieval Europe and through the eighteenth- and early-nineteenth-century Gothic Revivals of England and France to North America. In each of these iterations, as Victor Hugo observed in his preface to *The Hunchback of Notre Dame*, Gothic architecture and its expressive details captivated the public because they embodied the cultural ideas and social aspirations of each era.

In America, Carpenter Gothic architecture is an icon of the rural landscape and the country town. So it's fitting, perhaps, that the seminal figure in the development and dispersion of rural Gothic architecture through popular pattern books was Andrew Jackson Downing, America's first landscape architect. Following in the footsteps of the eighteenth-century romantics, Downing established the American standard for the vine-covered country cottage: he regarded the creation of a home as an act of individual expression, viewed the creation of a beautiful garden and a landscape as an art rivaling painting, and saw a link between buildings and their settings in which each was

geared to complement the other. America's Carpenter Gothic style began because of these ideas. They—along with the vital connection between proportion, detail, utility, and hominess—give houses built in this style their enduring charm.

It's astonishing how many ideas about American domestic architecture and gardens can be traced to Downing—even down to the current distaste, in many quarters, for ten-thousand-square-foot hedge-fund trophy houses and McMansions, which brag from the rooftops their owners' presumed "unlimited credit at the banker's." Most of us know better, understanding that the creation of a home is a matter of discernment, in which money matters, but the

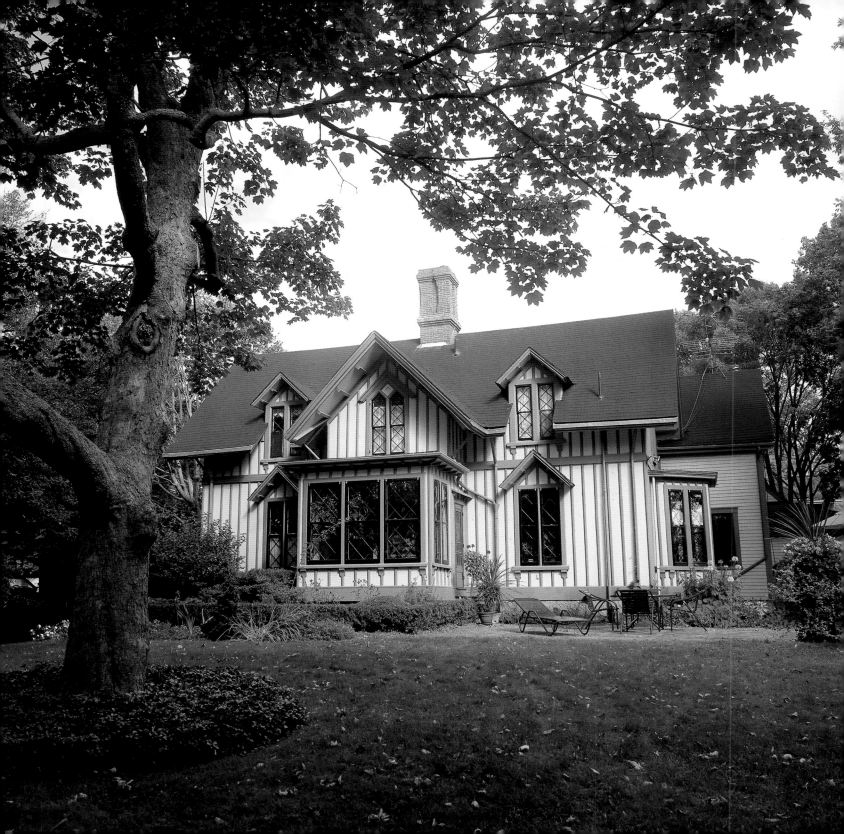

exercise of good taste always matters more. In any space, and especially in the small space, well-wrought details, functionality, and the gift of comfort conspire to make us feel at home. It's a tribute to Downing and his peers that our sense of this has not changed much in the past 170 years.

The development of the Carpenter Gothic style was inextricably linked to the development of the American country home and the railway suburb. Until the early nineteenth century in the United States, Downing noted in his first book, *A Treatise on the Theory and Practice of Landscape Gardening*, published in 1849, ". . . our peculiar position, in a new world, that required a population full of enterprise and energy to subdue and improve its vast territory, . . . left but little time to cultivate a taste for Rural Embellishment. But, in the older states, as wealth has accumulated, the country became populous, and society more fixed in its character, a return to those simple and fascinating enjoyments to be found in country life and rural pursuits, is witnessed on every side."

The nineteenth century was a period of unparalleled economic growth in the United States: between 1860 and 1901, 440,000 patents were issued for unique, new inventions, and by 1890 the value of manufactured goods in this country nearly equaled the total produced by the rest of the world. As Downing observed in *Treatise*, "the number of individuals among us who possess wealth and refinement sufficient to enable them to enjoy the pleasures of country life, and who desire in their private residences so much of the beauties of landscape gardening and rural embellishment as may be had without any enormous expenditure of means, is everyday increasing."

The wealth that derived from myriad new inventions, new industries, and new forms of commerce produced a new generation of professionals, small businessmen, and manufacturers who could afford to escape from the city. At the same time, the era's new steamboats, railroads, and canals meant that people could live and prosper outside urban centers. The opening of these transportation routes, which brought manufactured goods from burgeoning urban factories into distant areas, also meant that consumer goods and home furnishings could be easily shipped to rural residences.

As Downing pointed out in *Treatise*, "the increasing discomfort and expense of our large cities, and the great facilities which our numerous railways and steamers offer to business persons, [provided the opportunity] to reside permanently in the country. . . ." What developed in the country setting, was ". . . an improving taste, and love for rural life, which is always one of the agreeable and graceful accompaniments of increasing civilization."

Concurrent with the advance of industrialization, Americans began to romanticize their landscape. This sentiment took a variety of forms: the spiritual view that God was manifest in nature, which was expressed in the Transcendental Movement; the emergence of American landscape painting and first U.S. fine arts tradition, the Hudson River School; the urge to spend time in pastoral places and in the wilderness; and a concern about environmental protection, particularly of urban water supplies. Moreover, social observers complained that industrial and commercial urban centers were breeding a new kind of overworked American lacking in physical prowess, a development viewed as detrimental to the national good. So there was an increased emphasis on recreation, and new sports and leisure pastimes, such as rowing, bicycling, golf, and tennis, emerged. All of these factors made the retreat to the country an attractive idea.

As Downing's partner, Calvert Vaux (pronounced "vox") later wrote in his 1864 book, *Villas and Cottages*, "Almost every American has an equally appreciative love for 'the country.' This love appears intuitive, and the possibility of ease and a country place or suburban cottage, large

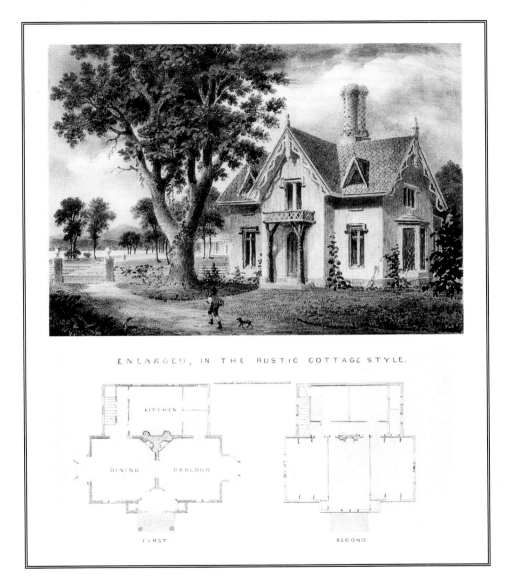

ENLARGED, IN THE RUSTIC COTTAGE STYLE.

KITCHEN

DINING PARLOUR

FIRST. SECOND.

or small, is a vision that gives a zest to the labors of industrious thousands."

But what made the rural Gothic style—the term Downing used for this architecture—the choice for modest country residences of the mid-nineteenth century? How does an architectural style migrate, over the course of seven centuries, from the soaring cathedrals of medieval Europe to the unprepossessing vernacular farmhouses of rural America? The answer to this question encompasses history, architecture, technology, economics, technology, human aspiration, and ideas about nature and spirituality, the dignity of hand work, mankind's place in the universe, and the soul's individual worth. This is one of the most fascinating stories in the world of architecture. One aspect of it—a truth that is literally writ in stone— is that—as Victor Hugo pointed out— architecture is always an expression of its era: some interesting parallels exist between the medieval period in Europe and mid-nineteenth-century America.

The original Gothic period (1140– 1540 CE) began at the end of the Dark Ages. During and following the death throes of the Roman Empire, this was a terrifying time in Europe. The continent was ravaged by the Plague of Justinian (the pandemic bubonic plague) between 540 and 750 CE, even as it was over-run by invasions by Norsemen, Magyars, Saracens, Moors, and Goths. Noblemen and townspeople alike hid within fortified villages and castles, peasants had no power against their conquerors, and Christianity's displacement of the old pagan beliefs cut

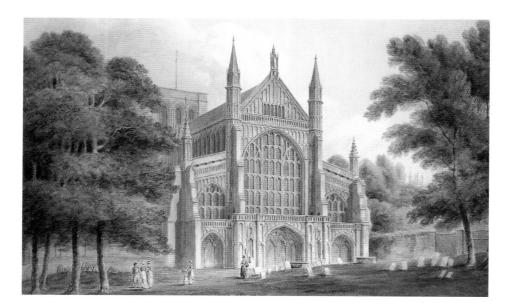

society loose from its spiritual anchors. In France, Norse invasions of the Seine Valley and the area around Paris began in 787, and Normandy, the Norse realm within Frankish territory, was created by treaty in 911; in Spain, the Moors invaded in 711 and were not completely and finally expelled until 1614.

Meanwhile, within the stone walls of remote monasteries—notably at Cluny, founded in 910 in a protected valley in Burgundy and the world's largest Christian church prior to the completion of St. Peter's in Rome—Roman Catholic monks kept civilization alive, copying religious texts and creating divinely inspired, illuminated manuscripts, embellishing their meticulous renderings with rich gilding and brilliant

color. In about ACE 1000, architects forged the Romanesque style—heavy stone structures with weight-bearing walls and small windows that resembled the fortifications that they were. Inside the Romanesque churches, the frightening realities of the time were symbolized in stone carvings of looming, devouring demons.

Early in the twelfth century, the invading hordes receded, and the reign of terror finally ended. Europe's release from the Dark Ages produced an awakening that endured for centuries. Quite literally, doors were flung open, as people stepped into the light, spiritually, physically, and intellectually. Prior to the Dark Ages, the Muslim world was the seat of science and learning; after this period, Europe was eager to assert its dominance in

these realms. The Crusades were launched to re-capture Jerusalem. Invention, trade, and scholasticism flourished. Once again, the world was viewed as a place created for mankind by the beneficence of God. The consequent mood of happiness and joyfulness—*laetius et jucundius*—was a vital force throughout the Gothic era, inextricably tied to the growth and glory of the Roman Catholic Church.

The era of the great cathedral began. A renewed sense of safety, confidence, and gratitude prompted architects to build the Romanesque barrel vault in the choir at Cluny to a height of one hundred feet. But because Romanesque structures depended upon their walls to support their massive weight, both their vertical potential and their ability to frame vast expanses of glass were limited. In keeping with the new spirit of the era, empowered by the invention of the flying buttress to support their buildings, Gothic architects changed this.

With the introduction of the pointed arch, vaulting, and the buttress, medieval cathedrals could reach spectacular heights. Artists and master stone carvers created a calming, reassuring atmosphere as they celebrated the glories of Christ and Creation.

Their deliberately awe-inspiring spires, vaulted interiors that surpassed the finest palaces in their decoration, images of joyful Virgins and angels, humanistic depictions of human faces, and an exuberance of leaves, animals, and flowers signified a reemerging love of nature, an appreciation of mankind's highest artistic vocation, and the idea of *animus mundi*, that the soul of the world is manifested in physical form.

Architecturally, because exterior walls were no longer supporting the weight of the building, they could be opened up to accommodate massive windows. Welcoming the light and craft of stained glass, these windows were like illuminated manuscripts writ large for all to see and understand. This was an important function of the cathedral: the Bible, after all, was still only in Latin, and the printing press would not be invented until 1535. As Victor Hugo, in his preface to *The Hunchback of Notre Dame*, would later observe, prior to the invention of the printing press, architecture was the form through which civilizations expressed their deepest beliefs and their highest aspirations. As it happens, this novel, published in France in 1831 and trans-

lated into English in 1833, was just one of several that sparked interest in the Gothic Revival in France, England, and America.

The medieval cathedral relied on architectural innovations and craftsmanship to achieve its glory, and it also relied upon tithes from the newly rich. The invention of the heavy plough during the Middle Ages led to clearing of more agricultural land and the gathering of families, who shared a single piece of this expensive equipment, into clusters and villages, a process that increased as waves of invaders receded. With the continent safe again, trade flourished, and commercial centers arose. A thriving new merchant class emerged, with the wealth to endow grand cathedrals and to build impressive homes.

In the nineteenth century, too, changing architectural preferences were a product of social changes, new intellectual ideas, and new wealth, and social forces echoed those that inspired medieval architects and artists to create the Gothic style. Just as the medieval period marked a spiritual reawakening, the mid-nineteenth century in America was a time of widespread religious revivalism. Just as the flying buttress and the pointed arch enabled medieval buildings to be opened up to the light, the balloon frame gave Carpenter Gothic homes a lightness that hadn't been known during the era of post-and-beam construction. Similarly, too, Carpenter Gothic interiors were illuminated by multiple windows in myriad forms. Just as

In a bucolic setting in Somerset, Wells Cathedral boasted a spire-topped tower, flying buttresses, and impressive cruciform plan.

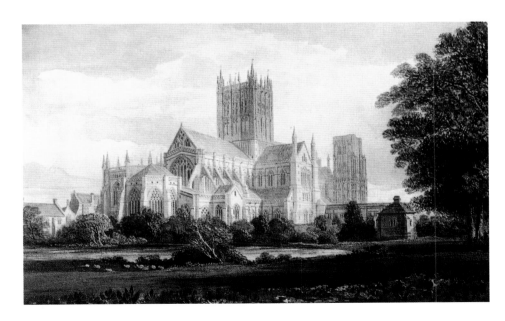

the heavy plough prompted the formation of medieval villages, the nineteenth-century "plow that broke the plains" and the promise of "forty Acres and a mule" propelled Americans out across the continent to create new farming communities and build new homes. And, just as the original Gothic era marked the European reawakening of science, invention, and commerce, mid-nineteenth-century America was a nexus of industry and innovation.

The growth of commerce in each period produced the wealth that helped to propagate the style: as Megan Aldrich notes in *Gothic Revival*, the term "bourgeois" was coined in the 1300s to describe the middle and merchant classes who had begun to adopt the Gothic style in their new stone houses.

Another parallel was the dark side of the Industrial Revolution. By the 1820s—and the last Neoclassical phase, the Greek Revival—industrialization was underway.

During the second half of the century, the population in the United States more than doubled, with most of that growth concentrated in industrial and commercial urban centers, which became blighted with overcrowding, poor hygiene, polluted rivers, sooty air, and disease. Immigration was the new "invasion" creating tremendous social stress. Tuberculosis, or "consumption,"

Naturalistic motifs in medieval finials and crockets, drawn by A. W. N. Pugin, are echoed in a high-style Gothic Revival home in America.

was responsible for one out of five mortalities in the nation during the nineteenth century. Transmitted by a sneeze, a cough, or someone spitting in an already-filthy street, the airborne tuberculosis bacteria thrived in densely populated cities, and decimated entire families, rich and poor alike. Seeking fresh air and treatment, city folk journeyed to places far and wide, including the Adirondacks, Cuba, the mountains of North Carolina, the Arizona desert, and the California coast. Enabled by the development of the railroads, they also sought the healthy country atmosphere in their new rural residences. The threat of disease provided ample motivation for city dwellers to find bucolic destinations that offered fresh air and healthy physical activity.

The move to the country as a weekend, vacation, or full-time residence was a matter of choice as well as of necessity. Concurrent with the growth of the industrial city, Americans began to romanticize the rural countryside, seeing nature, as people during the original Gothic period did, as a manifestation of God's handiwork: the Transcendental Movement and the Hudson River School of painting were both expressions of this idea. In short, industrial society was ripe for a picturesque style that was historically associated with

Medieval architectural details, such as the tracery in church windows, eventually came to America.

a celebration of the natural world and humanity's place in it.

How does one scale down a cathedral to be appropriate for domestic architecture? It was not just a matter of making it smaller. Downing admired the Gothic or pointed architecture in the churches and cathedrals of England and Germany for their purity, "unrivalled sublimity, variety, and beauty"; the powerful structural presence of their buttresses, pinnacles, clustered columns, and "richly groined roofs of stone supported in mid-air"; their large, light-admitting windows; and their decorative elements, such as "beautiful, elaborate tracery and carving of plants, flowers, and animate objects." But he was interested in translating the essence of the Gothic style into rural homes that celebrated their bucolic surroundings and enhanced the lives of those who lived in them. Naturally, the pretty rural cottage lacked the grandeur of the cathedral, but it could—and did—show "unrivalled sub-limity, variety, and beauty" nonetheless.

Observing that Gothic architecture had been "varied and adapted in a great diversity of ways" to dwellings, Downing listed a range of elaborate iterations—

baronial castles, monastic abbeys, Tudor and Elizabethan mansions "surrounded by [a] beautiful park, filled with old ancestral trees"—and he described "the pretty, rural, gabled cottage, of more humble pretensions."

Downing's books, which presented his designs along with those of architects, notably Alexander Jackson Davis, promoted the "the rural Gothic style." This was the nineteenth-century term for what we today call Carpenter Gothic. We now think of "gingerbread," or intricate scrollwork trim, on porches, bargeboards, and steep gables, as a hallmark of the Carpenter Gothic cottage; but in the nineteenth century, Downing used the term "gingerbread" disparagingly to describe the inferior scroll-saw carving of flimsy woods. Nonetheless, from its beginnings in the Hudson River Valley, which was the focus of most of Davis's and Downing's work, the "rural Gothic"— Carpenter Gothic—style spread, thanks to pattern books by Downing and others. Rural and small-town carpenters created their own interpretations and a new vernacular idiom in architecture was developed. From the medieval cathedral to the English estate to the high-style American country residence to rural and small-town builders across America who fashioned rural cottages with

Fig. 1.

Pointed diamond-paned windows, such as the one illustrated (top) by Edward Shaw, were standard in Carpenter Gothic homes.

"gingerbread" trim—this was the progression of the Gothic style.

But what's in a name? During the medieval period, one expression of the Gothic style was the "perpendicular Gothic" with its strong vertical lines. Later, England's Gothic Revival yielded the term, "the pointed style." Americans sometimes used that description, too, but more often "Gothic Revival" described buildings from churches to skyscrapers and rural residences. The Carpenter Gothic house was just one expression of the Gothic Revival in America.

Like the cathedral spires of earlier centuries, the gable finials on Carpenter Gothic houses reached heavenward, celebrating a new era of achievement. Just as the original Gothic artisans applied their chisels to shape glorious stone carvings, nineteenth-century craftsmen deployed the newly invented scroll saw to cut the wooden "gingerbread" that embellishes the thousands of bargeboards (or vergeboards) and porches that enliven our landscape. Like the magnificent Gothic cathedrals that once held European peasants in awe, egalitarian Carpenter Gothic homes marked a new chapter in the world's economic development. Moreover, they marked the emergence of the suburban American middle class.

The first of the Victorian period's romantic architectural revivals, the Gothic Revival style would contribute elements—irregular massing, multiple gables and porches, diamond-paned windows, and ornate interior and exterior trim details—to every Victorian architectural fashion that followed it, from Queen Anne to

Gable screens were another architectural idiom that continued to be used; today they are often seen in Adirondack-style log homes.

Eastlake or Tudor. After the Victorian period ended, Gothic features would resurface in Colonial Revival, Stick, Shingle, Richardson Romanesque, and

English Renaissance buildings, from baronial New York City townhouses to great camps in the Adirondacks. In fact, the Gothic Revival architectural vocabulary was lingua franca until the advent of Modernism. Today, the process continues as new homes are designed and built in the Gothic Revival and Carpenter Gothic styles.

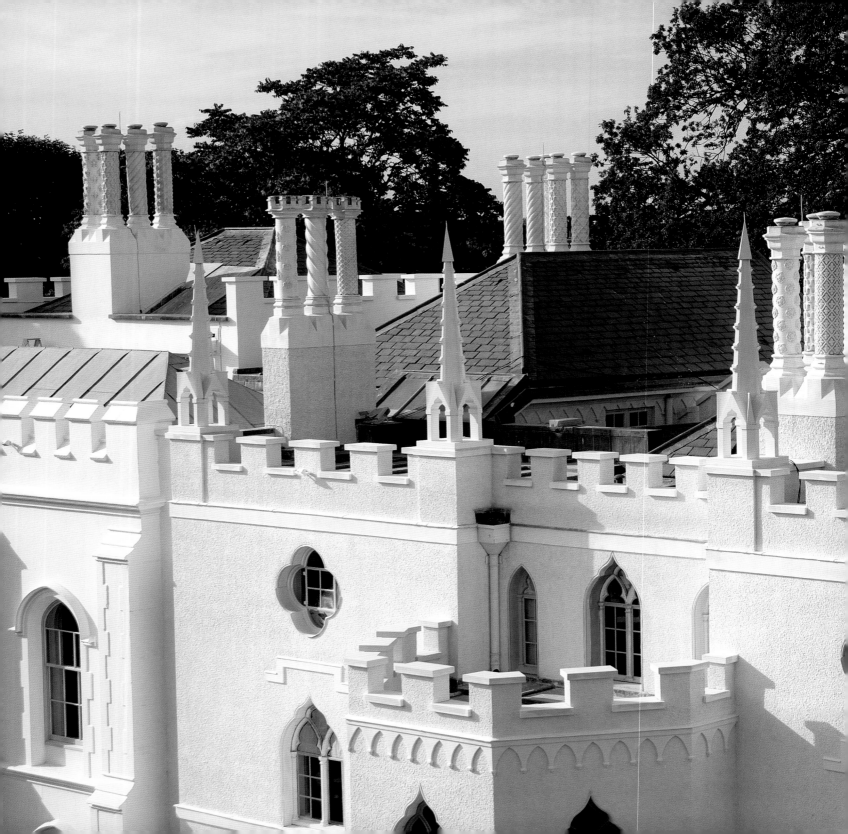

Chapter
One

England's Gothic Revival

THE LAUNCHING POINT FOR AMERICA'S GOTHIC REVIVAL AND CARPENTER GOTHIC

Every tower built during the pure style of pointed architecture either was, or was intended to be, surmounted by a spire.

—A. W. N. PUGIN, *THE TRUE PRINCIPLES*, 1841

[B]uild a porch or point a window if you can do nothing else; and remember that it is the glory of Gothic architecture that it can do anything.

—JOHN RUSKIN, 1853

The most significant step in the transatlantic crossing of the Gothic style to America was the Gothic Revival in England. Tracing its origins to the mid-twelfth through early sixteenth centuries in Europe, the Gothic style never really died out there, thanks to its grand religious, aristocratic, and academic associations. Medieval Gothic cathedrals required continual maintenance, repair, and restoration, so the crafts associated with them survived in Europe and England into the early eighteenth century, even when new buildings in this style were unpopular.

By the early seventeenth century, English travelers were singing the praises of Gothic architecture that they saw in their tours of the Continent, and Baroque painters incorporated picturesque ancient ruins and wild natural scenes in their allegorical paintings.

But, at the same time, a backlash occurred. Because of its associations with non-Christian cultures, Gothic architecture came to be regarded as barbaric, and its sacred historical associations were dismissed. In 1624, one commentator lambasted "the natural imbecility of the sharp angle"; later, Sir Christopher Wren, one of England's preeminent architects, said, "The Goths and Vandals, having demolished Greek and Roman architecture, introduced in its stead a certain fantastical and licentious

manner of building which we have since called modern or Gothic—of the greatest industry and expressive carving, full of fret and lamentable imagery, sparing neither pains nor cost."

Commissioned to rebuild London's St. Paul's Cathedral after the great fire of 1666, Wren rejected the Gothic in favor of the classically influenced Baroque style. Wren's Neoclassical leanings anticipated a contest that would prevail between the Neoclassical and the Gothic styles for nearly two centuries.

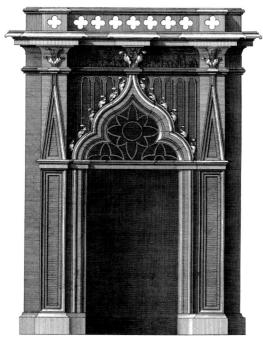

Designs from English architect Batty Langley's pattern books influenced Strawberry Hill (see page 18), Horace Walpole's "little plaything of a house."

During the early 1700s, English antiquarians and architects began to explore the Gothic style, creating castellated additions and towers and battlements on existing medieval castles. One true medieval building that had a profound effect on the Gothic Revival in England and America was Westminster Abbey, particularly the Henry VII chapel, which was copied by several wealthy residences on both sides of the Atlantic. The restoration goal for Westminster Abbey, between 1713 and 1725, was to complete the structure, begun during the reign of Henry III, as the late king would have wanted it. Working in the Gothic style, architect Nicholas Hawksmoor designed the abbey's west towers for this project; he also designed All Soul's College at Oxford. Among those who admired these buildings was Horace Walpole, the most influential style setter of the Gothic Revival in Britain. Following this project, the earliest complete Gothic Revival structures in Britain were picturesque garden buildings erected on the grand English estates of the Georgian period. The earliest known example, created in 1717, was a Gothic "temple," a garden seat surmounted by a stone gable and a rose window, in Oxfordshire. Though this period did not as a rule produce full-scale Gothic buildings, in 1717 architect John Vanbrugh created an

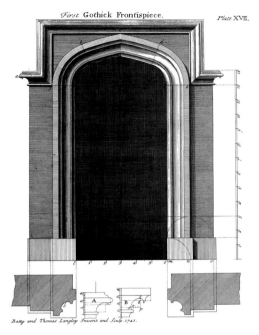

First **Gothick** Frontispiece. *Plate* XVII.

Batty and Thomas Langley Invent and Sculp. 1741.

LEFT AND RIGHT: *Batty Langley's books, published in the 1740s, showed options for arches, windows, and other features.*

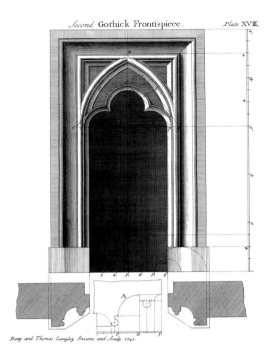

Second **Gothick** Frontispiece. *Plate* XVIII.

Batty and Thomas Langley Invent and Sculp. 1741.

LEFT AND RIGHT: *Batty Langley's books, published in the 1740s, showed options for arches, windows, and other features.*

naturalistic setting, where a formal structured garden adjacent to the main house segued to lawns punctuated by lovely groves, paths, and contrived "wildernesses" that gradually connected the house to the wider landscape. In 1733, for a prominent antiquarian in Surrey, Kent enlarged a medieval gatehouse into a residence with two symmetrical wings topped by battlements; he later remade other structures, including an old mill transformed into a neo-medieval "ruin." In 1741, he designed a new Gothic choir screen for Gloucester Cathedral, very similar to the designs being promoted by Batty and Thomas Langley, whose pattern books had a profound effect on the architecture of their era.

In the mid-eighteenth century, the Gothic style was challenged and largely supplanted in residential building by a new fashion: the Neoclassical. With excavations of archeological sites in Naples, Italy, which began in 1740, the western world, which by now included the new world, rediscovered—and enthusiastically embraced—the classical architecture of ancient Greece and Rome. From then on, there was a contest between

entirely new, asymmetrical brick castle for himself, replete with round and square towers and battlements, and located south of London, in Blackheath. In the same year, Alexander Pope published the medieval love story, *Abelard and Heloise*—this early literary example led to many others that helped to promote the Gothic style.

In the 1720s, William Kent, who had studied landscape painting and design in Italy for nine years, helped promote a taste for antique ruins as an element of the romantic and picturesque landscape in architectural and garden designs for his wealthy, aristocratic clientele. Kent was the first landscape architect to create a

two distinctly different architectural impulses: the clean-lined symmetry of the Neoclassical styles—Georgian, Federal (Adamesque), and Greek Revival—and the romantic, highly embellished irregularity of the Gothic. For a while, from the mid-eighteenth century to the early nineteenth, Neoclassical styles dominated. At Notre Dame, for instance, the glorious Gothic cathedral was renovated in the Neoclassical style; among the changes were the replacement of all its stained-glass windows with white glass.

By the 1740s, English architects were issuing pattern books that provided practical information for building in both the

Neoclassical and Gothic styles. Foremost among these were the brothers Batty and Thomas Langley, who issued *Ancient Architecture Restored and Improved* in 1741; this was reprised in 1742 as *Gothic Architecture Improved by Rules and Proportions in Many Grand Designs*. Langley favorites, such as tracery windows with quatrefoil motifs and ogee arches with foliate ornamentation and leaf finials, began to sprout on gables and windows of grand houses, such as Pool House, Astley, Worcestershire, and elsewhere in England. Batty Langley sought to codify the architectural orders of the Gothic style, as others had done for the Classical orders, applying these principles mostly to rural or summerhouses. Meanwhile, the Gothic style continued in church and cathedral architecture: in 1744, for instance, the designs that Inigo Jones and Willam Kent completed for York Cathedral incorporated a highly ornate pulpit in the Perpendicular Gothic style (see page 70).

Even early in its revival, the Gothic style was combined with other motifs in furniture and in architecture. In 1752, the brothers John and William Halfpenny issued *Rural Architecture in the Gothic Taste*, along with *Chinese and Gothic Architecture Properly Ornamented*, which contained designs for country houses in both styles. Two years later Thomas

A. W. N. Pugin emphasized authentic representation of the medieval in his drawings, such as these of oak tracery and panels, during the Gothic Revival.

Chippendale showcased Gothic furniture in his important *The Gentleman and Cabinet-Maker's Director*. And in 1762, Thomas Lightholer released *The Gentleman's and Farmer's Architect* with its plans for farm buildings and picturesque "ruins" in the Gothic style.

These books are known to have been in Colonial America, where they established a precedent for the nineteenth century's use of the Gothic style in country houses and in eclectic, romantic combination with the Oriental and other influences in architecture and interior decoration.

While England's Georgian-era estate houses themselves were invariably of high-style Neoclassical Palladian design, they often incorporated Gothic structures in their gardens and landscapes. Batty Langley, whose father was a gardener, showed a series of Gothic pavilions and porticos as garden structures in *Ancient Architecture*, and during the 1740s this idea caught on. English landscape architects, such as Lancelot "Capability" Brown began to place these romantic little buildings where they afforded a destination for a short walk, a vantage point from which to admire the "prospect" or view, and a picturesque focal point in the landscape when seen from the main house. Historically, as Horace Walpole, one of the style's leading proponents, scoffed, "The [Goths] never built summer houses or temples in a garden," but, there's also no evidence that they built churches or residences in the so-called Gothic style either.

At Stowe, Buckinghamshire, Kent installed a Gothic garden temple. In London, Sir John Soane created a Gothic library in

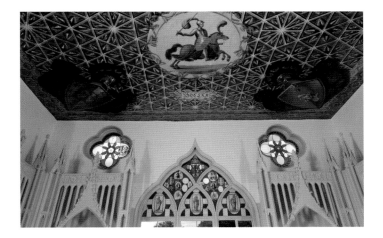

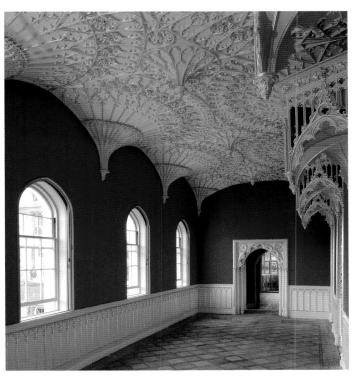

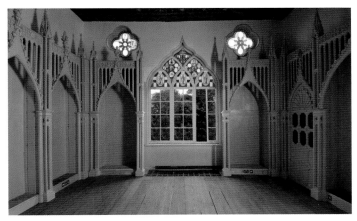

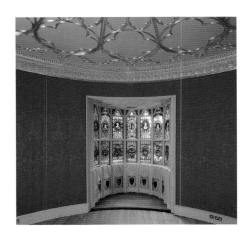

At Horace Walpole's recently restored Strawberry Hill, the gallery (above right) makes a statement, as does the library (left) and stained-glass window in the circular room (below).

his home, which is now a museum. One of the most important purveyors of the Gothic at this time was gentleman-architect Sanderson Miller, who relied heavily on Langley's designs to create a faux Gothic ruin and drawbridge at his home, Radway Grange. For Sir George Littleton, Miller devised a Gothic ruin so evocative of the medieval, Walpole famously remarked that it wore "the true rust of the Barons' wars."

Miller, in turn, influenced another amateur designer in Warwickshire, Sir Roger Newdigate, who remade the principal rooms of his sixteenth-century home, Arbury Hall, in the Perpendicular Gothic style, replete with ornate tracery, foliate decoration, and fan vaulting with pendants, all painted the color of stone. This was modeled on the Chapel of Henry VII in Westminster Abbey (which inspired and

informed a number of Gothic Revival projects in England), and he had the assistance of Henry Keene, former surveyor there. Novelist George Eliot (Mary Ann Evans), who grew up on the estate and used it in her 1857 *Scenes of Clerical Life* series, likened the effect to "petrified lacework." It took from 1748 to 1806 for Newdigate to completely transform every corner of Arbury; he also transformed a London townhouse into a Gothic building, which became known as Pomfret Castle.

It was architecture maven Horace Walpole, who, under a pen name, authored the first Gothic novel, *The Castle of Otranto*, published in 1764, and *Anecdotes of Painting* (1761–1771). The youngest child of Prime Minister Sir Robert Walpole, he created a Gothic Revival estate, Strawberry Hill, located in Twickenham, on the Thames, not far from Alexander Pope's country villa. Having purchased the estate in 1747, Walpole, an admirer of Kent, decided in 1750 to remodel the existing residence into a large, castellated magnificence, to house himself, his collections, and his pets, which would eventually be buried in a Gothic folly on the property. Of the endeavor, which spanned four decades, he said, "One has a satisfaction of imprinting the gloom of abbeys and cathedrals on one's house." Coining the word, "gloomth," to evoke the effect of warmth and gloom he

wanted to create, the eccentric Walpole remade his "little plaything of a house" with Gothic wallpapers, furniture, mantels, and wallpapers, and he gave England its first exercise in asymmetrical Georgian "Gothick" design. For the eager public, Walpole documented and described Strawberry Hill's Gothic transformation in books, which he published in 1774 and 1784: seeing it, droves of romantics and antiquarians took up the Gothick.

To assist with Strawberry Hill's architecture, interiors, and furnishings, Walpole gathered around him a group of friends of like mind whom he called his "committee of taste." This group included gentleman-architect John Chute, who was followed in his work on the estate by professional architects Thomas Pitt, Robert Adam, and James Wyatt. Walpole's friend Richard Bentley helped with the interior furnishings and designed chairs with backs modeled on the tracery of a cathedral stained-glass window.

Chute modeled Strawberry Hill's library upon old prints, including one of the choir of St. Paul's Cathedral, which was destroyed by the Great Fire of 1666. Perhaps because of its association with learning, the Gothic Revival was a popular style for libraries in buildings that were not Gothic in style; such libraries were common in grand homes in England in the eighteenth century and in North

America in the nineteenth. Strawberry Hill's interior architectural details included a painted ceiling with coats of arms; in the century that followed, heraldic emblems became a common feature of the Gothic Revival. Though Walpole disparaged Langley's designs as "bastard Gothic," he used them as models for quatrefoil windows and a papier-mâché frieze.

The estate's most over-the-top room, completed in 1763, was its expansive gallery, "richer than the roof of Paradise," as Walpole said, "we have dropped all humility in our style." Faux pendant vaulting on the ceiling, painted the color of stone, was copied from the Henry VII chapel at Westminster Abbey; walls were richly hung with red silk. Adjacent to it were a small, quatrefoil-shaped "tribune" and a round chamber, which contained a chimneypiece, ceiling, and tracery settee designed by Robert Adam. Adam designed a number of new "medieval" castles in England and Scotland, but is most associated with England's Classical Revival and the Neoclassical Adamesque style.

By the last decade of the eighteenth century more pattern books for residential architecture began to appear. These made the Gothic Revival style, once the province of the wealthy and aristocratic classes, more accessible to the middle class. For instance, John Crunden featured Neoclassical and

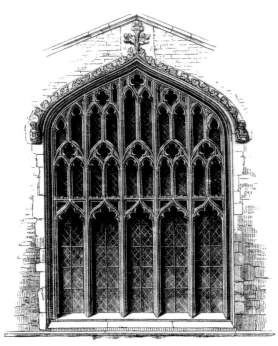

Gothic designs with plans and measurements, and an array of designs "to Suit all Persons in every Station of Life, "while E. Gyfford, in the 1806 *Designs for Elegant Cottages and Small Villas* (*"Calculated for the Comfort and Convenience of Persons of Moderate and of Ample Fortune"*), suggested that lancet windows, pointed arches, and battlements would elevate a mere cottage to the significance of a villa.

Most examples of Gothic during the Regency period—notably Eaton Hall designed by Wyatt's student William Porden—were highly ecclesiastical and ornate and were not based on accurate information about medieval buildings. In the early 1800s, more publications depicted

TOP: *Thomas Rickman codified architectural details in his drawings of medieval windows; the trefoil and quatrefoil (the pattern shown above by Batty Langley) became important motifs of the Gothic Revival.*

authentic medieval structures, and the emphasis shifted to accuracy; scholarship began to have a stronger influence on the Gothic Revival.

Prior to the nineteenth century, all sorts of theories about the Gothic style's origins abounded. Because the Saracens had invaded Europe, bringing elements of their architecture with them, Christopher Wren held that its roots were Islamic. Others insisted it arose first in England. Geologist Sir James Hall, who released his *Essay on the Origin and Principles of Gothic Architecture* in 1797, held that the style's earliest iterations were the sort of constructions in wood and wicker that might be associated with primitive Norsemen just out of the forest.

Thomas Rickman—a Quaker accountant in Liverpool who brought his interest in architectural history and penchant for precision to his analysis of the Gothic style—believed correctly that the Gothic Revival style had originated in France. Rickman authored the earliest of the authoritative texts on the authentic Gothic style, a lengthy essay: *An Attempt to Discriminate the Styles of English Architecture from the [Norman] Conquest to the Reformation*, published in 1817 and reissued through 1881. Rickman was the first to understand the chronology and invent the terms—still common today—for the various stages in the development of the style in England: Norman, Early English, Decorated, and Perpendicular. He also precisely cataloged the medieval Gothic's salient features; for example, he noted four types of window: narrow and sharply pointed; wider, less pointed, with tracery; wider still with a shallow point and tracery in a grid pattern; and round-headed with geometric ornamentation.

Rickman's work was an informative source for the building of English churches: the 1818 Church Building Act prompted the building of more than two hundred new places of worship, many of which were in the Gothic style.

Another attempt at accuracy was a Jacobean house, Toddington Manor, in Gloucestershire, rebuilt in 1819 by gentleman-architect Charles Hanbury Tracy in the Perpendicular Gothic style. Floor-to-ceiling pointed windows were limned with graceful tracery, ceiling vaulting dripped with pendants and displayed carvings of saints and sinners, trim was highlighted with gilt, oak paneling was finished with tracery and quatrefoil designs, and library bookcases were guarded by angels copied from Westminster Hall. Tracy was also involved, along with lead architect William Atkinson, in the Gothic renovation of Hampton Court in Hertfordshire, originally built after the Battle of Agincourt.

Architect James Wyatt turned to historic medieval examples to inform his designs. The surveyor of Westminster Abbey and later surveyor general to the crown, Wyatt was the nation's foremost professional architect. Wyatt caught the attention of Europe with his sweeping, much criticized, renovation of Salisbury Cathedral, which returned it to its original Gothic glory, his restoration of the Chapel of Henry VII at Westminster, and his design for writer William Beckford's Fonthill Abbey in Wiltshire, one of the most admired buildings of England's Gothic

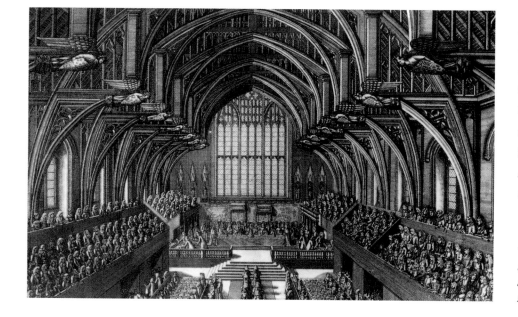

Westminster Hall and its Chapel of Henry VII exerted significant influence on architects and designers; here, its hammerbeam ceiling and stained-glass window are featured prominently.

Revival. With its massive cruciform plan, and standing on a medieval foundation, Fonthill Abbey was characterized by its varied, asymmetrical facade, battlements, and oriel windows; its central octagonal tower, 270 feet in height, collapsed—very dramatically—in a raging storm in 1825.

Fonthill's entry hall featured a hammerbeam ceiling and stone tracery like that of Salisbury Cathedral, two one-hundred-foot-long galleries, and a purple, red, and gold interior color palette that influenced other English Gothic Revival buildings. Another of Wyatt's important projects was Lee Priory, a sixteenth-century house in Kent, which he renovated in the Gothic style; though it no longer stands, sections of its library are in London's Victoria and Albert Museum. Unfortunately, the only Wyatt-designed Gothic Revival residence that is still standing is Ashridge Park in Hertfordshire, built between 1806 and 1818 for the Earl of Bridgewater, who owned a stone quarry near the site. Ashridge boasted battlements, turrets, clustered chimneys, fan vaulting, pointed arches, a timbered ceiling in its entrance hall, a ninety-five-foot ceiling in its great hall, and impressive carved-stone ornamentation. Begun when Wyatt was working on Westminster's Henry VII chapel, it incorporates many of the same motifs, notably the Tudor rose.

The Gothic Revival, perhaps more than any other architectural style, is very much associated with literature. Novels such as Walpole's *Castle of Otranto* and Ann Radcliffe's 1794 *The Mysteries of Udolpho* fueled the romantic fascination with picturesque landscapes, castles, and cloisters. The picturesque craze and faddish pilgrimages to ruined Gothic abbeys, such as Tintern and Whitby, were so popular that in 1812 poet William Combe satirized them in his highly popular parody, *The Tour of Dr. Syntax in Search of the Picturesque*. Even Jane Austen satirized the fascination with picturesque castles and cloisters in *Northanger Abbey*, written in 1798 and published in 1817.

But ridicule could not stem the tide, and literary expressions of the Gothic continued apace. Two other seminal literary figures were Sir Walter Scott and Victor Hugo. A novelist and antiquarian, Scott, with the help of architects Edward Blore and William Atkinson, one of Wyatt's students, remade his modest Neoclassical house on the River Tweed in Scotland in grand Gothic style. Scott's Abbotsford, built between 1811 and 1824, was a showcase for his collections of armor, antique furniture, weapons, curiosities, and architectural fragments. Another important clarion call of the Gothic Revival was Victor Hugo's *The*

Hunchback of Notre Dame, which was published in France in 1831 and translated into English in 1833. This continued to the end of the century, with English poet laureate Alfred Lord Tennyson's *Idylls of the King* (1856–1885), Bram Stoker's *Dracula* (1892), and many other works. In America, from Edgar Allan Poe's "The Raven" to Anne Rice's *Interview with a Vampire*, the Gothic literary tradition persisted.

In the early nineteenth century the Gothic Revival in architecture, as in literature, was really just beginning. When Wyatt died in 1813, he was succeeded by his nephew, architect Sir Jeffrey Wyattville who remodeled Windsor Castle in the Gothic style for George III during the 1820s. It was a medieval building, and Wyattville redid a portion of its interiors in the Rococo style. But, it was agreed, the only proper style for the castle's exterior and state rooms was the Gothic. Because of its longstanding identification with the British royal family, the Gothic was thought of as England's "national style," and it became associated with wealth and refinement.

By the 1820s, the "pointed style" appeared throughout England. A visiting German prince gave a view of it, describing a villa in Hertfordshire, as ". . . thoroughly in the rural-gothic style, with ornamented pointed gables; a 'genre'

in which English architects are peculiarly happy. The interior was also most prettily fitted up in the same style, and at the same time extremely comfortable and inviting." And, capturing the inevitable linkage between the Gothic style and its landscape, he continued, "The little flower-garden, too, was laid out in beds of gothic forms surrounded by gravel walks, and the fancy had not a bad effect."

English landscape designers continued to be major proponents of the Gothic style, even as they helped to define where it could appropriately be used. Chief among them was Humphrey Repton, who noted that the relatively low-slung architecture of the Gothic abbey or monastery was ideally suited to verdant valleys and flat fields, while the Gothic castle, with its turrets and battlements, was ideal at a commanding elevation in a craggy, wild landscape. Some English country estates, being very large, married the two versions.

The distinction that Repton made between the two types of landscapes—the lyrically beautiful on the one hand and the picturesquely wild on the other—was later echoed by Andrew Jackson Downing in the United States.

Fonthill Abbey, a Gothic Revival residence in Wiltshire, boasted battlements and an octagonal tower measuring 270 feet in height.

In 1833, landscape architect John Claudius Loudon released the first edition of his *Encyclopedia of Cottage, Farm, and Villa Architecture*, which became the handbook of middle-class builders in England. Loudon's designs spanned several styles, including Greek, Gothic, Tudor, Swiss, and Italian, all later echoed by Andrew Jackson Downing on the other side of the Atlantic. Gothic Revival structures began to pop up all over Europe.

Of all the architects in England during the Gothic Revival, the most loyal to the historic medieval model was A. W. N.

Pugin. The son of Augustus Charles Pugin (who authored *Specimens of Gothic Architecture*), the younger Pugin, born to a Protestant family in 1812, was one of the Roman Catholic Church's most ardent converts, particularly in an aesthetic sense. To Pugin, the Gothic Revival was a way to revive the Christian faith and glory as represented in the ecclesiastical art and architecture of the medieval period. Speaking of the "restoration of the ancient feelings and sentiments," he wrote, "'tis they alone can restore Gothic architecture." An aesthetic savant who benefited from his father's expertise and

connections, Pugin was a talented prodigy. While in his mid-teens, he illustrated Gothic furniture for Ackermann's *Repository of Arts*, the leading design magazine of the Regency period, and he designed a suite of Gothic rosewood furnishings with gilt decoration for the Windsor State dining room for King George IV. Pugin also served as the draftsman for John Nash, architect to the Crown.

With his study of original Gothic buildings and paintings of the Middle Ages, and his incredibly prolific output in the course of a short seventeen-year career, Pugin, like Rickman, was foremost among the ranks of those who approached design with the sensibility of an antiquarian and scholar.

The elder Pugin issued *Specimens of Gothic Architecture* in 1821. In 1831, he released *Gothic Ornament*, a pattern book of motifs and architectural details, which depicted intricate cornices and moldings, clusters of short, slender columns, pilasters with capitals carved with realistic or sur-realistic leaf and floral forms and animal shapes, up-reaching pinnacles with leafy crockets of cast or wrought iron above the rooflines, and pendants hanging from the eaves. He also authored a book of Gothic furniture designs and a comparative study of medieval and contemporary Gothic buildings. He remodeled Scarisbrick

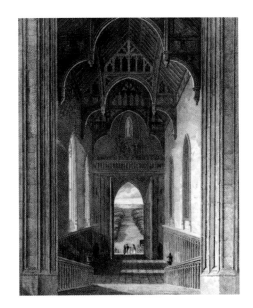

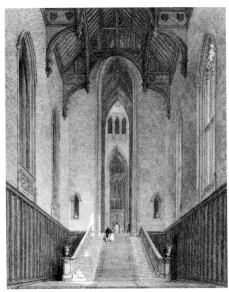

Interior vistas at Fonthill Abbey, the home of William Beckford, were designed to impress. "I am growing rich and mean to build towers," Beckford declared.

Hall, a late-medieval building for Charles Scarisbrick, a prominent antiquarian and collector, introducing painted ceilings and mural portraits, lavish foliate and figurative carved woodwork, pointed arch motifs, ornate tracery work, and the generous use of saturated color typical of the Gothic Revival's decorative phase. One of the distinctive pieces in the house is Pugin's first X-frame chair, in oak, one of his most influential designs. He also created intricate marquetry designs for tabletops, one of which was showcased in the Medieval Court of the 1851 Exposition.

In 1841, A. W. N. Pugin issued his landmark work, *The True Principles of Pointed or Christian Architecture*. Arguing for a "moral" architecture, a theme that was repeated throughout the English and American Gothic Revivals, he advocated "honest construction," namely that the structure and building materials should be exposed and adorned, rather than concealed by surface overlays. This book also presented an array of designs for tiles and wallpapers, characterized by their vibrant use of pattern and strong contrasting colors. As an architect, Pugin comprehended the three-dimensional space and mass, the structural logic of Gothic construction, and the restrained use of ornament as a complement to the final result. He loved rich color, and in 1849 he released *Foliated*

Ornament, a book of highly stylized two-dimensional designs.

The most significant statement in this book was Pugin's assertion that "the two great rules for design are these. First, that there should be no features about a building which are not necessary for convenience, construction, or propriety; second, that all ornament should consist of enrichment of the essential construction of the building." One example was the pinnacle, which helped to secure the buttresses and stabilize interior vaulting. He deplored faux architectural touches, such as plaster and papier-mâché vaulting, as being "sham" and "dishonest." Later adopted by Downing in America, Pugin's ideas become an important aspect of the Gothic Revival—and all styles that followed it, including the Arts and Crafts movement and mid-century Modernism, whose "form follows function" mantra is a distant echo of this idea.

Two Gothic Revival buildings of Pugin's that still stand are the Grange, built in 1843, and St. Augustine Church, both in Kent.

Pugin's publisher, John Britton, also issued series of books, such as *The Architectural Antiquities of Great Britain* (1807–26) and *Cathedral Antiquities* (1814–35) that contributed significantly to the understanding, popularity, and development of the Gothic style.

One of the most significant projects of England's Gothic Revival was the completion (between 1840 and 1870) of the New Palace of Westminster and its Houses of Parliament, where the Gothic style was chosen as an architectural reference to the parliamentary system's medieval heritage. Charles Hanbury Tracy headed the committee that chose the design for the building, which had been destroyed by fire in 1834. Architect Sir Charles Barry won the commission, and the completed structure bears several similarities, such as its square Victoria Tower, to Tracy's Toddington.

At about the same time that the work was going on at Westminster, architect Viollet-le-Duc was renovating Notre Dame Cathedral in Paris to correct damage done by the passage of time and during the French Revolution: in 1845, instead of restoring Notre Dame's Neoclassical layers, he stripped them away, replacing them with exquisite new work in the Gothic style, re-creating the building that medieval architects and artisans had known.

Polychrome color schemes had been an important part of original Gothic decoration, and were a component of its revival. In 1845, furniture designer J. G. Crace illustrated the rich, saturated colors used in the clustered columns at Paris's Sainte-Chapelle, restored by architects Felix Duban and Violett-le-Duc. Similar

decorative motifs were shown by Loudon and Downing as appropriate for chimneys.

After Pugin's death in 1852 at age forty, the Gothic Revival continued in Britain, with Crace, George Gilbert Scott, John Francis Bentley, William Butterfield, George Edmund Street, Alfred Waterhouse, H. A. Darbishire, and Robert Kerr among the devotees who picked up the fallen banner and completed public commissions, churches, and country manors in the Gothic style.

Contemporaneous with Pugin and the most significant influence in the late Gothic Revival, as it was practiced in the last quarter of the nineteenth century, was art critic John Ruskin. In his 1853 book, *The Stones of Venice*, he devoted a chapter to "the nature of the Gothic."

Sowing the seeds that would ultimately produce the Arts and Crafts style of the early twentieth century, Ruskin pointed out that the medieval Gothic cathedral was the product of the free expression of individual craftsmen, who strove for beauty, used "honest" materials and building techniques, and imbued their work with the essence of spirituality. In *The Stones of Venice*, he wrote, "[i]t is one of the chief virtues of the Gothic builders that they never suffered ideas of outside symmetries and consistencies to interfere with the real use and value of

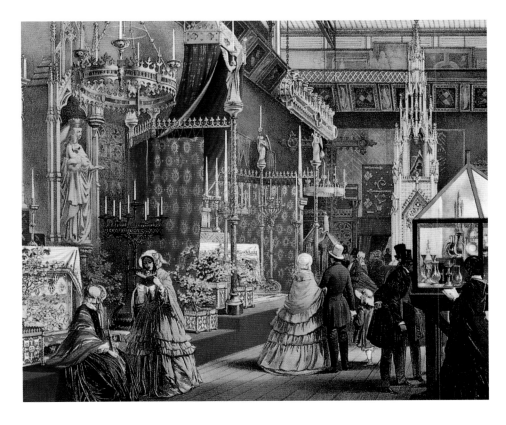

what they did. If they wanted a window, they opened one; a room, they added one; a buttress, they built one; utterly regardless of any established conventionalities of external appearance."

Ruskin was not an architect, and this last statement, was, in fact, not quite true. The cathedral cruciform design created a bicameral footprint; rose windows were typically at the center of a facade; rhythmic rows of pointed windows and columns were often paired; and the twin towers of Notre Dame, Chartres, and other medieval cathedrals were decidedly symmetrical. In England and North America, Gothic Revival architects often did deploy symmetry: many a front facade consisted of a central core with a steep gable, flanked on either side by a porch. But it was true that the Gothic Revival afforded more freedom and introduced the idea of using varied forms and masses to balance one another.

Dismissive of the Gothic style as it appeared in England—he called it "wildness without invention, and exuberance without completion" and deplored its "small pinnacles, and dots, crockets, and twitched faces"—Ruskin's preference was for the late-medieval Gothic buildings he saw in Venice. The Venetian polychrome schemes that he admired were translated, in Britain and late-nineteenth-century America, into patterned brickwork in varied hues of red, gray, and tan. Once again, architects viewed the Gothic not from the archeological perspective that Pugin had advocated but as an interpretation of medieval precedents.

In the high Victorian period, Charles Eastlake was another leading influence in the late Gothic Revival. Writing in his *History of the Gothic Revival*, published in 1872, he said, "Our too sophisticated age may want the rich instincts of inventive genius, which in days of yore made our streets interesting, our houses loveable, and our churches sublime. It may want . . . the very social conditions which would render a return to the Medieval principles universally acceptable. But at least we have learnt . . . in what those principles consist."

An understanding of those principles was one aspect of the legacy the English Gothic Revival passed to America, but, as usual, America had ideas of its own.

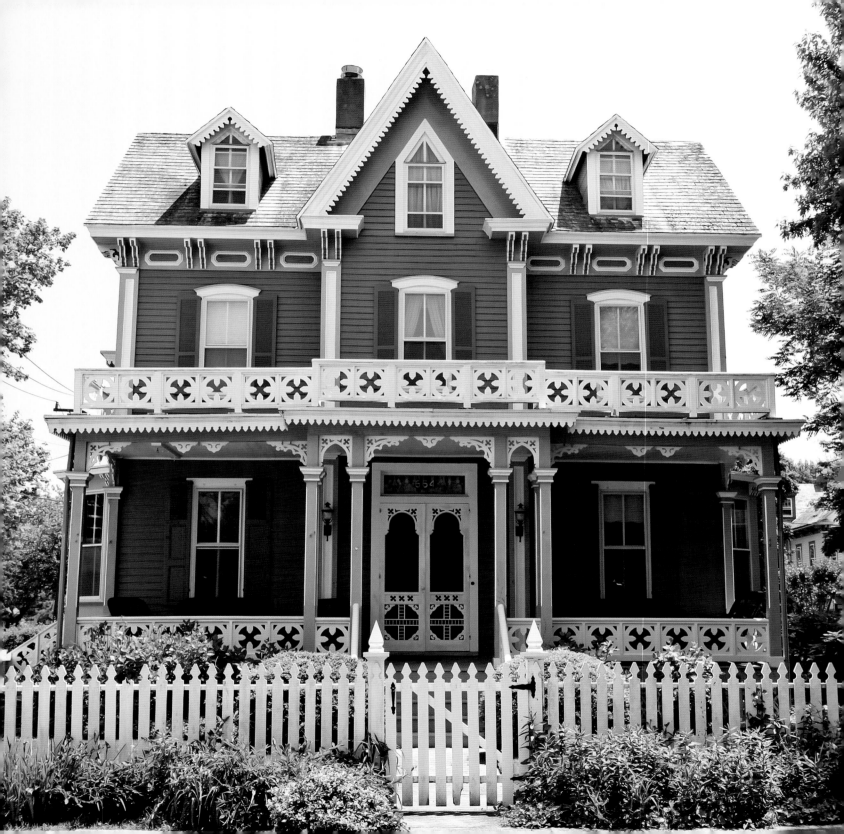

Chapter
Two

American Gothic

THE GOTHIC REVIVAL IN THE NEW WORLD

*[A] preference for the natural in contradistinction to the artificial—a
preference for the works of God to the works of man . . . [is] inherent
proof of inherent good, true, and healthy taste.*

—CALVERT VAUX, *VILLAS AND COTTAGES*, 1864

*Sir Walter Scott is probably responsible for the [Louisiana] Capitol
building, for it is not conceivable that this little sham castle would have
been built if he had not run the people mad, a couple of generations
ago, with his Medieval romances. The South has not yet recovered from
the debilitating effects of his books.*

—MARK TWAIN, *LIFE ON THE MISSISSIPPI*, 1883

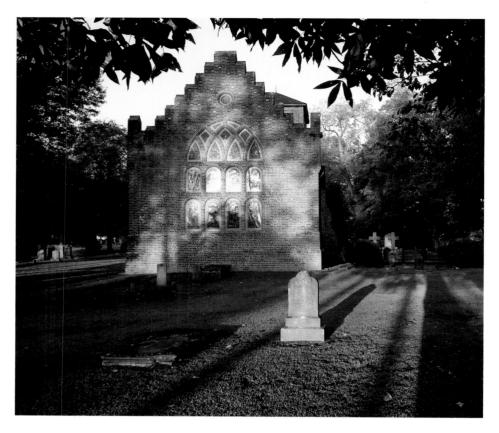

The development of the Gothic Revival style in the United States began during the colonial period and reached its apogee during the mid-nineteenth century, spreading from New York's Hudson Valley across the country, as American builders developed the vernacular style that we know now as Carpenter Gothic.

The Gothic Revival style migrated across the Atlantic from England during the early seventeenth century. The earliest Gothic buildings in colonial America were churches. The first known example is St. Luke's Church, built sometime around 1632 in Isle of Wight, Virginia; originally called Newport Parish Church, it was renamed St. Luke's Church in 1828. With its square tower, stocky massing, pointed (lancet) side windows, large, tracery-decorated east window, and brickwork laid in Flemish bond, this modest church is the link between the medieval European tradition and the mid-nineteenth-century Gothic Revival in the United States.

The earliest brick church at Jamestown, Virginia, completed in 1644, featured buttressed walls and a tower, which still survives as a ruin; in 1944, Ralph Adams Cram, leading Gothic Revivalist, was commissioned to rebuild it, which he did in the Gothic style. Documents and ruins of other Virginia churches from this early Colonial period indicate a similar preference for the Gothic.

PREVIOUS:
A classic Carpenter Gothic home.
THIS PAGE:
Historic St. Luke's Church, in Isle of Wight, Virginia, built in about 1632, is the oldest surviving Gothic Revival building in America.

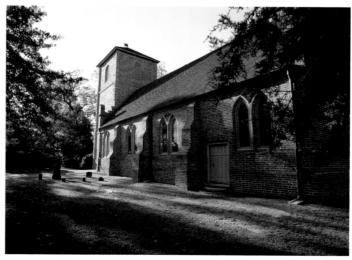

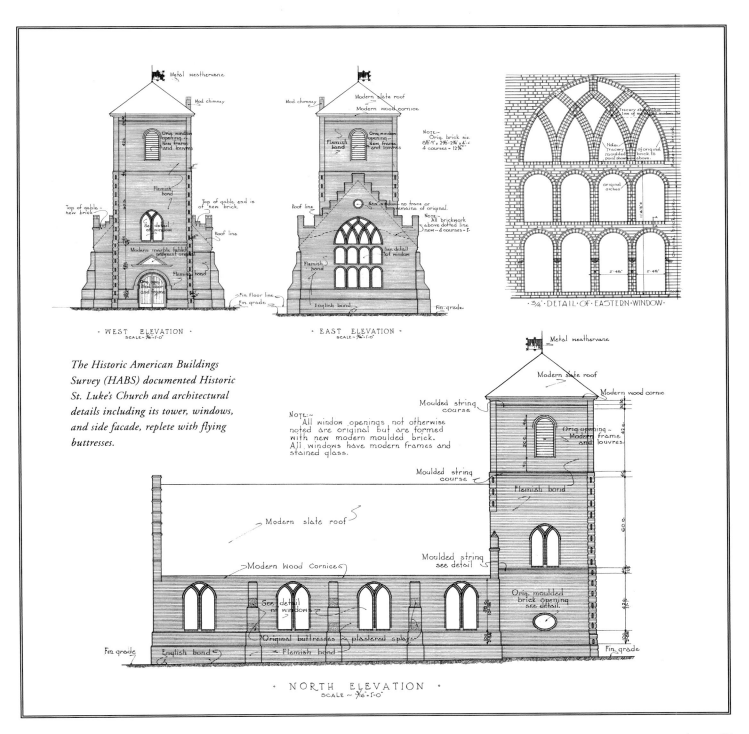

The Historic American Buildings Survey (HABS) documented Historic St. Luke's Church and architectural details including its tower, windows, and side facade, replete with flying buttresses.

Similarly, New York City's Trinity Church, completed in 1698 and destroyed in 1776, incorporated an apse with lancet windows decorated with tracery and shallow buttresses at its corners. This church was rebuilt in the Georgian style with some Gothic detailing in 1788–94 by architect Josiah Brady. Demolished in 1839, Brady's building was reconstructed in a clearer interpretation of the Gothic style by Richard Upjohn in 1846.

Though Gothic-style churches existed in early America, the post-and-beam dwellings of the Colonial, Georgian, Federal, and Greek Revival periods were never Gothic by design. The post-and-beam construction that prevailed from 1620–1830 was a medieval method of timber framing, which hadn't changed in several centuries. In this construction, early American buildings, with their massive interior corner posts and chamfered beams, which were meant to be exposed, did not differ much from the half-timbered Gothic-era structures that had inspired Pugin. But residential architecture prior to the nineteenth-century's Gothic Revival did not contain pointed arches, lancet windows, tracery, or other features associated with the medieval era.

In eighteenth-century America, Gothic structures were used as garden or service buildings or tacked onto those that were otherwise Neoclassical in style. For Gunston Hall, in Fairfax, Virginia, in 1755, carpenter William Buckland, apparently borrowed pointed-arch openings for the entry porch from a 1742 illustration of an "octangular umbrello" by English architect Batty Langley, whose pattern book was among the volumes in the library of the owner, George Mason. Similarly, the two-door carriage house of the Miles Brewton House in Charleston, South Carolina, constructed in the 1760s of English bond brickwork, boasted a crenellated roofline, a spire in the center of the front gable and spires at each end, and a central oriel window surmounted by a trefoil and flanked by pointed windows with tracery. This set the stage for Charlestonians to create Gothic dependencies for their Neoclassical residences.

The first residence in the United States to incorporate Gothic elements was Sedgley, built in 1799 in Philadelphia for William Cramond. A townhouse set into a lawn, it incorporated pointed arches in the four lovely towers that anchored its corners. But its massing—as designed by Neoclassical architect Benjamin Henry Latrobe, who also designed the U.S. Capitol and the White House—was a basic, symmetrical block, not the irregular form that emerged in the century that followed. Sedgley was destroyed by fire in the mid-1800s.

In otherwise Neoclassical buildings, Gothic details began to appear. From Philadelphia to Newport, Charleston, Salem, Newburyport, Baltimore, and New York— each an important eighteenth-century port city with great wealth and an interest in the latest imported fashions—pointed arches were sometimes incorporated into Neoclassical mantels, entry porches, and other ancillary structures, even as pointed tracery was sometimes deployed in fan windows. At Mount Clare, the 1754 Georgian mansion of Charles Carroll, bookcases in the pointed style featured twin doors with tracery. At Monticello, influenced by what he had seen in England and France, Thomas Jefferson penned instructions for "a small Gothic temple of antique appearance" to be placed in the plantation graveyard in 1771, and, in 1807, he developed plans for "a Gothic temple or rather portico"; this was based upon a German book in his library, *Schone Landbaukunst*, but apparently never constructed. At Hayes Plantation, in Edenton, North Carolina, the estate of James C. Johnston—who owned a complete set of Horace Walpole's books about Strawberry Hill—the library, circa 1818, was in the Gothic style. So was the Old Georgia State Capitol, in Milledgeville, built in 1807. And, in Alexandria, Virginia, just up the lane from Gadsby's Tavern, where the

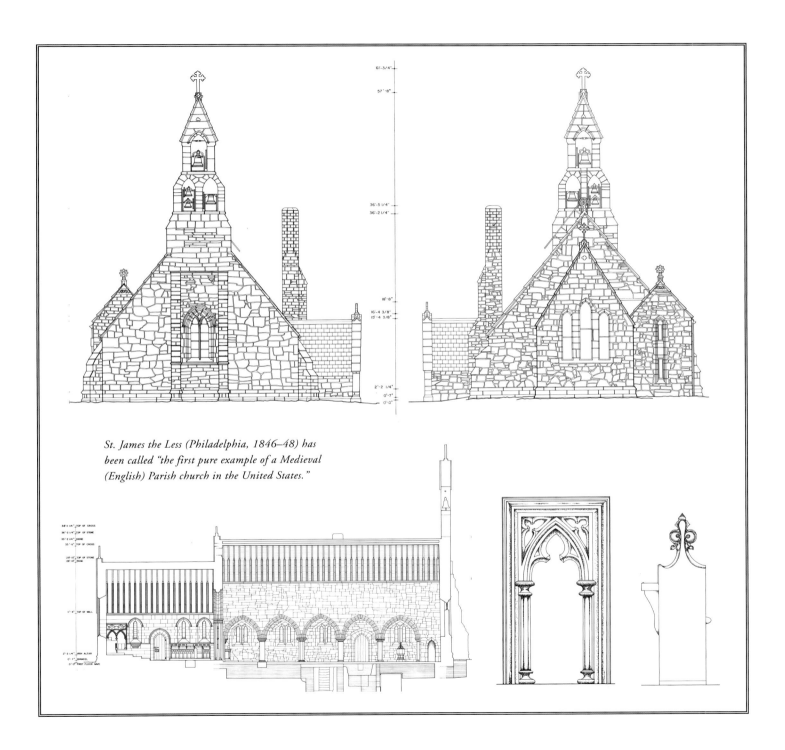

St. James the Less (Philadelphia, 1846–48) has been called "the first pure example of a Medieval (English) Parish church in the United States."

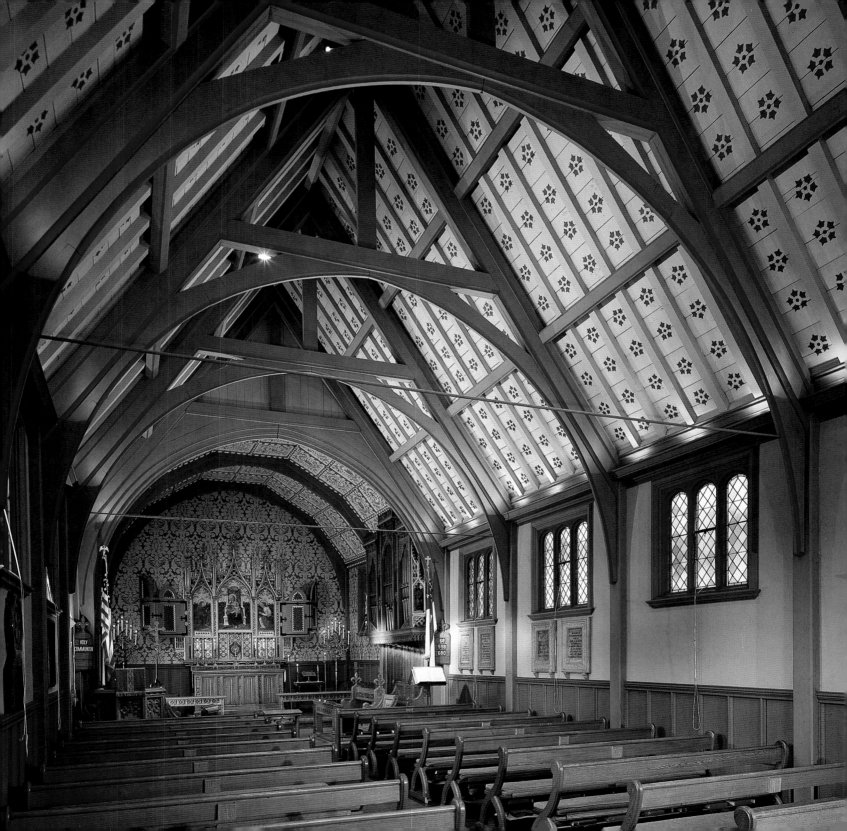

Baltimore Cathedral was selected over his Gothic design; and in 1808 he startled many by designing the Bank of Philadelphia in the Gothic style. In its blocky massing, and its pointed spires, windows, and entry, the bank was a clear cousin of his Gothic plan for the Baltimore Cathedral: Latrobe was prescient about the direction of his adoptive country's aspirations and its coming worship of commerce.

The next notable home to be built in the Gothic Revival style was John Dorsey's mansion in Philadelphia in 1809. The owner,

founding fathers often met, an apothecary boasted shelving ornamented with trifoliate drops in the Gothic style.

At this time, Gothic architecture had three leading proponents in the United States: Latrobe, an Englishman who was the first professionally trained architect to practice in the United States, and French-men Joseph Mangin and Maximilian Godefroy. The few buildings they executed in the Gothic style featured simple geo-metric massing embellished with Gothic treatments, and were the exceptions to the preference for the Neoclassical styles that dominated up until the 1840s. Latrobe, based in Philadelphia, worked both veins: in 1800 he designed the nation's first Greek Revival building, the Bank of Pennsylvania; in 1804, his Neoclassical design for the

OPPOSITE: *In a New Castle, Maine, church, a hammerbeam ceiling is embellished with five-petaled Tudor roses.* THIS PAGE: *In this group of New England churches, steeples, spires, and doorways take on a rural purity.*

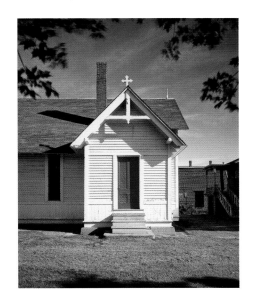

a politician and amateur architect, chose the design and detailed it with quatrefoil guilloches, shields, escutcheons, tablets, and bas-relief. The building became a boarding school and was eventually demolished.

Meanwhile, churches continued to be constructed in the Gothic idiom. The first deliberately Gothic church in New England was Boston's Federal Street Church, designed by Charles Bulfinch, built in 1809 and dismantled in 1859. (Nearby, the family mansion of John Hancock, a signer of the Declaration of Independence, was removed to make way for the Massachusetts State House, also designed by Bulfinch, a demolition that helped launch the historic preservation movement in the United States.)

(continued on page 44)

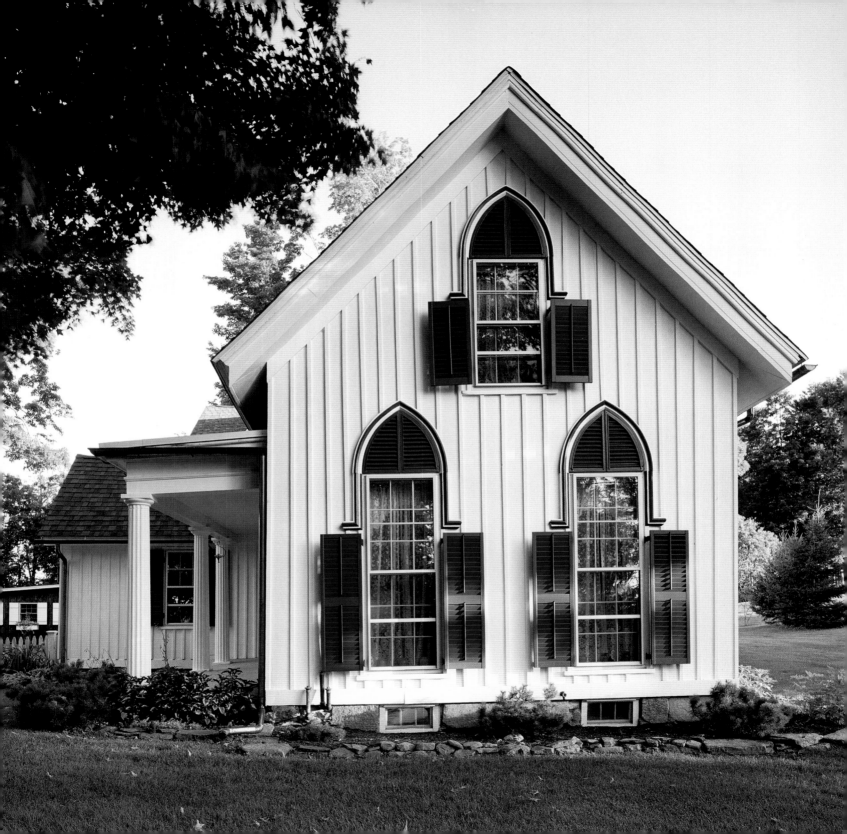

❧ Granville, Massachusetts ❧

Built in 1850 and located in a rural community, this cottage, owned by an architectural photographer, evokes purity, simplicity, and grace of form. Its side porch has Doric columns, a holdover from the Neoclassical Greek Revival period that preceded the Gothic Revival. Other exterior features are pure Gothic. Board-and-batten siding frames pointed windows with hooded tops. Each window

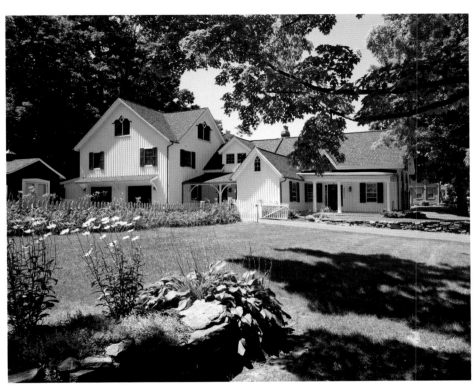

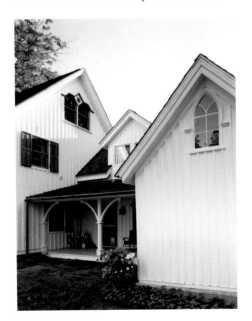

OPPOSITE: *The side facade shows both Greek Revival and Gothic features.* THIS PAGE: *A carriage house complements the original home.*

on the side facade features two sets of shutters. Painted grass green, a popular color for shutters and doors in the early to mid-nineteenth century, the top shutters follow the curve of the pointed window, while bottom shutters are rectangular over double-hung sash.

Inside, this house is all about modern living and modern taste. The dining room ceiling was removed to create a cathedral treatment and reveal post-and-beam construction. The pared down, contemporary interiors eliminate visual distractions, thus highlighting original Gothic Revival accents, such as pointed and stained-glass windows, triangular door pediments, and the gracious curve of the staircase.

CLOCKWISE FROM TOP: *In the dining room, renovated to expose timber framing and create a peaked ceiling, white walls and simple furnishings create a graphic quality; a view to the porch; the kitchen.*

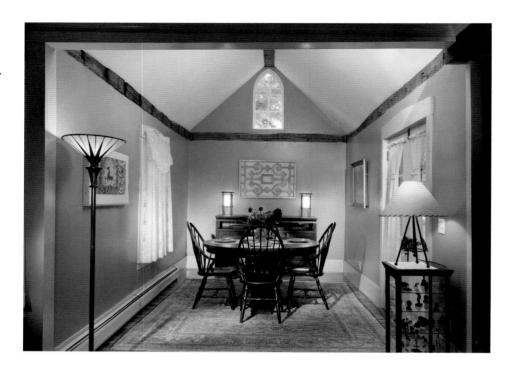

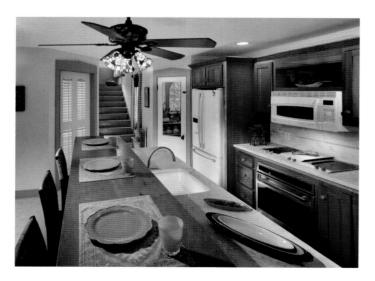

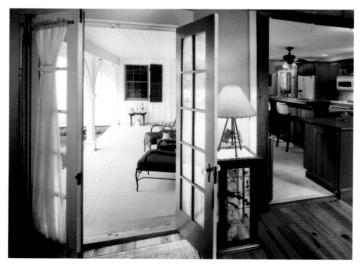

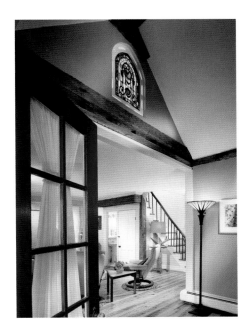

ABOVE: *The view from the dining room to the hall was enhanced with a new stained-glass window in the peak of the wall.* RIGHT: *In the front hall, a graceful staircase and triangular door pediments are a beautifully simple visual composition.*

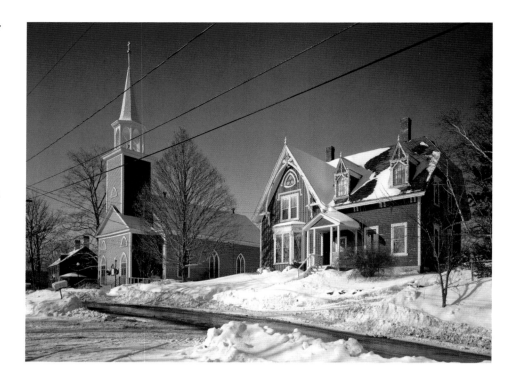

A Gothic Revival church and residence punctuate a streetscape in Wiscasset, Maine.

In New Haven, architect Ithiel Town launched his career with his design for Trinity Church on the green, in 1814–16. This was the first Gothic work by Town, who had trained with popular pattern-book author Asher Benjamin and who formed a partnership with Alexander Jackson Davis in 1829. Trinity Church's revolutionary design was described as the "only correct specimen" of Gothic architecture in the United States. The building had crenellated parapets, which were removed in 1844; its tower was modified in 1870; and the rear apse was added in 1885.

The Town and Davis partnership, which continued until 1835, was the first fully developed architectural practice in the United States. Though Town was very respected prior to it, it was Davis's versatile talent as a designer and his skill as a draftsman in pen and watercolor—which became his trademark—that most contributed to the firm's success. Davis went on to become a leading figure in the Gothic Revival in the United States.

In Philadelphia, Latrobe's student, William Strickland, was responsible for churches and a Gothic-style Masonic Hall in 1815. Architect Francis D. Lee, of Charleston, South Carolina, modeled the ceiling decorations for that city's Unitarian Church after Westminster Abbey, using plaster to imitate the fan-vaulted ceiling of the Henry VII chapel. In Providence, Rhode Island, John Holden Green created St. John's Cathedral with a portico—like a medieval jousting pavilion—that was straight out of Batty Langley's pattern books; later, Green designed the Gothic Revival Sullivan Dorr house, with pointed tracery decoration on the entablature of its Palladian window and front entry.

In New York, architect James Renwick, Jr.—who also designed the Smithsonian Institution in Washington, D.C., in the Norman Gothic style—adhered to English examples in his Gothic design for Grace Church, and in his designs for St. Patrick's Cathedral, completed in 1878. The cathedral on Fifth Avenue at Fiftieth Street replaced the earlier Gothic church on Mott Street to a design by Mangin and razed in 1866. Renwick was influenced by French, German, and English churches and cathedrals, notably Sainte-Clotilde, in Paris, where work began in 1846. St. Patrick's was the first cathedral in America to be realized on the grand medieval scale. Renwick designed it with a three-portal facade, a

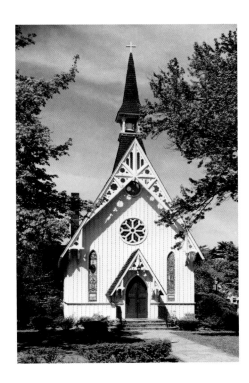

great rose window, "stone lace" ornamentation, French and German elements, and spires that were not completed until 1888. Its plan, with shallow transepts and an ambulatory, follows classic French pattern, but interior details are all in the English Decorated Gothic style, with English stellar vaulting rising 112 feet to the ceiling.

Architects soon had competition from the clergy: in 1845, the Reverend John

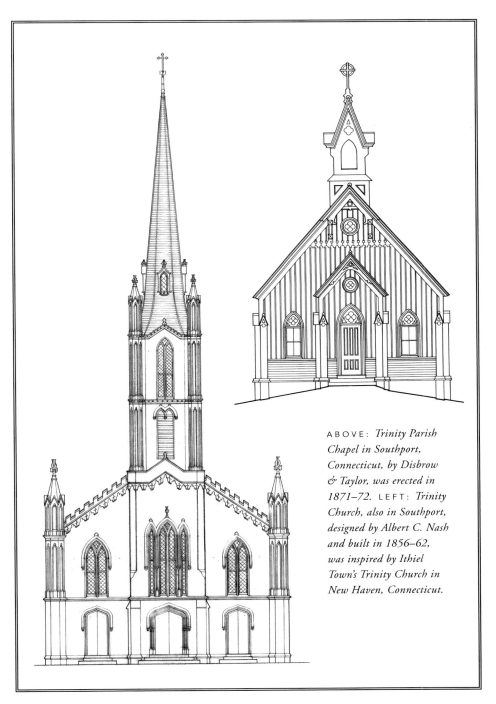

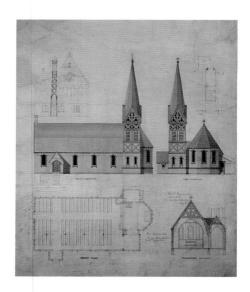

Richard Upjohn's well-known and widely disseminated plans spawned many a rural Gothic church.

Medley moved to New York to work as an architect; he patterned the Chapel of the Cross in Mississippi, erected in 1849 and replete with bell cote, buttresses, and a side porch entrance with simple lancet openings after St. Michael's Long Staunton in England. The first American book on Gothic church architecture was written by John Henry Hopkins, the first Episcopal Bishop of Vermont, who was frustrated by the lack of plans available when, as a young minister, he supervised the construction of the Gothic St. Paul Lutheran Church in Zelienople, Pennsylvania. He based his book upon John Britton's *Architectural Antiquities of Great Britain,*

intended "chiefly for use of the clergy"; it showed little grasp of structure and much appreciation of Gothic details.

The most influential figure in the nineteenth-century design of urban, small town, and rural churches throughout the United States was Richard Upjohn. An English cabinetmaker, Upjohn came to America in 1829 and settled in New Bedford, Massachusetts, where he worked as a draftsman; he then moved to Boston, where he was employed by architect Alexander Parris; interested in the Gothic Revival, he left that office to set up his own practice. One of his first important commissions was St. John's Church, in Bangor, Maine.

Based on that project, Upjohn was hired in 1839 to rebuild New York's Trinity Church, which had been weakened by heavy snows. For his model, he used an illustration for "An Ideal Church" from A. W. N. Pugin's *True Principles.* Completed in 1846, Trinity Church was a watershed because of its cohesion of concept, its adherence to true medieval design, and its rich embellishments. Too costly to replicate elsewhere, Episcopal churches adopted early English and Decorated styles rather than Perpendicular.

Thus began a stylistic trend that continued in the architecture of American churches, even to the recent completion

of the Cathedral Church of St. John the Divine, on New York's Upper West Side.

Following his work at Trinity, Upjohn designed St. Mary's Church in Burlington, New Jersey, which he also derived from an English example: St. John the Baptist, a medieval church in Shottesbrooke, Berkshire. With it, the stone steeple topped with a pinnacle at each of its four corners, became an idiom of church design in America.

These two projects earned Upjohn church commissions around the country, which he imbued with buttresses, lancet windows, and steep gables: Christ Church in Raleigh, North Carolina (1848–54), St. Paul's, Buffalo, New York in (1850–51), St. Peter's in Albany, New York (1859–60), Christ Church in Binghamton, New York (1855), the Central Congregational Church in Boston (1865–67), and St. Thomas's Church in New York City (1868–70). He also accepted commissions to design rural wooden meetinghouses at no fee, and his 1852 pattern book, *Rural Architecture,* contained designs for inexpensive board-and-batten churches, parsonages, and schoolhouses.

Upjohn also designed houses. In 1835, he created Oaklands, a stone castle, for Richard Gardiner of Gardiner, Maine. In 1839, he devised a whimsical Gothic Revival summer cottage in Newport, Rhode Island, for George Noble Jones,

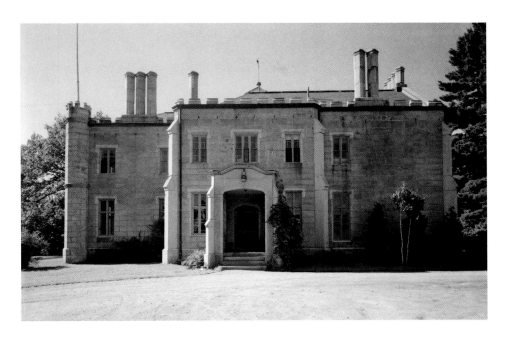

a businessman from Savannah, Georgia. The structure featured irregular massing, though the house was basically a long rectangle with a large towerlike section, Tuscan in feeling, at one end. At the front, surmounting a crenellated oriel window, was a projecting bay with a steeply peaked gable, scrollwork trim at the bargeboard, and a spire at its peak; to its right, between it and the tower, was a small connector

Gothic Revival mansions designed by Richard Upjohn include (left) Oaklands (1835) in Gardiner, Maine, and (below) Kingscote (1839), in Newport, Rhode Island.

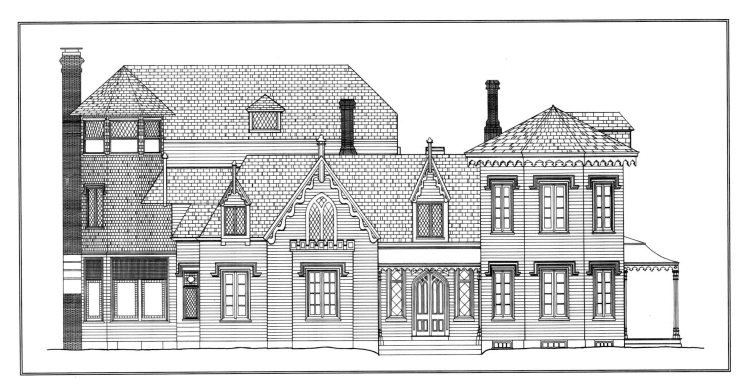

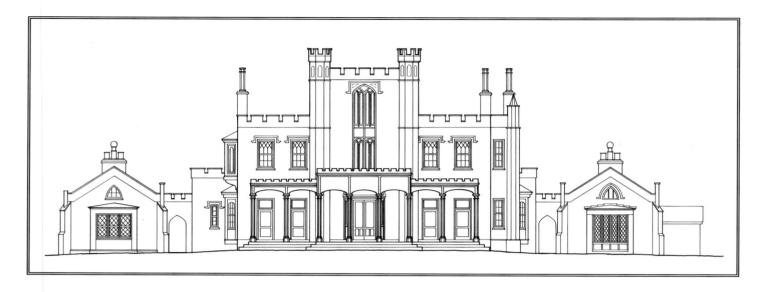

with a porch, entry door, and small dor-
mer. A larger oriel window, also topped by
a crenellated battlement, was tucked into
the L. Clustered chimneys and uniform
trim on all the windows and on the eaves
of the tower helped to unify the visually
rhythmic facade. The original interiors
were not particularly Gothic in style.

In 1864, the property was acquired by
William King, who had made his fortune
in the China trade, and it was renamed
Kingscote. In 1876, King's nephew and
heir, David King, enlisted McKim, Mead
and White, working with Louis Comfort
Tiffany, to renovate and expand the
house. Today Kingscote is a museum
and a National Historic Landmark.

A similarly grand home, Staunton
Hill, was built in Charlotte, Virginia, in

*Staunton Hill, in Charlotte, Virginia, was
designed and constructed by architect/builder John
Evans Johnson in 1848–50 for Charles Bruce.*

1848 for Charles Bruce. With exterior
stuccoed walls and a veranda of gray
Italian marble brought upriver by barge,
the twenty-five-room castellated Gothic
mansion comprised a fairly symmetrical
plan with a central section and octagonal
entrance hall, flanking wings, and a piazza.
In the hall, where Gothic ribs formed a
tent ceiling, four niches displayed classical
sculptures. Gothic detailing was evident
in the marble mantels, carved motifs in
doors, plaster cornices, four identical
Gothic drawing-room mirrors imported
from Venice, a stair balustrade with
pointed arches, columns separating the

rooms and defining the library bookcases,
casement windows, and prominent rear
oriel window; on the third story, a huge
tracery-decorated window overlooked the
Staunton (Roanoke) River.

The Gothic style also found its way
into academic campuses, beginning with
the Reverend (and amateur architect)
Norman Nash's designs for Old Kenyon
at Kenyon College, Gambier, Ohio, built
between 1827 and 1829, with a central
spire and spires on its wings. James
Renwick, Sr., the father of the famed
architect, created designs for Columbia
University, which were never executed.

In 1832, the second Gothic Re-
vival residence in the United States took
shape, when New Haven–based architects
Ithiel Town and Alexander Jackson Davis

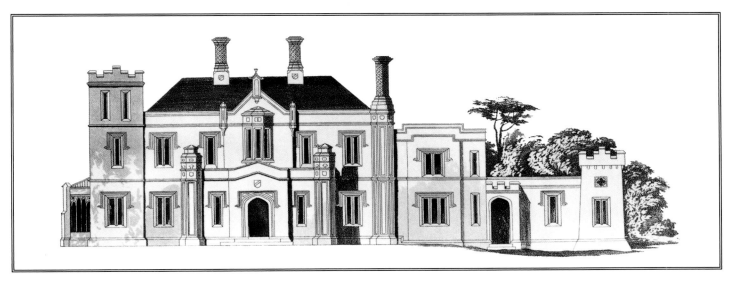

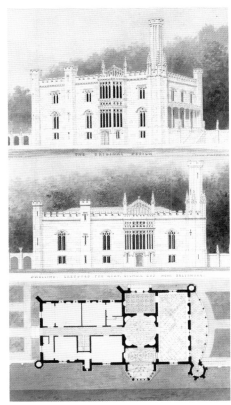

departed from the Neoclassical work for which they were known to design Glen Ellen, in Towson, Maryland, the first true Gothic country villa in the United States. For client Robert Gilmore, the home was, Davis said, "the first English Perpendicular Gothic Villa with Barge Boards, Bracketts, Oriels, Tracery in windows, etc." Inspired by Gilmore's visit to Abbotsford, Sir Walter Scott's Gothic Revival home in Scotland, it boasted marble floors, vaulted ceilings, and stained-glass windows. Glen Ellen was demolished in 1919 to make way for a reservoir. Although Glen Ellen does not survive, the project marked a shift in Davis's focus to the romantic revival styles, and he became known as the foremost architect of the residential Gothic Revival style.

Glen Ellen (1832) by Town & Davis, in Towson, Maryland (right) took its cues from English country villas, like the one above, which appeared in Francis Goodwin's 1833 pattern book, Domestic Architecture.

The most important collaboration of Davis's career was with landscape designer Andrew Jackson Downing. On a visit to Blithewood in 1837, Davis's client Robert Donaldson recommended the two men meet, as Downing was studying homes and landscapes for inclusion in his magazine, *The Horticulturist.* Though the two never had a formal partnership, their informal alliance—and the different points of view from which they approached residential design—yielded a new American vision, not only about architecture but about the harmonious relationship between a building and its setting.

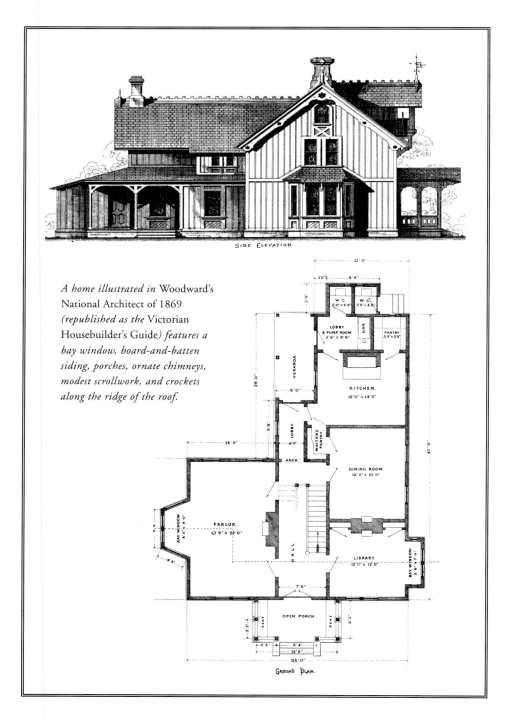

SIDE ELEVATION.

A home illustrated in Woodward's National Architect *of 1869 (republished as the* Victorian Housebuilder's Guide*) features a bay window, board-and-batten siding, porches, ornate chimneys, modest scrollwork, and crockets along the ridge of the roof.*

GROUND PLAN.

Davis's plans for Gothic Revival—and Tuscan-style houses—another iteration of the era's romantic architectural impulse—appeared in several of Downing's highly successful pattern books. Davis also did the drawings for the engravings and illustrations. Together, these two men with the confusingly similar names took the lead in popularizing the Gothic Revival—and the Carpenter Gothic—style in the United States.

It was Alexander Jackson Davis and Andrew Jackson Downing, working principally in New York's Hudson Valley, who made the Gothic Revival style and construction methods accessible to homeowners and those outside the building trades, even as their interpretation of the "cottage-villa" opened the way for the development, in increasing numbers, of tasteful, well-outfitted, and appropriately scaled homes—and suburbs—for America's emerging middle class.

They also created something new, which became known as the Carpenter Gothic style. Because it was plentiful, Americans customarily favored wood as a primary building material. This tended to look less formal than stone or brick. So American Gothic Revival designs, embellished with hand-carved details and abetted by the development of the scroll saw, took on an intimate, romantic character that had not been seen in England.

Downing's and Davis's were not the only pattern books. Among these how-to books intended for the general public were Joseph Nash's *Mansions of England in the Olden Time* (1839–1849), William Ranlett's *The Architect* (1847), Lewis F. Allen's *Rural Architecture* (1852), Samuel Sloan's *The Model Architect* (1852), Gervase Wheeler's *Rural Homes* (1851), Richard Upjohn's *Rural Architecture* (1852), *National Architect* (1869) by George Woodward and Edward G. Thompson, and Calvert Vaux's *Villas and Cottages*. Most of the era's building guides dealt with dwellings, though they sometimes included plans for garden temples, carriage houses, boathouses, ice houses, schools, and churches.

Until the Civil War, the Gothic Revival style continued to co-exist with the Neoclassical: for instance, though the 1854 pattern book issued by New Hampshire builder Edward Shaw contained several Gothic homes, the majority of plans it presented were in the Greek Revival style.

In 1850, Downing and Davis parted ways, and Downing invited Calvert Vaux to form a partnership. After Downing's death in 1852, Vaux went on to join the

A Gothic Revival boathouse captures the fanciful, picturesque spirit of the style.

firm of preeminent landscape architect Frederick Law Olmstead. Their designs for Central Park, completed in 1858, incorporated fanciful Gothic structures. In 1864, Vaux published *Villas and Cottages*, which included several Gothic Revival designs, ranging from a farmhouse to "a villa on a large scale" and which he dedicated to Downing's widow in memory of his late partner.

Significantly, Davis and Downing centered much of their work in the Hudson Valley. An easy trip by railroad or steamboat from the nation's emergent capital of taste, style, and sophistication, this area was the location of choice for well-to-do New Yorkers desirous of a country home. The region became a weekend destination for businessmen and civic leaders, and a full-time home to writers and artists. With the two foremost proponents of the rural Gothic style focused mainly in this region, it was, more than any other place, the hotbed in which this new style took hold, and from which it spread.

(continued on page 56)

American Gothic 51

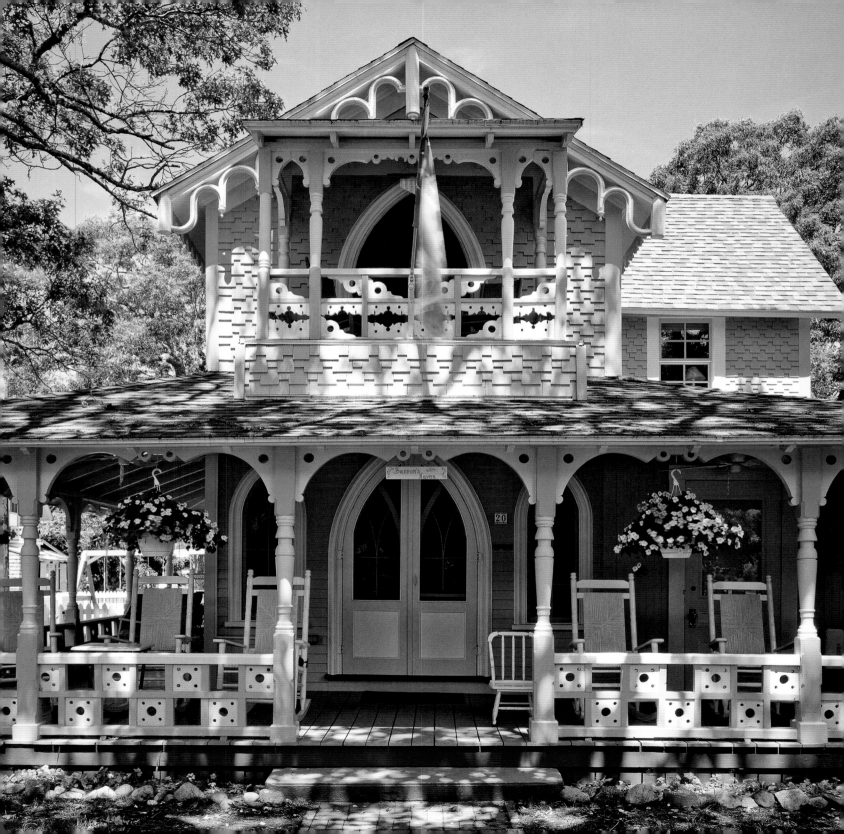

❧ Oak Bluffs, Massachusetts ❧

On Martha's Vineyard, the landmark community of Oak Bluffs began its life as a Methodist campground. The nineteenth century's religious revivals encouraged such gatherings, and sites by the sea and in the mountains held appeal beyond the spiritual meaning of these summer meetings.

The Carpenter Gothic style was a natural choice for these communities, in part because its playful exterior scrollwork detailing captured the sensibility of a resort. These highly individual cottages with their varied architectural features are a perfect expression of the highly pictur-

OPPOSITE AND BELOW: Exterior color schemes and varied styles of gingerbread trim give each Oak Bluffs cottage an individual personality.

esque quality sought by owners and builders during the Gothic Revival. Typically, these small seasonal cottages were loosely arrayed in an enclave that encompassed a chapel and a central lawn. Many of these residences were built without kitchens or baths, as families took their meals in a common dining room and used common sanitary facilities.

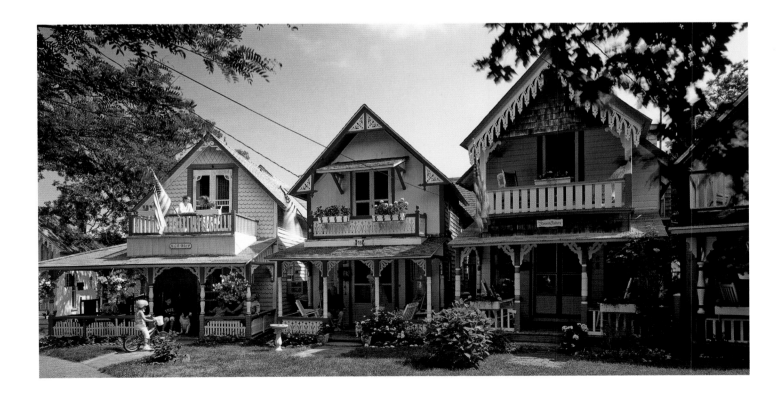

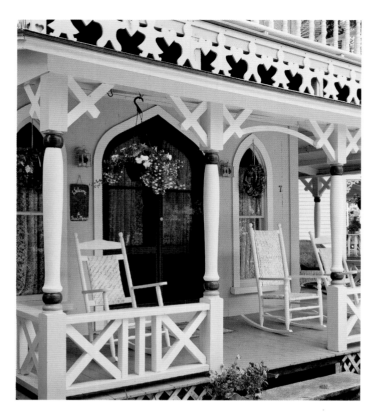

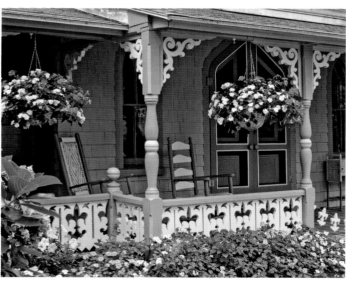

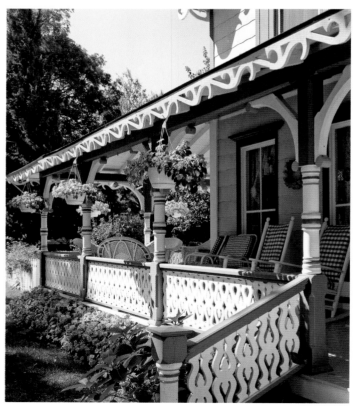

OPPOSITE: *A plethora of porches with diverse scroll-work trim, including one with gingerbread figures.* RIGHT: *With its flag flying, this cottage becomes an exuberant expression of Americana.*

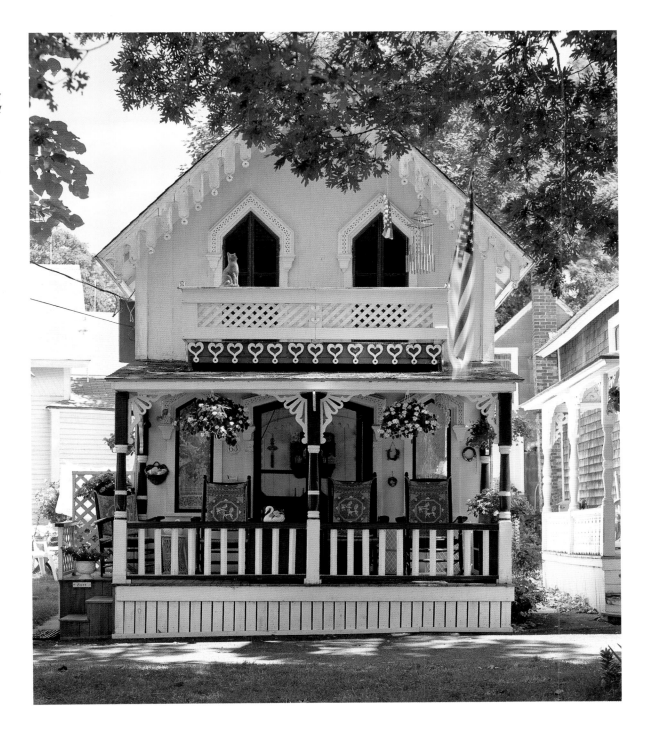

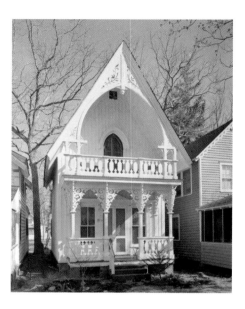

CLOCKWISE FROM TOP LEFT: *Details from* The Model Architect *by Samuel Sloan; cottage South Seaville, Cape May, New Jersey; slave cabin, Arundel Plantation, Georgetown, South Carolina.*

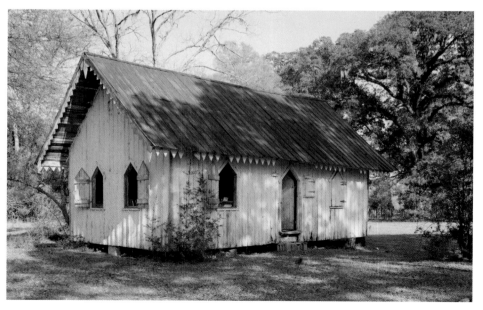

The style also spread to a new sort of American community: the commuter suburb, made possible by the advent of the railroad. In 1857, Davis was hired by pharmaceutical magnate Llewellyn Haskell to remake his West Orange, New Jersey, home into a Gothic Revival villa, which Haskell dubbed the Eerie. A man with a vision, he enlisted Davis to help him develop his property into a planned bedroom community within commuting distance from New York City by railroad. Davis reprised details from the Eerie for the community's turreted stone gatehouse.

For their designs, Davis and other American architects drew on English sources, including books by Loudon, Repton, Langley, Pugin, and others. Pugin's *True Principles* and *Theories on the moral and ethical nature of architecture and practical guidance related to Gothic details and building methods* had a strong impact on the North American Gothic Revival. This book in particular helped architects and laymen translate the medieval model into workable buildings and contributed to a more sophisticated and precise interpretation of the Gothic style. Pugin's ideas influenced Richard Upjohn, James Renwick, Minard Lafever, and others.

American architects also took cues from English churches of the medieval and

the Gothic Revival periods. James Harrison Dakin, who apprenticed with Town and Davis, based his design for the chapel at New York University on the Perpendicular Gothic Chapel Royal at Hampton Court, which, prior to its demolition in 1911, established the standard for Gothic Revival buildings in the United States. Dakin relocated to New Orleans, where he became one of that city's preeminent nineteenth-century architects, designing St. Patrick's Cathedral and, in 1849, the Old Louisiana State Capitol, which Mark Twain so deplored.

Of it, Dakin wrote, "I have used the Castellated Gothic style of Architecture in the Design because it is quite as appropriate as any other Style or Mode of building and because no style or order of architecture can be employed which would give suitable character to a Building with so little cost as the Castellated Gothic."

"Should a Design be adopted on the Grecian or Roman Order of Architecture," he continued, "we should accomplish only what would unavoidably appear to be a mere copy of some other Edifice already erected and repeated in every city and town in the country. Those orders have been so much employed for many years past that it is almost impossible to start an original conception with them."

Davis probably would have agreed.

The association between the Gothic style, the cottage-villa, and ecclesiastical architecture made it the choice for the religious revival movements of the nineteenth century. Chief among these were the Methodist camp-meeting grounds. At Oak Bluffs, on Martha's Vineyard, Massachusetts, Shelter Island Heights, New York, South Seaville in Cape May, New Jersey, Pine Grove in Falls Village, Connecticut, and other locales, religious revivalism dovetailed with architectural impulses. As it had in the Middle Ages, the pointed Carpenter Gothic style, in

(continued on page 64)

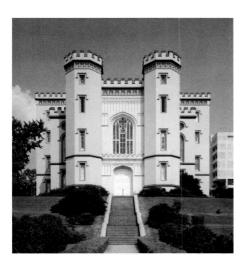

THIS PAGE: *Built in 1849, the Old Louisiana State Capitol, by James Harrison Dakin, is a castellated building with battlements and towers.*

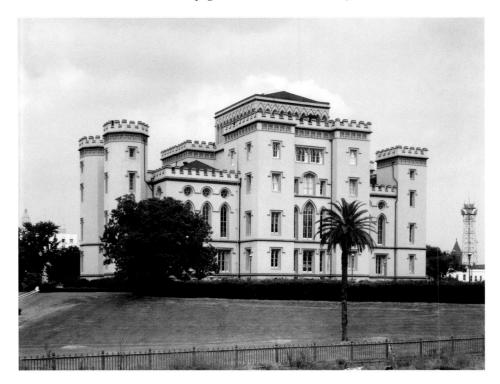

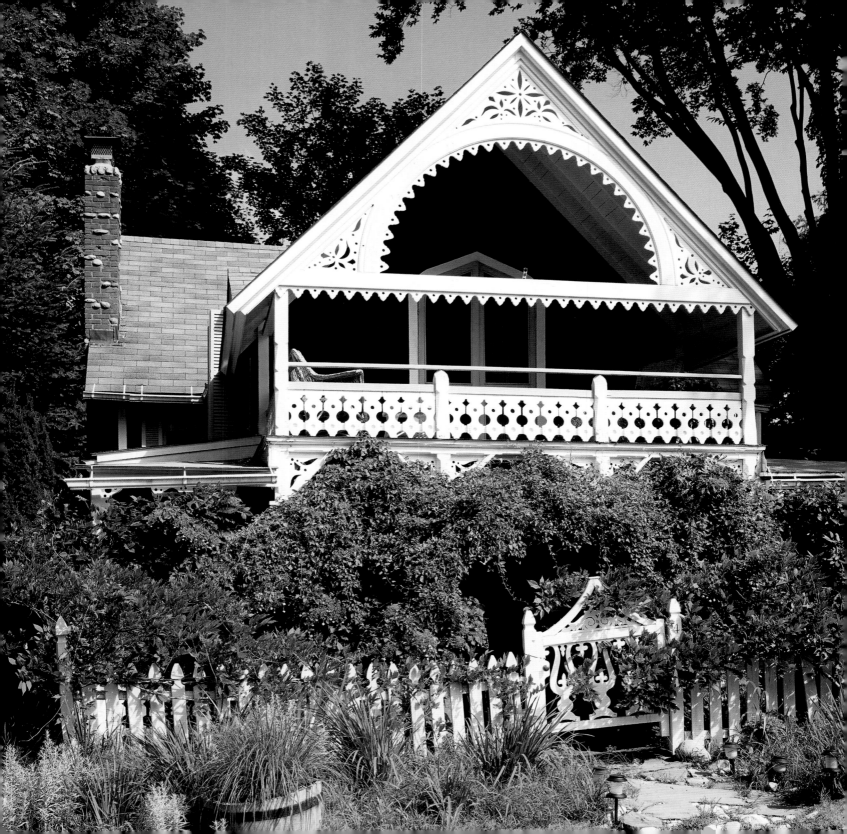

❧ Shelter Island, New York ❧

This sweet summer cottage, built in 1875 and owned by a savvy New York designer, is part of a community that began as a Methodist campground during the era's religious revival. To create a calm feeling and to amplify scant light admitted by exterior porches and relatively small windows, the owner painted interiors a warm, creamy white. Rooms receive

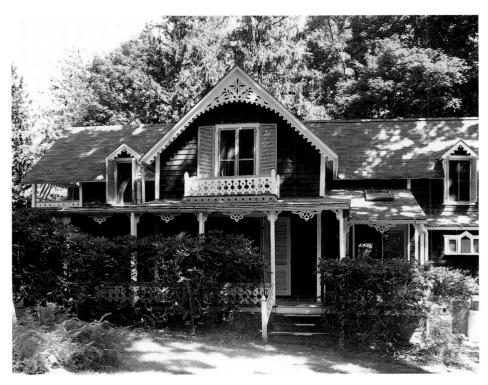

OPPOSITE AND THIS PAGE: *Porches mediate between inside and outside space and provide places to enjoy the shade and ocean breezes.*

additional lift and life from pale Prussian-blue ceilings—the traditional color for porch ceilings—a hue that reinforces the home's sense of summery ease.

The easy, comfortable ambiance is born of a stylish collection of tag-sale furnishings, a delightful mix of high and low, old and new, where African pottery coexists happily with Gothic throne chairs salvaged from a Masonic lodge. Chosen for comfort, these furnishings encourage guests to put their feet up and add to the air of playfulness that befits the home's setting in a summer colony by the sea.

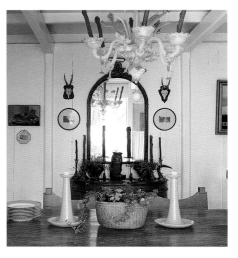

OPPOSITE: *A stone fireplace and African pottery find the perfect complement in this living room's peaceful neutral color scheme.*

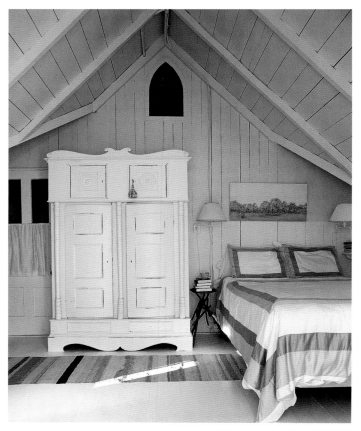

CLOCKWISE FROM TOP RIGHT: *Diverse objects bring visual interest to the dining room; a bedroom is tucked into a gable; sunlight streams through a pointed window.*

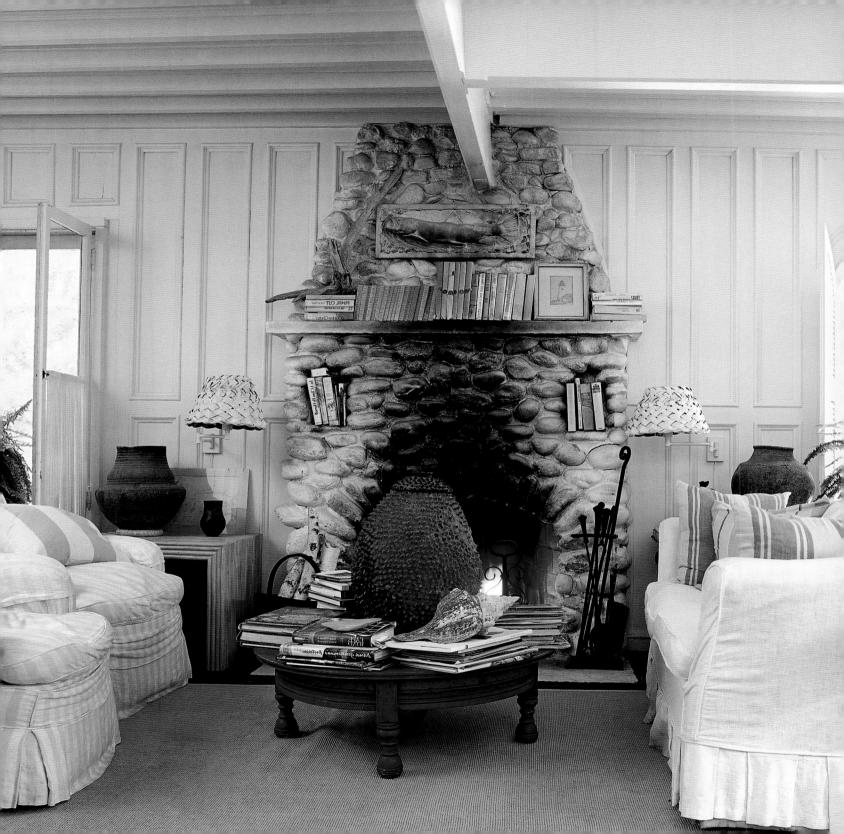

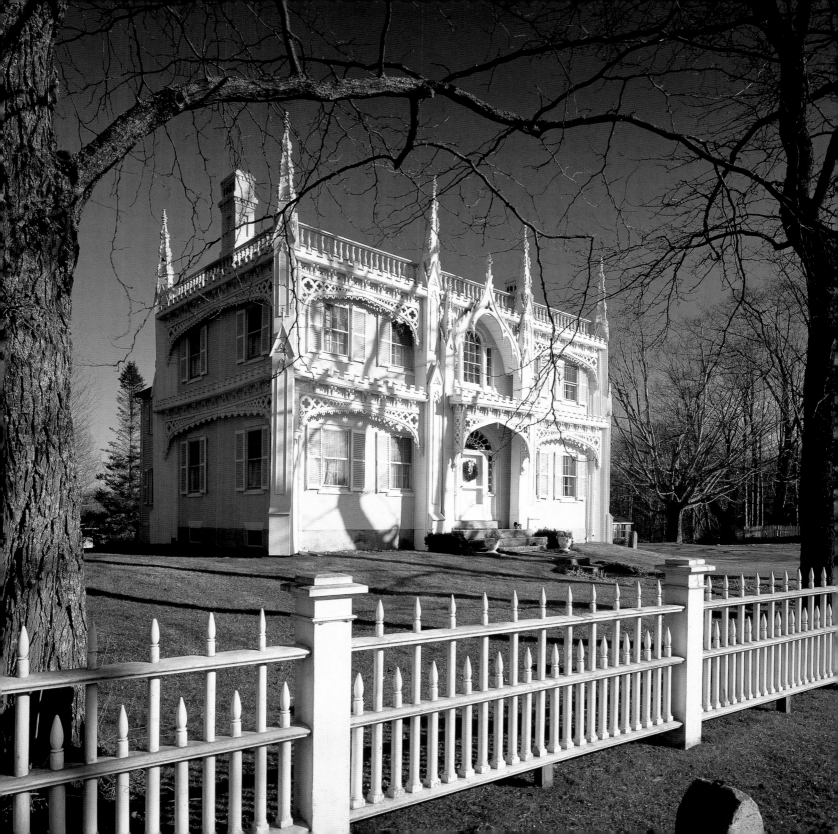

❧ Kennebunk, Maine ❧

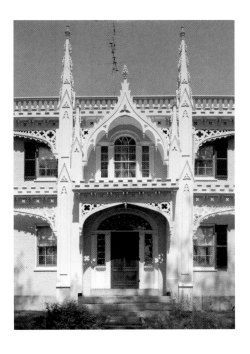

In 1855, George W. Bourne, to impress his bride-to-be, embellished his Federal-period home with a wedding veil of trim, which all but obscures its original Neo-classical lines and features. Known as the Wedding Cake house—possibly because its ornamentation is that many steps above simple "gingerbread" trim—it is as close as residential America ever came to replicating the extravagant spirit of England's Strawberry Hill. Documented in the Historic American Buildings survey, the Bourne house is the most ornate example of a Carpenter Gothic home in America.

At each corner of the house, a tall spire, like those on a church steeple, reaches heavenward. The exuberant facade incorporates trefoil-embellished spandrels that extend its length and pointed arches that frame its original Palladian window and fanlight-topped front door. Even the outdoor water pump is shielded by a Gothic roof, which cantilevers from the exterior wall of the house. Presumably, the new Mrs. Bourne was not drawing her own water—there would have been servants for that—but her neighbors would certainly have known how highly her husband prized his wife.

The Bourne House, shown in color, along with black and white images from the Historic American Buildings Survey that highlight the home's virtuoso trim.

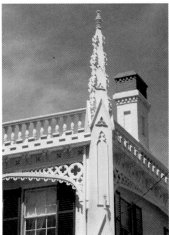

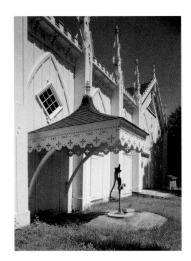

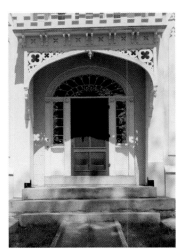

particular, became a joyous expression of religious impulse.

The Carpenter Gothic style was also perfectly consonant with resort architecture, which emerged in the 1830s and continued throughout the century. From Cape May to the islands of the Caribbean, beach cottages and seaside hotels adopted Carpenter Gothic elements. It was in the resort, perhaps, that the era's exuberant architectural eclecticism was most evident, as porches were layered on the first and second stories of front facades, cupolas surmounted peaked roofs, spires topped steep gables, and towers and turrets rose skyward, all ornately detailed in scrollwork tracery.

Following established English and European precedents which traced to the medieval period, academic institutions in America also adopted the Gothic Revival style, executing it principally in stone. With the founding and expansion of U.S. colleges and universities and the rise of private boarding schools and military academies, the Gothic Revival style proliferated on campuses, including Princeton, Harvard, Yale, the University of Chicago, the University of Michigan (by Davis), the Virginia Military Institute (by Davis), and the U.S. Military Academy at West Point. It showed up in slave quarters in the South, castellated prisons, insane asylums, iron

bridges, cemetery structures, garden outbuildings and gazebos, fountains, carriage houses, lighthouses, water towers (including the Chicago Water Tower), bridges (including the Brooklyn Bridge with its landmark pointed arches), the Cincinnati Music Hall, Richmond City Hall (1894) by Elijah E. Myers, pavilions in public parks, including New York's Central Park and Philadelphia's Fairmount Park, playhouses, doghouses, train stations, locomotives, one-room schoolhouses, and the floating church of Our Saviour for Seamen, New York (1844). It was also much used in Canada, notably in Ottawa's Canadian Dominion Parliament Building (1867) by Thomas Fuller.

In residential architecture, from its picturesque, romantic beginnings at Sedgley, the Gothic style spread from high-style estates to vernacular pattern-book houses during the first three quarters of the nineteenth century. While high-style Gothic Revival villas were built for the rich, and Carpenter Gothic cottage-villas for the well-to-do, many Carpenter Gothic cottages were built for people of more modest means. In New Orleans, for instance, the only Carpenter Gothic building in the Garden District, the mid-nineteenth-century area developed for the wealthy, was built as servants' quarters: the Briggs-Staub house has a simple porch, a single

center gable with a Tudor rose in its peak, and pointed windows with pointed shutters.

Unlike European buildings where the Neoclassical and Gothic styles seldom merged in single buildings, American builders often blended the two. Because the Gothic Revival immediately followed—and overlapped with—the Neoclassical Greek Revival period in America, it was not unusual to see Ionic or Doric columns used on the porches of Gothic Revival houses, for the straight front eaves of earlier houses to be modernized with a single steep gable at the center, or for Georgian or Federal period homes to be dressed up with scrollwork.

As Walpole and Scott had done in England, Davis and others gave earlier American Federal-era buildings fashionable updates in the Gothic style. However, the most delightful example of this in the United States wasn't the project of a professional architect, it was the work of homeowner George W. Bourne in Kennebunk, Maine. Bourne, reportedly for his fiancé, revamped his home's unembellished late-Federal facade in 1855 with an extravagant overlay of virtuoso lacework tracery and trim. The original Federal balustrade and Palladian window withered in the presence of eight-foot decorated wooden spires at the corners of the house and above the front door; a crenellated horizontal cornice

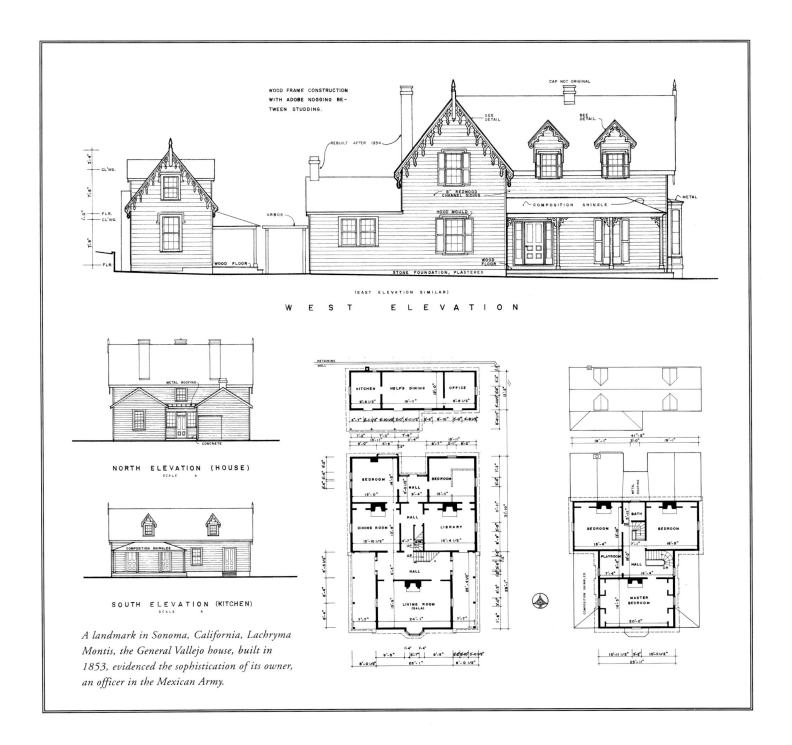

WOOD FRAME CONSTRUCTION
WITH ADOBE NOGGING BE-
TWEEN STUDDING.

CAP NOT ORIGINAL

REBUILT AFTER 1934

SEE DETAIL

SEE DETAIL

8" REDWOOD CHANNEL SIDING

COMPOSITION SHINGLE

METAL

CL'NG.

FLR. CL'NG.

ARBOR

HOOD MOULD

FLR.

WOOD FLOOR

WOOD FLOOR

STONE FOUNDATION, PLASTERED

(EAST ELEVATION SIMILAR)

W E S T E L E V A T I O N

METAL ROOFING

CONCRETE

NORTH ELEVATION (HOUSE)
SCALE A

COMPOSITION SHINGLES

SOUTH ELEVATION (KITCHEN)
SCALE A

A landmark in Sonoma, California, Lachryma Montis, the General Vallejo house, built in 1853, evidenced the sophistication of its owner, an officer in the Mexican Army.

RETAINING WALL

KITCHEN

HELP'S DINING

OFFICE

BEDROOM

HALL

BEDROOM

DINING ROOM

HALL

LIBRARY

HALL

LIVING ROOM (SALA)

BEDROOM

BATH

BEDROOM

PLAYROOM

HALL

MASTER BEDROOM

METAL ROOFING

COMPOSITION SHINGLE

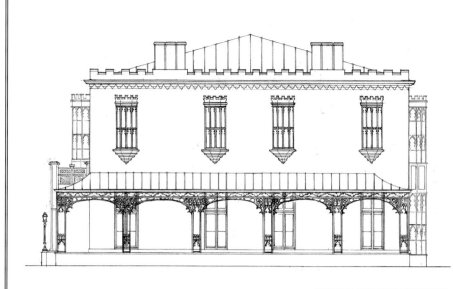

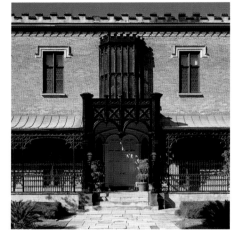

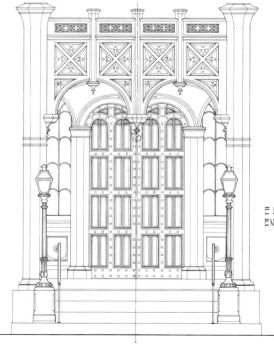

Ornate cast-iron exterior trim on the Green-Meldrim house, in Savannah, Georgia, hints at interior grandeur; the house was the Civil War headquarters of Union General William T. Sherman.

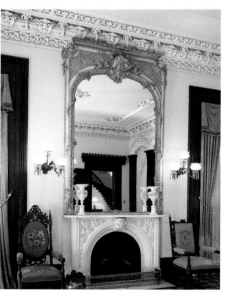

between the first and second stories; board buttresses; and scroll-sawn spandrels with lacy, scalloped veils and quatrefoil details forming an upper frame for the doorway and upper and lower window bays on each side. With a frosting of trim that surpasses the era's love of gingerbread, it is called the Wedding Cake House.

Though it hasn't been said that Bourne's romantic representation of the Gothic style was influenced much by Sir Walter Scott, the novelist's Gothic descriptions did play a role in American design: in Louisiana, Afton Villa was expanded and remodeled in the Carpenter Gothic style in 1849 by David Barrow to please his Kentucky bride, an avid fan of Sir Walter Scott's Waverley novels. Barrow transformed his wooden house with a two-story center section and flanking wings,

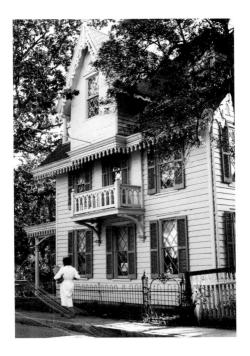

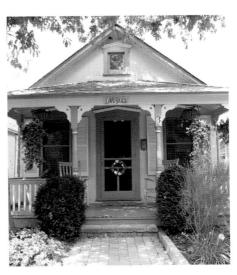

ornate trim on its porches and bargeboard, drop pendants, clustered columns, and pointed arches.

Regional variations also prevailed. After the invention of cast iron, the homes of Savannah and other Southern areas erupted with porches and balconies decorated with elaborate ironwork posts, railings, and spandrels. In New Orleans, these embellishments were fitted on a convex curve to create a landmark known

Vernacular cottages in St. Augustine, Florida (top), rural Louisiana (left), and New Orleans (right) exemplify the variety of Carpenter Gothic examples in the South.

as the Steamboat House. In Columbus, Mississippi, the front facades of a number of antebellum homes were dressed up with Gothic columns, pointed arches, and scroll-sawn spandrels, while in Savannah, Georgia, the Gothic Revival Green-Meldrim house designed by John S. Norris for Charles Green and used by General Sherman after his destructive march through the South, lacked steep gables but had a crenellated parapet and a veranda embellished with intricate cast iron work. In eclectic combination with the Italianate style, Carpenter Gothic assumed a Polynesian air as Honolulu House, in Marshall, Michigan, built in 1860 for Abner Pratt, who had served as American consul in Hawaii.

Fanciful "gingerbread" houses were built by merchants and farmers from Ohio to Michigan, Iowa, Illinois, and Indiana.

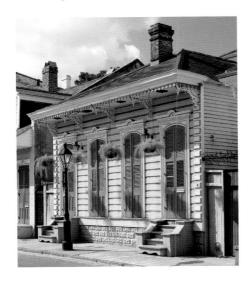

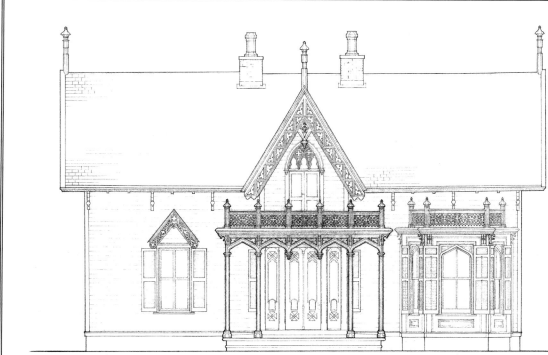

*The Peter Neff Cottage
(1860) at Kenyon College,
in Gambier, Ohio, designed
by Alexander Jackson Davis,
was built by Irish immigrant
William Tinsley for the
inventor of the tintype.*

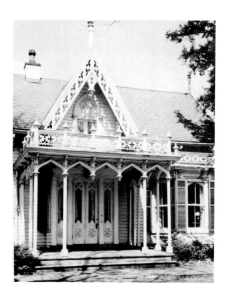

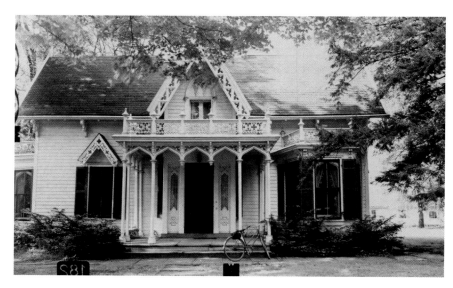

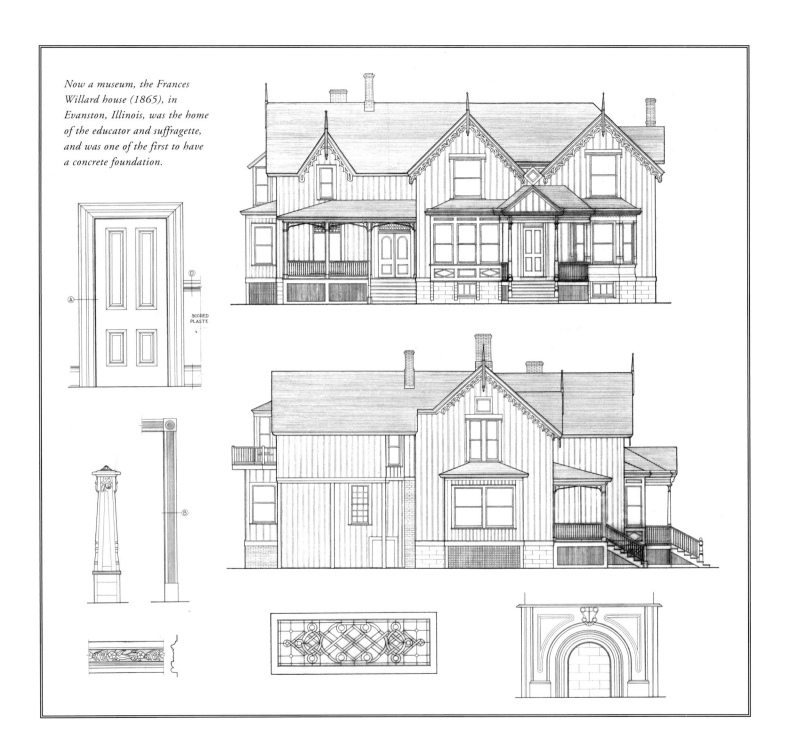

Now a museum, the Frances Willard house (1865), in Evanston, Illinois, was the home of the educator and suffragette, and was one of the first to have a concrete foundation.

SCORED PLASTE

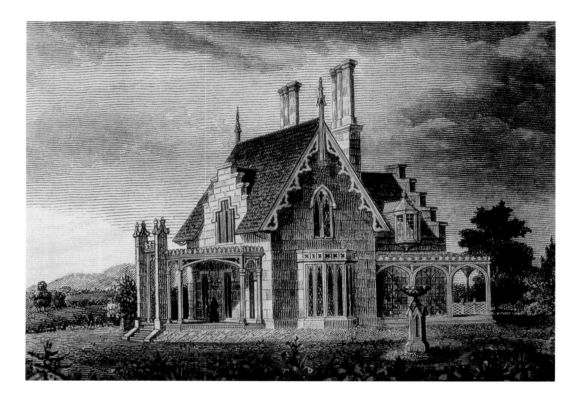

Echoing York Cathedral's medieval pulpit, shown in a 1744 book by Inigo Jones and William Kent, oriel windows are a feature in this water-color of the Nathan B. Warren cottage, in Troy, New York, designed by Alexander Jackson Davis, and at Mosswood (opposite), the J. Mora Moss house in Oakland, California, built in 1864.

In Gambier, Ohio, the 1869 Neff cottage at Kenyon College, built by Irishman William Tinsley, was constructed of wood, every board hand-planed and hand-carved rather than sawn. In Evanston, Illinois, a Carpenter Gothic house with irregular massing and board-and-batten siding, built in the 1860s, was the home of Frances E. Willard, first dean of the Women's Christian Temperance Union. Amelia Earhart's birthplace in Atchison, Kansas, was a sweet cottage with a front porch surmounted by a second-story porch; a pair of pointed windows flanked its front door and another was tucked under the gable. And in Eldon, Iowa, a tiny board-and-batten-sided farmhouse with a simple porch and arched windows became an iconic image in Grant Wood's painting, *American Gothic*. The Evanston and Atchison homes are now museums open to the public, while the Eldon, too tiny to accommodate museum traffic, is owned and maintained by the local historical society.

With pattern books, migrating carpenters, and freight trains carrying new scroll saws, the Carpenter Gothic style migrated west to newly prosperous and domesticated towns in Nevada, Colorado, Utah, and California, where they spoke eloquently of their owners' prosperity and sophisticated knowledge of the latest fashion. In Oakland, California, J. Mora Moss's Mosswood took a whimsical approach in 1864 with an oriel over the

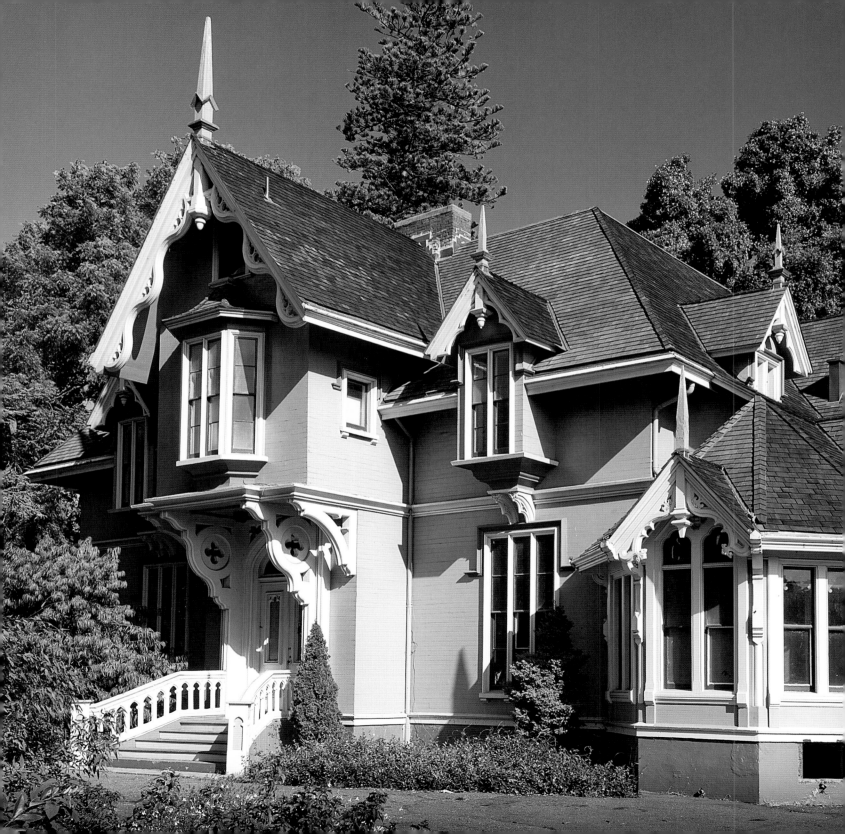

recessed front entry, steep gables and dormers with spires, and a polygonal bay that extended from one corner. Whole houses were prefabricated in the east and shipped around Cape Horn to California: one is the 1851 cottage—with irregular massing, highly decorated bargeboards, and pointed windows—which was built for General Mariano Guadelupe Vallejo, who was instrumental in establishing California statehood, on his ranch, Lachryma Montis, north of San Francisco. Even so, the style was too modest for some: in Brentwood, California, in 1853–56, San Francisco architect Thomas Boyd designed a castle with a crenellated tower for merchant John Marsh, about which the *San Francisco Evening Bulletin* said, "The architect . . .

with true artistic perception of the beauty of the site, and of what was wanted in the building to make it harmonize with the surrounding scenery, has departed from the stereotyped square box . . . and has adopted the old English domestic style of architecture—a pleasing and appropriate union of Manor House and Castle."

It's interesting to note that while Britain embraced the Gothic as its

OPPOSITE: *The Justin Morrill house (1848) in Strafford, Vermont, a museum, was home to the U.S. Senator who penned legislation establishing state land grant colleges.* BELOW: *American Hudson River School painter and architect Jasper Francis Cropsey's home and studio, built in 1835, in Hastings-on-Hudson, New York.*

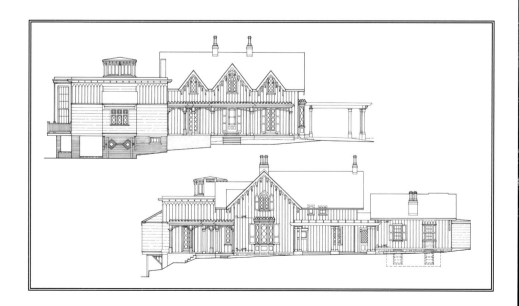

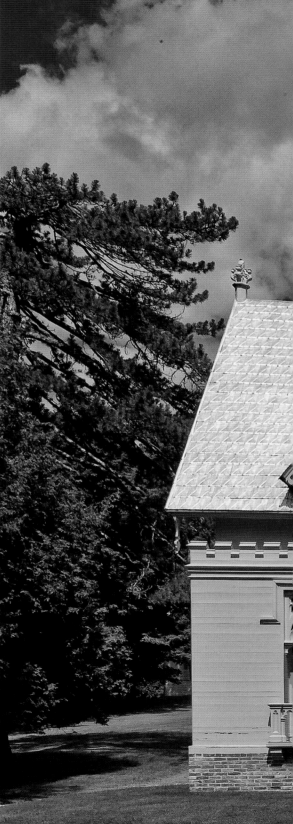

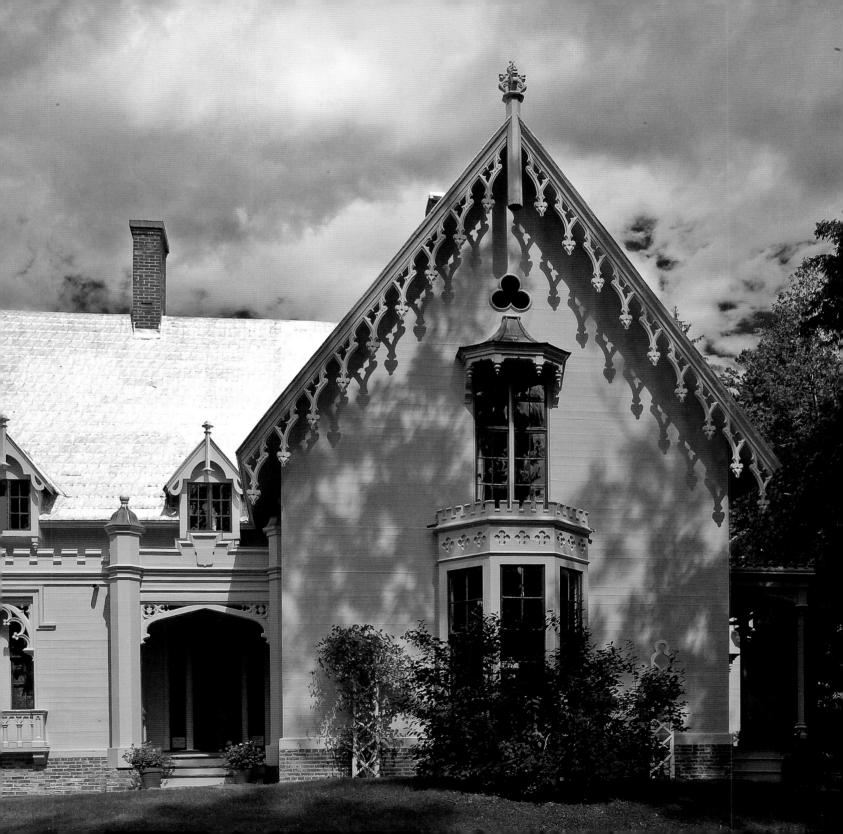

Gothic Revival details persisted in later buildings, including this Queen Anne Victorian (above), and the thirty-two-story Woolworth Building (below).

"national style" because of its association with the monarchy, in the United States that distinction was accorded to Greek Revival architecture, in part, at least, because of its associations with the ancient democratic republics and its development during America's first great period of commercial expansion. Though the Gothic Revival style was popular and Carpenter Gothic residences were seen nationwide, the Carpenter Gothic was never a predominant style.

Nonetheless, the Gothic had a great influence on subsequent Victorian building styles. Once Carpenter Gothic and Gothic Revival elements—notably scrollwork trim; gable screens; bay, oriel, and diamond-paned casement windows; towers; verandas; and picturesque siding—entered the architectural vocabulary of residential building, they never left it. In the eclectic spirit of the Victorian era and the periods that followed, these elements would reappear again and again in Queen Anne, Tudor, Colonial Revival, Stick, Shingle, and Arts and Crafts residential styles. Gothic Revival influences can even be seen in the Adirondack great camp architecture, where, beginning in the 1870s, decorative twig-work became the doppelgänger for scrollwork trim on porches, gable screens were common, and diamond-paned windows were an oft-used feature.

By the last quarter of the nineteenth century, the Carpenter Gothic style, as presented by Davis, Downing, and others, had pretty much run its course, and the Gothic Revival took yet another turn, with ultimately more massive buildings, often built of stone or brick, with an interior and exterior presence that proclaimed established wealth. The major influence in this development, known as High Victorian, was English critic John Ruskin, whose books were more widely read in the United States than in England, and who took his inspiration from Venice's late-medieval Gothic palaces.

Advocating the use of polychrome color schemes and varicolored stone, the restrained use of ornament, the use of rich materials, and attention to craftsmanship, Ruskin admired the late-medieval Gothic style for its "large fields of uncarved surface, and [that it] concentrated the labour of the chisel in detached portions, in which the eye, being rather directed to them by their isolation than attracted by their salience, required perfect finish and pure design rather than force of shade or breadth of parts."

Breathing new, if temporary, life into an architectural style that was on its last legs, and informing the now well-established architectural profession, Ruskin's ideas

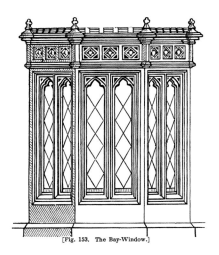

ABOVE: *A drawing of a bay window by Andrew Jackson Downing.* RIGHT: *Gothic Revival bay windows appeared in early-twentieth-century Tudor homes, including this one by Frank Lloyd Wright, Oak Park, Illinois.*

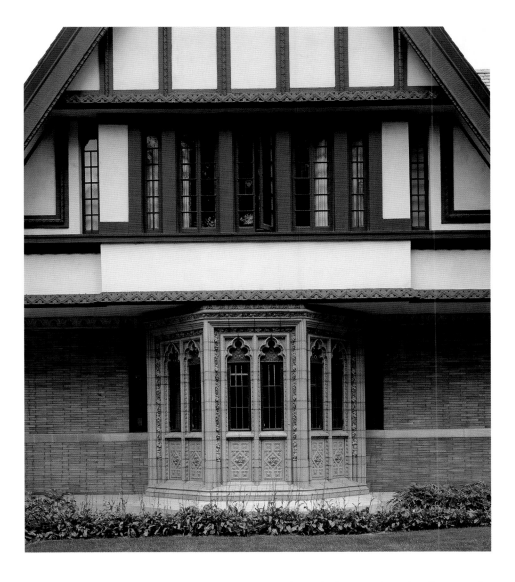

influenced numerous American buildings. These included the National Academy of Design in New York (1862–65) by Peter Bonnett Wight, the Old Museum of Fine Arts, Boston by John H. Sturgis (1872–78), the Pennsylvania Academy of the Fine Arts in Philadelphia by Frank Furness (1871–78), Memorial Hall at Harvard University by Charles Eliot Norton (1870–78), the Chancellor Green Library at Princeton University by William Potter (1873). Ruskin's ideas also led to the style that we know as Richardson Romanesque, developed by Henry Hobson Richardson. And, in Oak Park, Illinois, Frank Lloyd Wright designed in the Tudor Gothic style.

By the end of the nineteenth century, Western civilization's highest aspirations were no longer religious, as they had been in the twelfth century, they were commercial. The skyscraper, notably New York's Woolworth Building, took the Gothic style to new heights, which were achieved with iron and steel construction, a new innovation, just as the flying buttress had been seven hundred years earlier. Designed by Cass Gilbert in 1913, the Woolworth Building was described as a Cathedral of Commerce.

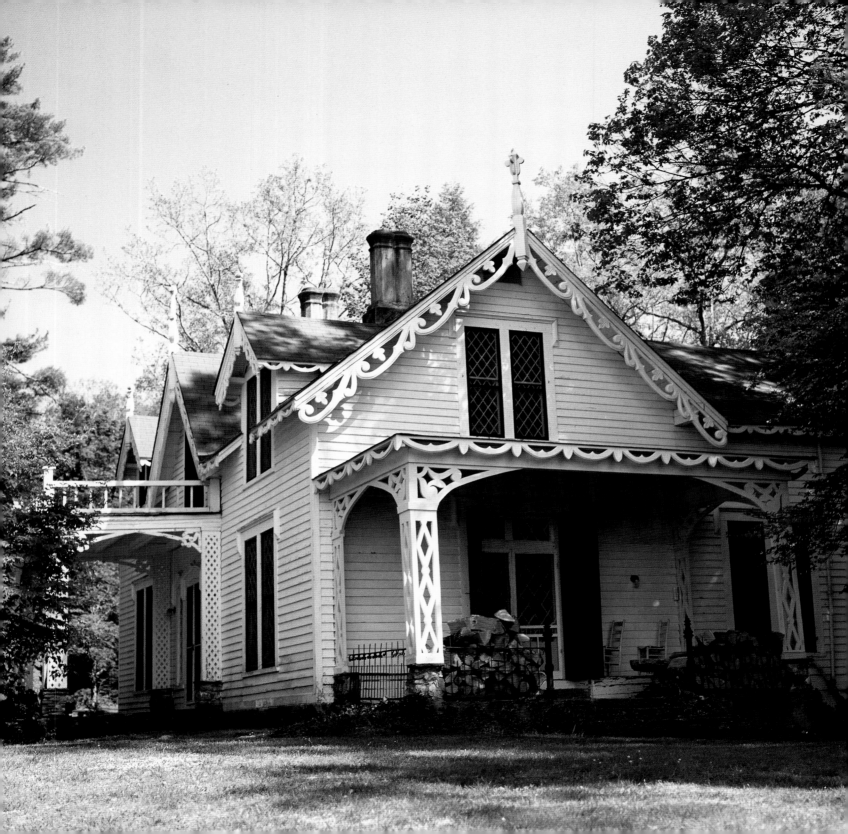

Chapter
Three

Alexander
Jackson Davis

THE CARPENTER GOTHIC'S
LEADING ARCHITECT

I am but an architectural composer.

I have designed more buildings than any living American architect.

—ALEXANDER JACKSON DAVIS

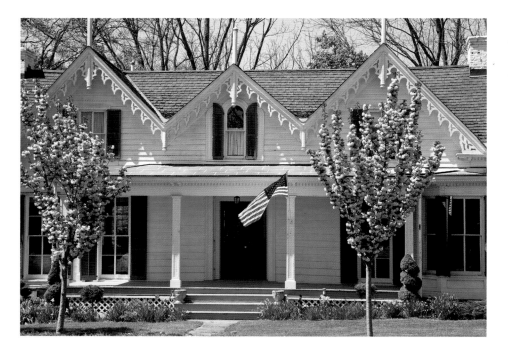

stone, its architectural features—a battlemented tower, crockets, and clustered chimneys—evidence Davis's interest in the historic representation of medieval Gothic architecture, and showed his familiarity with Gothic Revival architecture and taste in England. The timbered ceiling for the Knoll's library, for instance, was copied from an illustration in John Loudon's 1833 *Encyclopedia.*

Born in New York City in 1803, Davis grew up in New Jersey and central New York State. He moved to Alexandria, Virginia, at the age of sixteen and worked as a newspaper compositor. As a student who witnessed a building surge in that area and as a boy in Utica, New York, Davis developed what he called "a Mind formed for Architecture." He enrolled in New York's Antiques School in 1823, and four years later opened his own office on Wall Street, where he worked until architect Ithiel Town recruited him to New Haven, Connecticut. They formed a partnership in 1829 and worked mostly in the Neoclassical vein. A superb draftsman, Davis often executed his drawings in pen, ink, and watercolor, which became his trademark.

Capturing the romantic spirit of his age as well as his view of himself, the foremost architect working in the Gothic Revival style in the mid-nineteenth century, Alexander Jackson Davis, referred to himself as an "architectural composer." And, though statistics may not exist to support his claim of being foremost among American architects in terms of quantity, he was certainly one of the most prolific of the era. Measured in quality and impact, his work helped to prompt a surge of interest in the Gothic Revival and represented a watershed in American architecture.

In 1837, Davis—who had served his first apprenticeship with Josiah Brady, the architect of New York City's second Trinity Church—began a Gothic Revival project in the Hudson Valley: a stylistic transformation of Sunnyside, writer Washington Irving's home in Tarrytown, New York. This influenced two other buildings. One was James Fenimore Cooper's remodeling of his Federal house in Cooperstown, New York, into a country seat, with plans by Samuel Morse, inventor of the telegraph.

The second was a home in Tarrytown, with a commanding view of the Hudson River, which Davis completed in 1842 for William Paulding, who was related to Irving by marriage. The Knoll was Davis's most important Gothic villa. Built of

In 1832, Town and Davis designed the first Gothic country villa in the United States, Glen Ellen, in Towson, Maryland, which was, as Davis described, "the first English Perpendicular Gothic Villa with Barge Boards, Bracketts, Oriels, Tracery in windows, etc." Davis's relationship with Town and later his relationship with Andrew Jackson Downing, whose books showcased his designs, opened doors to residential work for wealthy clients and to projects for universities, and public and commercial institutions. Davis's stylistic focus shifted to the Gothic Revival.

After he left his partnership with Town in 1835, he focused primarily on Tuscan and Gothic designs, interpreting the latter with crenellated parapets, sawn bargeboards, and plaster vaulted ceilings. Davis designed a few churches, schools, and commercial buildings, but his major interest was residential commissions for townhouses, villas, and cottages. The design he and Town developed for the Virginia Military Institute became a prototype for the architecture of military schools throughout the country. He designed the First Congregational Church in New Bedford, Massachusetts, in 1835, and in 1845, the New York Yacht Club with board-and-batten siding and scrollwork trim. This building is now in Connecticut's Mystic Seaport Museum.

Another of his residential projects was Blithewood, which he completed in 1836 for Robert Donaldson. Overlooking the Hudson River, in Annandale-on-Hudson, New York, this was a "bracketed" villa (i.e. a building with a row of brackets under the eaves), remodeled from a circa 1812 Federal house. Showcasing this cottage-villa in his 1837 book, *Rural Residences*, Davis writes, "The design [is] irregular and suited to scenery of a picturesque character and to an eminence commanding an extensive prospect. . . . This house should be built of stone or brick, stuccoed in imitation of stone, having marble or light colored free-stone trimmings. The bay windows and oriel [are] of wood, painted and dusted with pulverized marble or grained in imitation of oak. The entrance porch might be either of stone or wood. The battlements and gable with its crockets might be of wood, painted to match the stone, as well as all tracery in window frames, bays, and oriels."

The long, detailed title of that book—*Rural Residences, Etc., Consisting of Designs, Original and Selected, for Cottages, Farm-houses, Villas, and Village Churches: With Brief Explanations, Estimates, and a Specification of Materials, Construction, Etc.*—notable for its length even in an era of wordy titles—provides a fairly good idea about how thorough the era's architec-

tural how-to books, intended for builder's rather than laypeople, could be. This was the only book that Davis authored solo. In 1837, Donaldson introduced Davis to Andrew Jackson Downing, and during the following year the two began an informal collaboration that lasted until Davis launched his architectural partnership with Calvert Vaux in 1850.

Davis's plans for houses in the Gothic Revival and Tuscan styles were showcased in Downing's highly successful books, and he did the drawings for the engravings and illustrations. These books made the Gothic Revival—and Carpenter Gothic—styles accessible to homeowners and laypeople, and had an enormous impact on the popularity and development of these styles.

Similar to Blithewood was Davis's 1845 design for Belmead, the first plantation house on the James River in Virginia executed in the Gothic Revival style. Constructed of Virginia brick, its blocky massing was alleviated by two bay windows, heavy spires extending upward from the four corners of a crenellated square tower, and an irregular roof line; it incorporated imposing clustered chimneys, diamond-paned casement windows, and stained-glass windows depicting the crops grown there.

(continued on page 84)

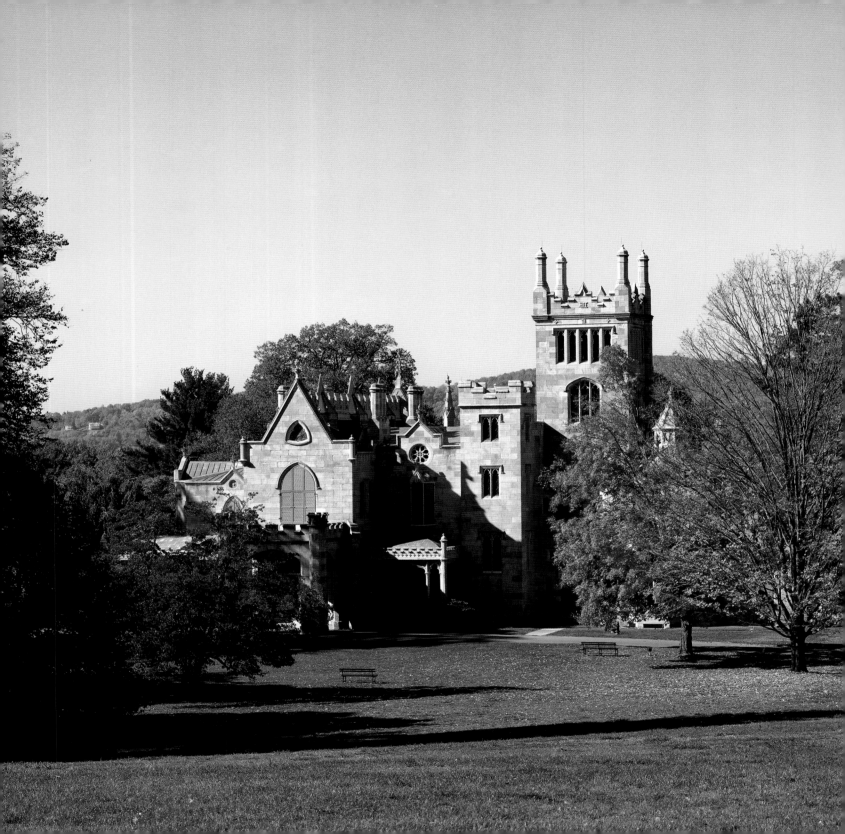

❧ Lyndhurst ❧

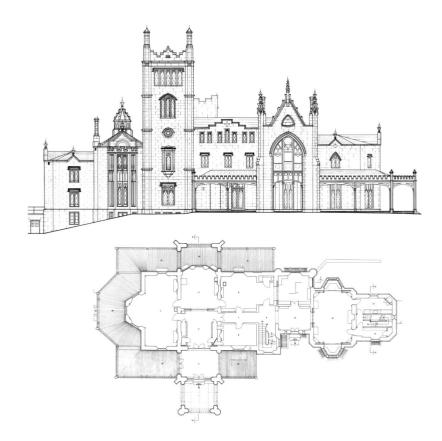

Now a museum owned and operated by the National Trust for Historic Preservation, Lyndhurst is considered the finest high-style Gothic Revival residence in the United States. In addition to its value as a building and an example of this architecture, it is significant in that it helps to document the varied influences on Davis and other architects of the day.

At Lyndhurst, Davis deployed a mix of Early English, Decorated, and Picturesque Gothic architectural details and clearly drew upon designs shown in A. W. N. Pugin's *Specimens* and Thomas

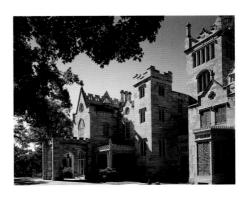

OPPOSITE AND ABOVE: *For his design of Lyndhurst, Alexander Jackson Davis drew upon medieval and English Gothic Revival sources.*

Rickman's *Attempt*. These sources, along with works by John Loudon, Humphrey Repton, and A. C. Pugin, were only a few of the list of two hundred books and other materials that Davis recommended to his client, George Merritt. At Lyndhurst, construction was of grayish-white marble quarried in Sing Sing (now Ossining, New York). The second story of the central portion of the front facade, overlooking the river, contained the principal room of the residence: a Gothic library with a great arched west window and bookcases in the pointed style. Davis designed the furniture, including tables and side chairs. He also added Gothic-style greenhouses.

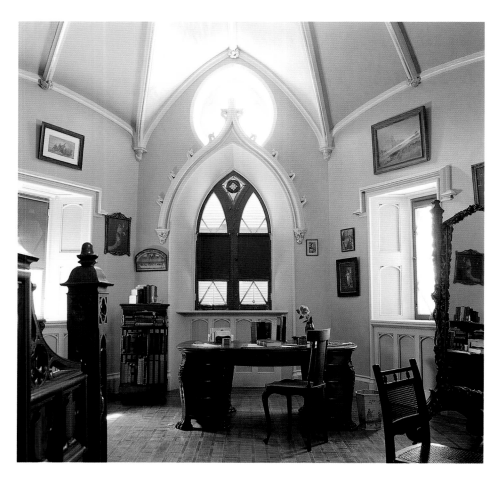

CLOCKWISE FROM TOP LEFT: *In the bedrooms (photos at top), high style combines with practical areas to read, write letters, and sleep; view into a parlor; window and doors to the veranda; the gallery. Furnishings mix Gothic Revival and other styles.* OPPOSITE: *Lyndhurst's grand dining room, with its wooden tracery, period wallpaper, marble columns, and Gothic Revival table and chairs.*

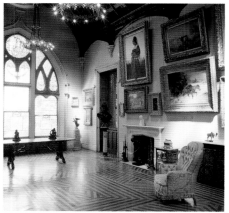

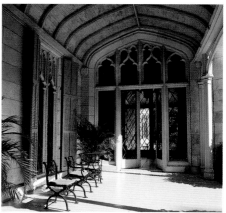

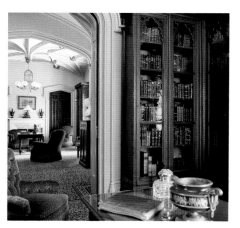

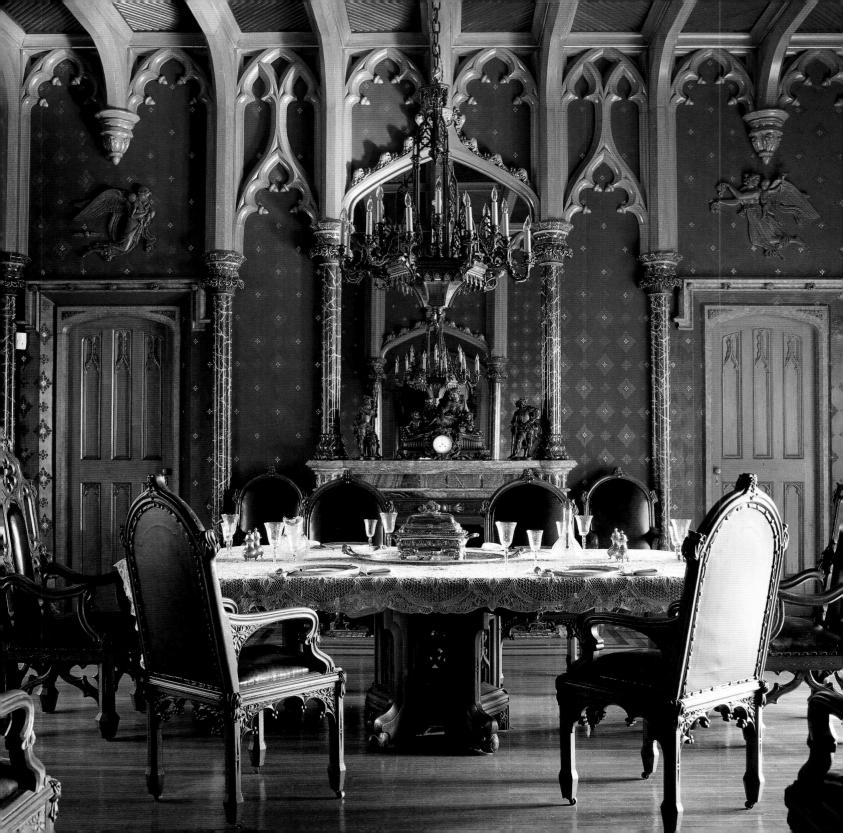

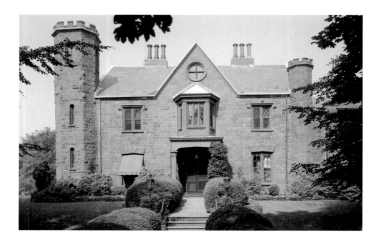

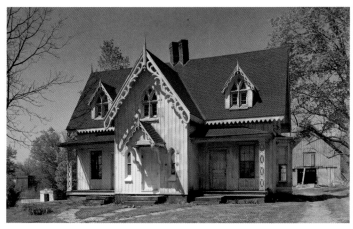

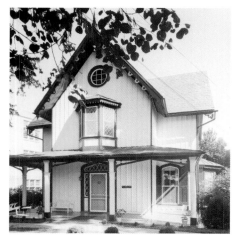

On a grander scheme, in 1864 Davis enlarged and remodeled Knoll for its new owner, George Merritt, who renamed it Lyndhurst.

In 1836, busy with several residential projects and with writing a book, Davis completed the designs for one of the nation's landmark Carpenter Gothic houses, the William J. Rotch house, a two-and-a-half-story "Pointed Cottage," in New Bedford, Massachusetts. Featured in Andrew Jackson Downing's *The Architecture of Country Houses*, its plan was composed of two interlocking blocks of post-and-beam construction, one of which projected to the front, at the east, to form a prominent center pavilion. This sharply peaked center section contained a large window with a shallow pointed Tudor arch on the first floor, an oriel window on the second, and a pointed window with a small balcony tucked under the steep gable. This had a fairly deep overhang, a hand-carved bargeboard with curving trim and quatrefoil medallions, and a spire topped with a Tudor rose detail and balanced by a pendant. A parapet afforded a view of New Bedford harbor, a prosperous port known in early America for its whaling industry.

Of this "Cottage-Villa in the Rural Gothic Style," design XXIII in that book,

Davis's designs included Malbone (1849), in Newport, Rhode Island (above left) and the iconic Delamater house, in Rhinebeck, New York (opposite). His work inspired the Timothy Copp house (1850), in Chautauqua, New York (above right) and the Pendleton-Coles house (1850), in Lexington, Virginia (below left).

Downing noted, "The body of the house is nearly square, and the elevation is a successful illustration of the manner in which a form usually uninteresting (probably a reference to the Federal and Greek Revival styles), can be so treated as to be highly picturesque. There is, indeed, a combination of the aspiring lines of the roof with the horizontal lines of the verandah, which expresses picturesqueness and domesticity very successfully. The high, pointed gable of the central and highest part of this design has a bold and spirited effect, which

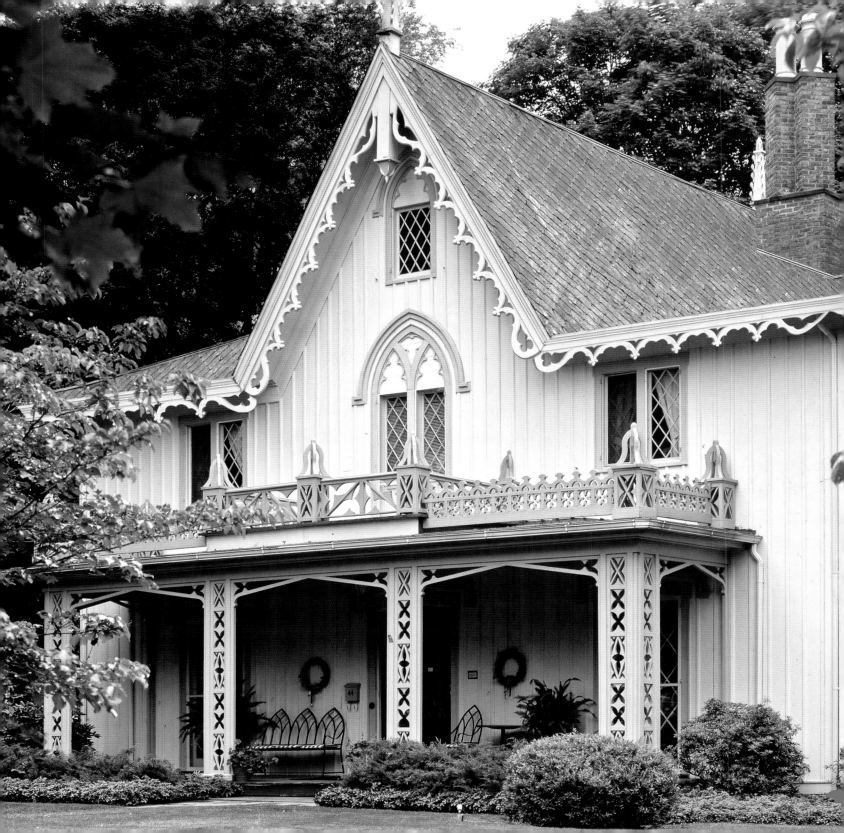

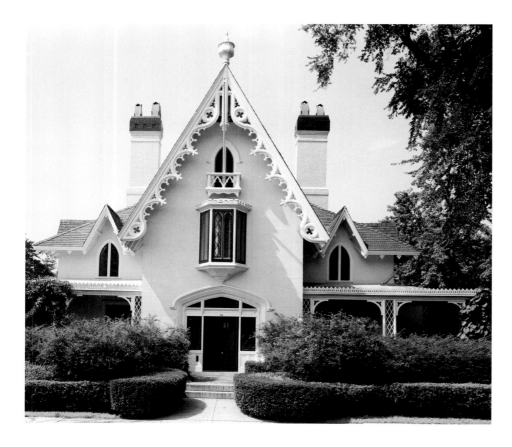

THIS PAGE AND OPPOSITE: *Davis's design for the William J. Rotch house (1846), in New Bedford, Massachusetts, published by Downing, was used by many builders.*

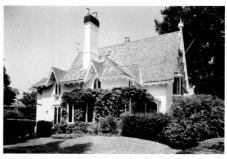

would be out of keeping with the cottage-like modesty of the drooping, hipped roof, were it not for the equally bold manner in which the chimney-tops spring upwards. Altogether, then, we should say that the character expressed by the exterior of this design is that of a man or family of domestic tastes, but with strong aspirations after something higher than social pleasure."

The center pavilion of the Rotch house was flanked by two lattice-trimmed porches, each of which enclosed an entry door into the center section; each was later modified at the second floor with a small gabled dormer containing a pointed casement window. The exterior was sided in wide, flush horizontal wooden boards; decorated bargeboards encircled the house, complementing the more ornate treatment of the center gable. The south elevation incorporated a large bay window along with six diamond-paned double casements.

The interior floor plan for the Rotch house was symmetrical, comprising a center hall from which other rooms opened, four on the first floor and four on the second. Principal rooms were finished in pine flooring, woodwork of ash, butternut, and black walnut, and walls of lime plaster over wooden lath. Interior cornices and decorative ornamentation were also of plaster, rather than of wood; in the public rooms, a billeted Gothic cavetto molding ran along the ceiling. Wooden doors were of six panels and on the first floor were embellished with cusped and ornamented

Tudor arches; surrounds consisted of Gothic-style architraves and crenellated molding. Other details in the parlor and library included mantels of black and gray marble and louvered pocket shutters at the widows.

Still privately owned and not open to the public, the Rotch house is a National Historic Landmark, and is listed on the National Register of Historic Places, along with three other remaining Carpenter Gothic houses that Davis designed: the John B. Angier house in Medford, Massachusetts; Cottage Lawn, in Oneida, New York (1849–50); and the Henry Delamater House in Rhinebeck, New York (1844).

More significant than any single house of his design, perhaps, is Davis's vision of a new kind of American town: the suburb, which was made possible by the development of the railroad. In 1857, Davis designed the first planned bedroom community in the United States. Located in West Orange, New Jersey, Llewellyn Park—the nation's first suburb—was within commuting distance of New York City by railroad. There, he remodeled an earlier home into a Gothic Revival residence, dubbed the Eerie, and adapted its design in the community's turreted stone gatehouse.

The most important collaboration of Davis's career, by far, was with landscape designer Andrew Jackson Downing.

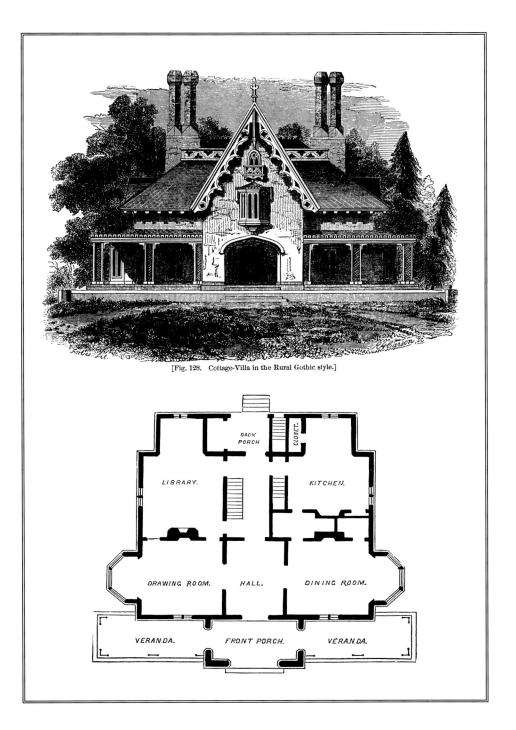

[Fig. 128. Cottage-Villa in the Rural Gothic style.]

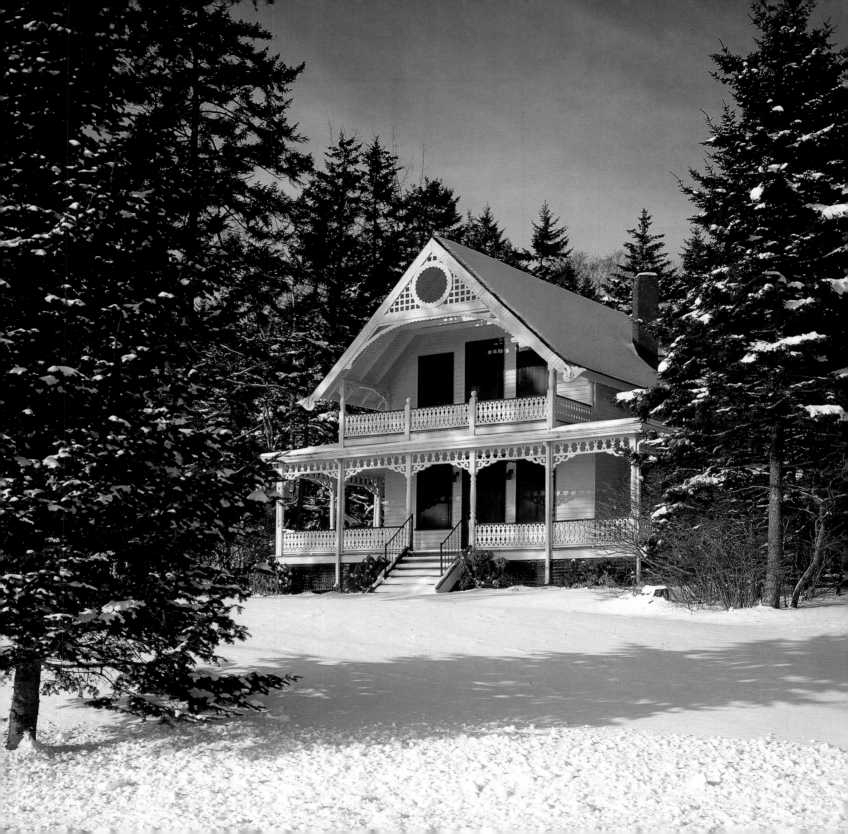

Chapter
Four

Andrew Jackson Downing

THE FOUNDING FATHER OF
THE CARPENTER GOTHIC STYLE

The temples and cathedral are the orations and epic poems, [while] the dwelling-houses [are] the familiar epistles or conversations.

—ANDREW JACKSON DOWNING, *COTTAGE RESIDENCES*, 1842

Rural Gothic, that beautiful modified form of Gothic architecture which we adopt from the English people; . . . certainly expresses as large a union of domestic feeling and artistic knowledge as any other known.

—ANDREW JACKSON DOWNING, *THE ARCHITECTURE OF COUNTRY HOUSES*, 1850

Though Alexander Jackson Davis, Richard Upjohn, and other architects had a significant impact on the Gothic Revival style in the United States, the man who was truly the force majeure in the development and dispersion of the "rural Gothic" style, which became known as Carpenter Gothic during the twentieth century, wasn't an architect. It was the nation's first professional landscape designer, Andrew Jackson Downing. His architectural pattern books, like those in England published one hundred years earlier, had a profound influence on the picturesque variations of the Gothic Revival style in the United States and Canada. Born in Newburgh,

New York, in 1815, Downing was the son of a well-respected nurseryman, and surrounded by plants and garden plans from childhood on. Though his life was short—he drowned at the age of thirty-six—his ideas had an enormous influence on American architecture for the duration of the nineteenth century and are still felt today. Most importantly, Downing maintained that harmony would be achieved only by "adapting the house to the scenery where it is to be placed."

It is no miscarriage of history that this influential proponent in the United States of the the "rural Gothic" style was a "landscape gardener," the term Downing

preferred because it implied that a mastery of design and of horticulture were both vital in the profession. In England, during the eighteenth century, landscape gardeners, notably John Loudon and Humphrey Repton, were the first to deploy picturesque structures in the Gothic Revival style to enhance country properties. Downing cited the works of these men in his books, and clearly built on their work and ideas in forming his own contributions to the development of the Gothic Revival style and its application to rural residences.

Having written for Loudon's publications in England as an American correspondent, Downing founded and edited

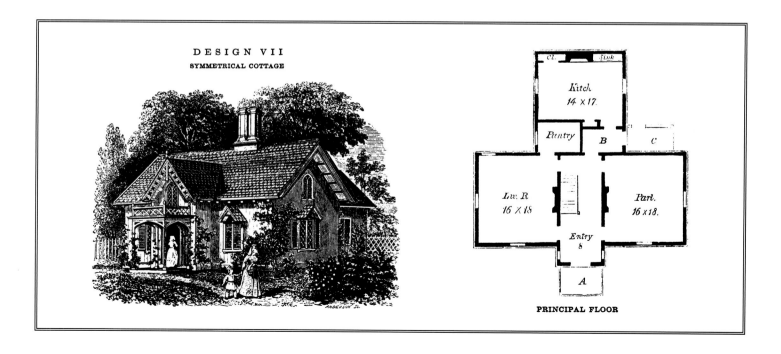

DESIGN VII
SYMMETRICAL COTTAGE

PRINCIPAL FLOOR

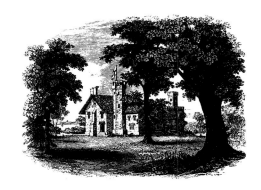

OPPOSITE AND THIS PAGE: *Downing's designs encompassed castellated villas, modest rural Gothic cottages, and other styles, including the Swiss chalet (see page 88).*

The Horticulturist magazine. This led to his first book *The Theory and Practice of Landscape Gardening*, published in 1841. It was a critical and commercial success, as were his *Cottage Residences* (1842) and *The Architecture of Country Houses* (1850), both of which included drawings and plans by architect Alexander Jackson Davis. In the first book the focus was on landscape gardening; in the other two, Downing covered both architecture and landscape, with plans for houses, grounds, and gardens, as well as extensive lists and descriptions of trees, shrubs, and perennial and annual flowering plants, down to their height, color, and bloom time. Today, many a beginning gardener might appreciate having the information in these books and many a modern architect and builder might benefit from a close reading of them.

The eighteenth century's love of nature and of the picturesque gave rise to the romantic notion that residential buildings should harmonize with their surrounding landscapes. Like the Gothic Revival itself, the concept originated in England, where Romantic poet William Wordsworth, in the early nineteenth century, was among those to theorize that buildings should appear "to have grown rather than to have been erected—to have risen, by an instinct of their own, out of the native rock." In America, Downing was a key proponent of this idea, and it was he who most strongly associated the Gothic Revival style with rural settings. In *Cottage Residences* he wrote, "A great deal of the charm of architectural style, in all cases, will arise from the happy union between the locality or site, and the style chosen. . . ." Like Wordsworth, Downing admired the English skill at what he called "*rural adaptation*. Their residences seem to be a part of the scenes in which they're situated . . . picturesque edifices, which, by their varied outlines, seem to be in exquisite keeping with nature."

In the rural setting, he noted, there was the "tendency of a country house to *spread out* and extend itself on the ground, rather than to run up in the air." In terms of design, this meant that the building would take advantage of contours in the terrain, rather than assert itself by sheer impressiveness of height. To build a castle in level fields, he said "would immediately be felt to be bad taste." Rather, Downing maintained, "In the rural Gothic, the lines of which point upwards, in the pyramidal gables, tall clusters of chimneys, finials, and the several other portions of its varied outline, harmonizes easily with the tall trees, the tapering masses of foliage, or the surrounding hills; and while it is seldom or never misplaced in spirited rural scenery, it gives character and picturesque expression to many landscapes entirely devoid of that quality."

To connect the building to its landscape, Downing advised that residential designs include a vine-covered porch and plantings, wings, and outbuildings that extended from the body of the house "to connect it, with a less abrupt manner, with the grounds," a notion that is still a touchstone of successful design.

Downing originated the idea of the "vine covered cottage" in America, and his advocacy of the porch as an outdoor room helped to launch a hallowed American icon. In the English cottage, he said, "a veranda is rarely seen, as the dampness of their climate renders such an appendage scarcely necessary. But its great utility in our hot summers makes it indispensable to every house . . . [for] shelter, prospect (or view), and an agreeable promenade."

The architectural epitome of "thorough comfort and utility" and of "the domestic virtues, the love of home, rural beauty, and seclusion" was, Downing believed, "the English cottage, with its many upward pointing gables, its intricate tracery, its spacious bay windows, and its walls planted with vines and flowering shrubs." This not only set the stage for the Carpenter Gothic cottage, it also launched the modern use of foundation plantings, which were not generally used in American homes in periods prior to this time. To illustrate how to achieve harmony between a residence and its setting, Downing offered extensive landscape and garden plans along with his Gothic-influenced architectural designs.

Articulating an idea that was central to the Victorian aesthetic in architecture and decoration that is still very much with us today, Downing also maintained that the beauty of domestic architecture derived from the fact that it was an "individual expression" of the homeowner. This was important, he said, because "in the design

THIS PAGE AND OPPOSITE: Whether villa or cottage in the "pointed" Gothic style, Downing intended his designs to be accommodating and comfortable. Emphasizing the harmony between house and landscape, his books presented homes in their settings.

lies the whole individuality of the building, whether it shall be full of beauty, grace, or picturesqueness, or abound in uncouthness, incongruity, and foolish conceits—a matter of the more importance as it is to continue before our eyes and become identified with ourselves, perhaps for a lifetime!"

Another of Downing's major contributions was to envision homes for the middle and lower classes that were of a smaller size but were not inferior in "correct taste and refined judgment" to the houses of the wealthy. Designs were intended to be attainable, to provide aesthetic pleasure while meeting the basic human need for shelter at a cost easily afforded by the middle class. "There are thousands of working men in this country," Downing wrote, "who now wish to give something of beauty and interest to the simple forms of cottage life; there are many of these who are desir-

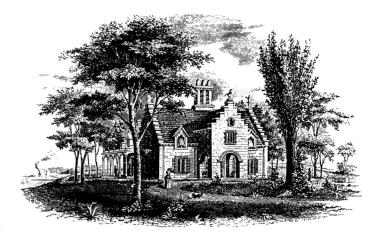

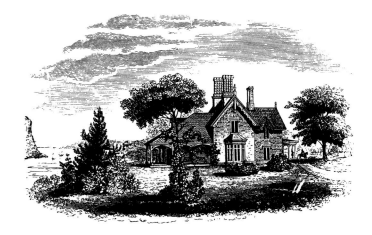

ous to have their home of three rooms taste-
ful and expressive, no less than among those
whose dwellings number thirty rooms."

Though pattern books, notably those
by Asher Benjamin, published before
Downing's, had depicted homes for
those who were not of great wealth, it was
Downing, preeminent among the Victorian
pattern-book authors, who presented a
range of designs, from impressive villas to
small cottages for people of more modest
means, and who pointed out that mass
production made tasteful furnishings avail-
able to virtually everyone. He and Davis
coined the term "cottage-villa" to denote
a rural (or suburban) middle-class home
that combined the romantic simplicity
and appeal of the former with the appoint-
ments and comfort level of the latter.

In addition, Downing may have been
among the first to articulate a fundamen-
tal aspect of the American dream. In *The
Architecture of Country Houses*, he noted,
"Domestic Architecture [demands] a higher
consideration in a country where the ease
of obtaining a house and land, and the
ability of almost every industrious citizen to
build his own house, constitute a distinctive
feature of national prosperity." Widespread
homeownership was not just the mark of
a prosperous country, he believed: it was
necessary for the national good. "There are

(continued on page 98)

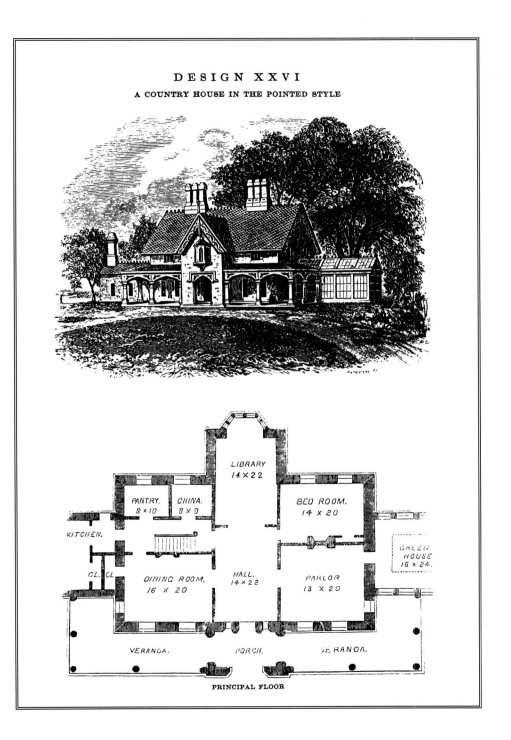

DESIGN XXVI

A COUNTRY HOUSE IN THE POINTED STYLE

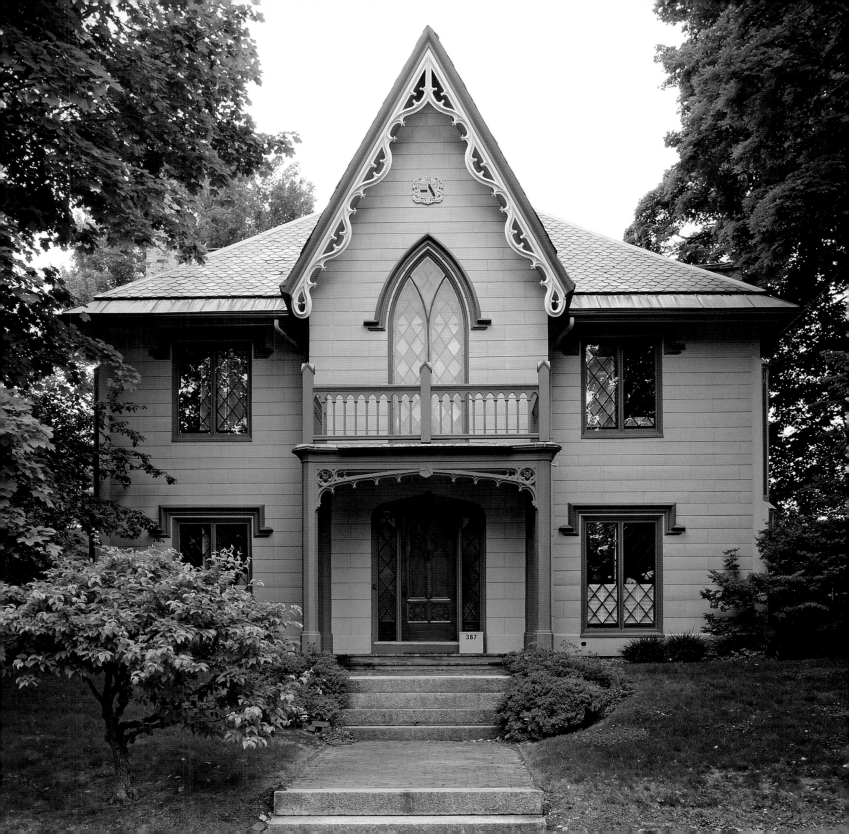

❧ Portland, Maine ❧

One of the earliest Carpenter Gothic homes in Maine, the John J. Brown house was built by English-trained-, Irish-immigrant-architect Henry Rowe in 1845. For his design, Rowe borrowed heavily from Andrew Jackson Downing, but he eliminated the porches that often flank the projecting center bay and added angled buttresses. The hoods bracketing the tops of the windows, second-story balcony, pointed, stained-glass window, flush horizontal board siding, and diamond-paned windows are classic Gothic Revival details, which Downing promoted.

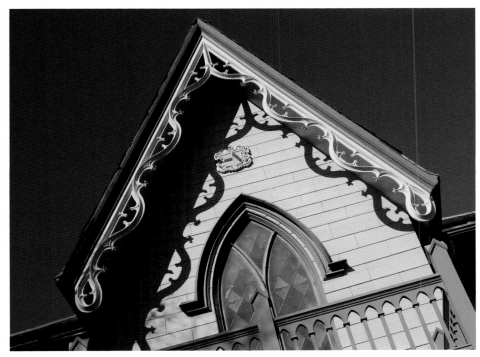

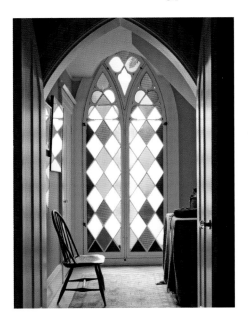

Inside, the homeowner, who grew up in the American Southwest, enlivened her rooms with a joyful palette—orange, yellow, and green as vivid as the hues of the home's stained-glass window. In this jewel box, original pointed niches and ornate hand-carved woodwork, cushy upholstered pieces, and items collected while traveling conspire to create a comfortable in-town home.

OPPOSITE AND THIS PAGE: *Pattern books, especially those by Downing, exerted enormous influence on American builders, as the plan and detailing of this home shows.*

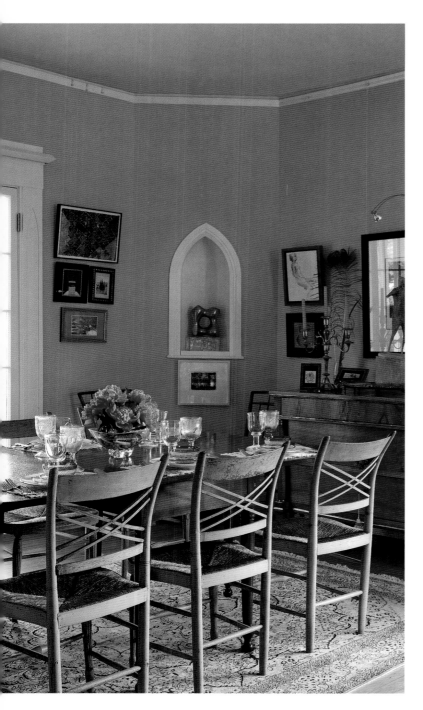

CLOCKWISE FROM LEFT: *In the dining area, which is at one end of the thirty-by-fifteen-foot main room, vivid orange walls and a tinted ceiling warm things up, highlighting white woodwork, a pointed niche, and a stylish mix of furnishings; hand-carved wooden tracery embellishes the front door; a window detail in the hall adds a grace note.*

OPPOSITE: *Sunny yellow paint paired with white woodwork lightens and brightens the library, which originally served as the dining room. The mantel, with its arch and naturalistic carving, is the focal point, flanked by a diamond-paned window and a bookcase. Comfortable chairs invite relaxation and echo Downing's advice about interior design.*

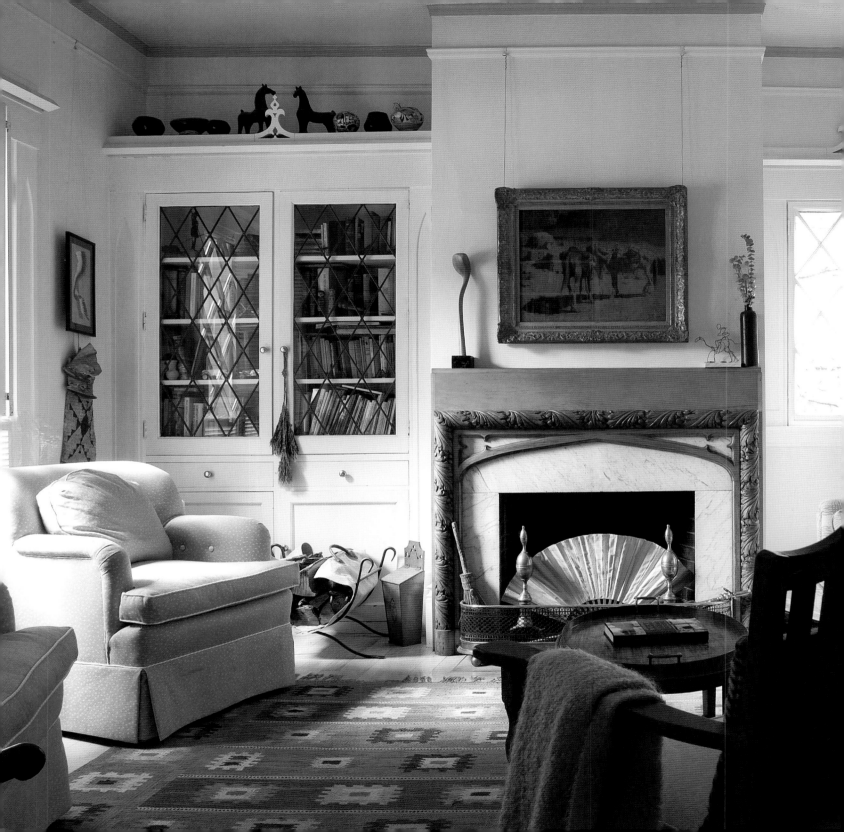

three reasons why my countrymen should have good houses," he wrote. First, ". . . when smiling lawns and tasteful cottages begin to embellish a country, we know that order and culture are established," and ". . . the interest manifested in Rural Architecture of a country like this, has much to do with the progress of civilization." Secondly, he continued, "It is the solitude and freedom of the family home in the country which constantly preserves the purity of the nation, and invigorates its intellectual powers." And, he said, "there is the moral influence in a country home—when among an educated, truthful, and refined people, it is an echo of their character—which is more powerful than any mere oral teachings of virtue and morality . . . where the family hearth is made a central point of the Beautiful and the Good."

With respect to architectural design—just as Thomas Rickman had done in England—Downing made an effort to develop a typology that distinguished between different iterations of the Gothic Revival style. He identified "The *Castellated*, the *Tudor*, the *Elizabethan*, and the *rural Gothic* or old English cottage styles." In *The Architecture of Country Houses* he included a range of designs, from Venetian, Italian, and Romanesque villas with their varied towers, "light balconies," "grouped windows," "open arcades," and "vase

bordered terraces," to Swiss chalets, which he called "homely, yet strong and quaint."

Whether the house was large or small, Downing argued for discernment in combining "correct proportions, the unity of decorations, and of appropriateness of style." In this too, his remarks haven't been surpassed. "The great charm which we find in a house where beauty and convenience are combined with that kind of artistic treatment which is called style, is, that the whole has a certain *unity of design*, which shows that, from the smallest to the greatest feature, all has been the result of one harmonious plan; that it has been produced by a mind working consistently throughout, adjusting and arranging all with a purpose, both of beauty and utility. . . ."

As a practical matter, Downing recommended the use of materials of the best quality. Like A. W. N. Pugin and others, he advocated what he called the "truthfulness of materials," that "the material should appear to be what it is" whether stone or wood; he also discouraged the mixing of these materials in a single structure. Many builders of Carpenter Gothic houses rejected this advice in their choice of paint colors, which were often grays and browns to mimic stone or pink to resemble marble.

Downing used the term gingerbread, which we invoke as a romantic word for exterior embellishment on bargeboards

and porches, to disparage decoration produced of flimsy wood using the era's newly invented scroll saw. He believed this practice to be all too common and promised little durability or longevity. Instead, he recommended that thick boards be hand-carved, producing long-lasting trim whose life would extend as long as the house itself. Hand-carving these thick boards was a labor-intensive task, and some of the best remaining examples of Carpenter Gothic houses indicate the wisdom of Downing's advice.

In addition to high-quality materials and workmanship, he advised on some fundamental elements of good design. These entailed a "combination of the agreeable and the useful" along with certain principles, which he capitalized for emphasis: "PROPORTION, SYMMETRY, VARIETY, HARMONY, AND UNITY."

Whereas Neoclassical designs achieved symmetry via identical mirror-image parts flanking a center, Downing presented a different idea. Above all other styles, the Gothic was picturesque, a quality that derived from charming irregularity of form. "The most irregular building," he wrote, "will form an outline, in which there will be a central portion or point, which unites two sides into one symmetrical whole; two parts, which if they do not balance each other in exact forms and proportions

as in regular symmetry, do balance in the general impression which they made on the eye, in the mass and grouping of the composition." In terms of the building's exterior massing, this approach meant that a two-story tower at one end of a front facade could be balanced by the length and mass of the one-story section that extended opposite. A round tower, Downing noted, could be balanced by arched windows, and "the square-headed doors and window heads are made to harmonize with those of the pointed form, by introducing an arched spandrel under the square-head." Similarly, in a parlor, "A [round or oval] rosette in the middle of a square ceiling is out of harmony with it; but it may be made to harmonize, by surrounding it with a border in which the two forms are ingeniously blended."

Although many interiors shown by Downing featured a center hall flanked by front parlors, entry doors were generally on the side of the hall, rather than in the front, which had been the Neoclassical convention; from this symmetrical portion, an ell containing the kitchen might extend from the rear of the house; this was a floor plan that dated from the eighteenth century. But, in the interior of the house conceived with irregular massing, Downing said, "There must be nooks and crannies about it, where one would love to linger . . . cozy rooms where all domestic fireside joys are invited to dwell."

From their origins in New York's Hudson Valley, Downing's designs for modest cottages and country villas spread throughout America.

The notion of symmetry produced by the union of irregular parts became a touchstone of the Victorian period. But this effect required a sure hand. It was not a wild agglomeration of disparate pieces that Downing sought, but only "a partial want of proportion and symmetry." In fact, he emphasized, in a small cottage, "proportion and symmetry are the proper sources of beauty."

To achieve the union of disparate parts, Downing advocated that the architect or builder handle the irregular massing and details to achieve harmony—not an easy task. Particularly in the small cottage, simplicity was important, and he criticized builders for the "cocked-hat cottages" that achieved picturesque effect with several pointed gables, so that "nothing but gables salutes our eyes." He added, "To stick

DESIGN XX

VILLA FARM HOUSE

PRINCIPAL FLOOR

them in the front of a cottage of 25 feet front, and, not content with this, to repeat them everywhere else upon the roof where a gable can possibly be perched, is only to give the cottage the appearance, as the familiar saying goes, of being 'knocked into a cocked hat.'"

Downing first began to emphasize the Gothic Revival style in *Cottage Residences*, including a sketch of a rural church, "a cottage in the English or Rural Gothic Style," a "cottage for a country clergyman" with rustic twig-work porches, a stone villa in the "pointed style," and a small cottage, or gate lodge. Harking back to A. W. N Pugin and the origins of the Gothic Revival, he offered a stone "Cottage in the Pointed, or Tudor Style." Designs ranged from the relatively modest one-and-a-half-story dwellings to be managed without full-time household help to a gatehouse that merged the popular Swiss-chalet style with Gothic Revival embellishments, the brick "cottage" of a prominent judge, and a stable/ carriage house with a cupola for ventilation, board-and-batten siding, and trefoil window details. Downing aimed to express "domestic comfort" with sheltering porches, terraces and gardens, steeply pointed gables, decorated gables, dormers and bargeboards, clustered corbelled chimneys, pointed arches, and intricately carved exterior trim. Inside, his designs also emphasized creature

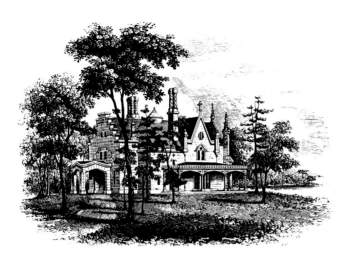
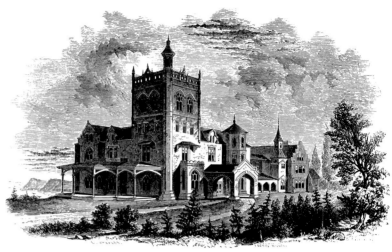

comfort, affording—for clients with the means to have them—woodwork of chestnut and black walnut, multiple fireplaces in the center of the house "so that no heat may be lost by outside exposure," central heating, a bathroom, heated "by a hot-air chamber attached to the kitchen range," a parlor and formal dining room, kitchen, several family bedrooms, servants' rooms, and a butler's pantry.

On the more modest end of the spectrum, and epitomizing the designs that we most associate with Downing today, was "A Cottage in the Rural Gothic Style," built of stone and designed for "internal convenience. There are many families," he noted, "mainly composed of invalids, or persons advanced in years, who have a strong preference for a plan giving the kitchen, and at least one bed-room, upon

OPPOSITE AND THIS PAGE: *Though he presented castellated designs, such as the one at right, Downing maintained that the rural Gothic style was more in keeping with the American spirit and landscape.*

the same floor with the living rooms, and in which there is little or no necessity for ascending or descending stairs. . . ." Though modest in size overall, the cottage's architectural detailing was fine. Its front facade incorporated a porch—which Downing called an umbrage—with a second-story balcony above its center section. From this a pointed doorway with a diamond-paned transom afforded access from the house. Above was a prominent, pointed center gable with a spire; scrollwork embellished the gable's bargeboard,

and the porch was well detailed with trim. Completing the design were ornate chimneys, diamond-paned ("latticed") casement windows, and a bay window with a crenellated battlement and pointed windows extending out from the parlor. To maintain the verticality associated with the Gothic style, Downing broke the horizontal line of its front porch by setting the side sections back slightly, and he paid special attention to the detailing of its tall chimneys. Inside the house, a center hallway bisected the space, extending from the front door between the two principal front rooms, each of which measured seventeen by twenty feet, to the back of the house where it opened to a larger hall with a staircase. This was flanked by a bedroom behind the parlor, a pantry and closet behind the living room, and a kitchen in a

*Downing often incorporated porches flanking
a center bay, as in his own home (above).*
OPPOSITE: *The Charles H. Manship house
(c. 1857), in Jackson, Mississippi, is based upon
a design in* The Architecture of Country Houses.

DESIGN II.
A Cottage in the English or Rural Gothic Style.

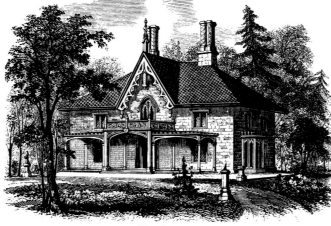

Fig. 9.

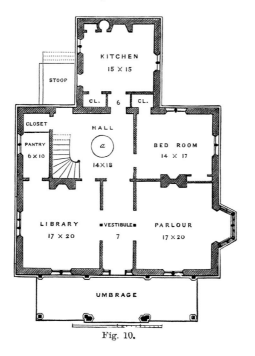

KITCHEN
15 X 15

STOOP

CL. 6 CL.

CLOSET

HALL

PANTRY
6 X 10

a

14 X 18

BED ROOM
14 X 17

LIBRARY
17 X 20

VESTIBULE
7

PARLOUR
17 X 20

UMBRAGE

Fig. 10.

one-story ell at the rear. The second floor
contained four additional bedrooms.

In describing this house, which was
later constructed on Staten Island, New
York, Downing provides insight into
his era's embrace of the Gothic Revival
style. Emphasizing its "picturesqueness,"
he noted that "the genius of pointed or
Gothic architecture may be chastened or
moulded into forms for domestic habita-
tions." Furthermore, he said, the pointed
style's "steep roofs are highly suitable for a
cold country liable to heavy snows."

Downing authored his major aesthetic
treatise, *The Architecture of Country Houses,*
in 1850. He called rural architecture more
a "sentiment" than a science and to con-
tribute to "the popular taste," he showed
villas in the Italian style and six cottages

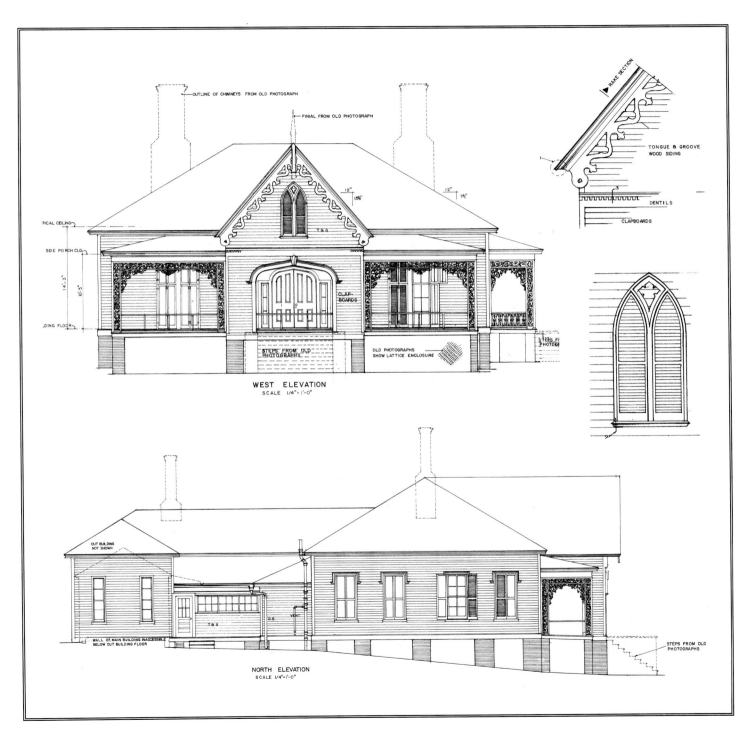

OUTLINE OF CHIMNEYS FROM OLD PHOTOGRAPH

FINIAL FROM OLD PHOTOGRAPH

RAKE SECTION

TONGUE & GROOVE
WOOD SIDING

12"
15¾"
12"
7½"

DENTILS

CLAPBOARDS

T & G

'PICAL CEILING

SIDE PORCH CLG.

14'-3"
10'-5"

CLAP-
BOARDS

'DING FLOOR

STEPS FROM OLD
PHOTOGRAPHS

OLD PHOTOGRAPHS
SHOW LATTICE ENCLOSURE

STEPS FR
PHOTOGR

WEST ELEVATION
SCALE 1/4" x 1'-0"

OUT BUILDING
NOT SHOWN

T & G

D.S.
VENT

WALL OF MAIN BUILDING INACCESSIBLE
BELOW OUT BUILDING FLOOR

STEPS FROM OLD
PHOTOGRAPHS

NORTH ELEVATION
SCALE 1/4"=1'-0"

and villas in the Gothic or "pointed style." Incorporating examples of more expensive homes by Alexander Jackson Davis and Gervase Wheeler, *The Architecture of Country Houses* offered a range of designs—from an economical three-room wooden cottage to a comparatively grand five-bedroom villa built of stone.

Several of its designs anticipated the later Victorian styles, including the Queen Anne and Eastlake, and they evidence the preference for the eclectic that would increase during the Victorian era. The eclecticism of the Gothic style when combined with other influences was most evident in Downing's Design XXXII, a lake or river villa in which a tall square tower at the

left of the front facade was balanced by a central core with a pointed gable and, to its right, a long ground-level porch, which was surmounted by a small gabled dormer in the roof. In this, the most embellished and fanciful of his designs, the bottom edges of the gables and tower roof kicked out in uplifted curves, a balcony opened from the tower, the small attic dormer projected over the second-story rooms, and the bay window over the main dormer showed an Oriental influence. It was, he noted, ideal for the highlands along the Hudson River, where several of these homes were built.

The romantic notion of the picturesque cottage that Wordsworth celebrated

in England and that Downing described took hold in the mid-nineteenth century and it has persisted into the twenty-first. The cottage—whether a historic Gothic Revival house, a twentieth-century Arts and Crafts bungalow, or a new home built in the Carpenter Gothic style—remains one of the most beloved of all forms of domestic architecture, combining, as Downing put it, "beauty and picturesqueness" and "a union of domestic feeling and artistic knowledge." Its enduring charm remains as Downing articulated in 1850: the casual, comfortable, and economical style of the cottage is "less severe" and therefore less constraining than a larger, more formal home, and it exhibits "more

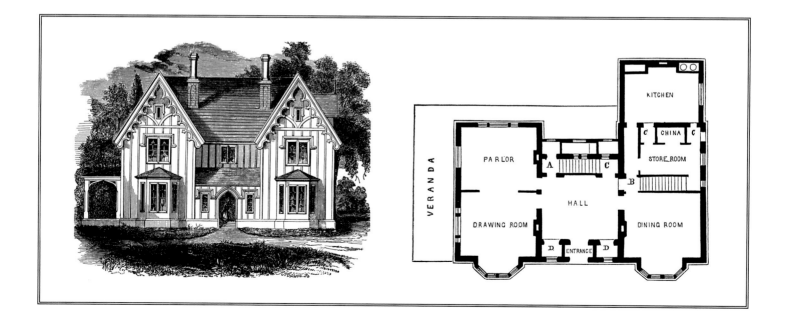

of the freedom and play of feeling of every-day life." Downing, the generation that relied on his books, and the generations that followed shared a romantic vision that imbued the cottage with what he called "domestic feeling." But even the grand Tudor houses, built of stone, in suburbs such as Bronxville, New York, Lake Forest, Illinois, and Bryn Mawr, Pennsylvania, are direct descendants of the stone villas that Downing described.

In 1850, shortly after the publication of *The Architecture of Country Houses*, Downing and his wife visited Europe. While in England, he was introduced to Calvert Vaux, a young architect also enamored of medieval buildings. Returning to New York, they established the firm of Downing and Vaux. Their partnership was short-lived: Downing died in a steamboat accident on the Hudson River in 1852. However, his brief life represented a transformative moment in both American architecture and the American lifestyle, and his ideas continue to influence homeowners, architects, builders, interior designers, and landscape architects today.

Downing's picturesque cottage designs featured board-and-batten siding, scrollwork trim, bay windows, gable screens, and steep, finial-topped gables, as seen in the Plain Timber Cottage-Villa (opposite) and Rural Gothic Villa. Floor plans emphasized ease of living.

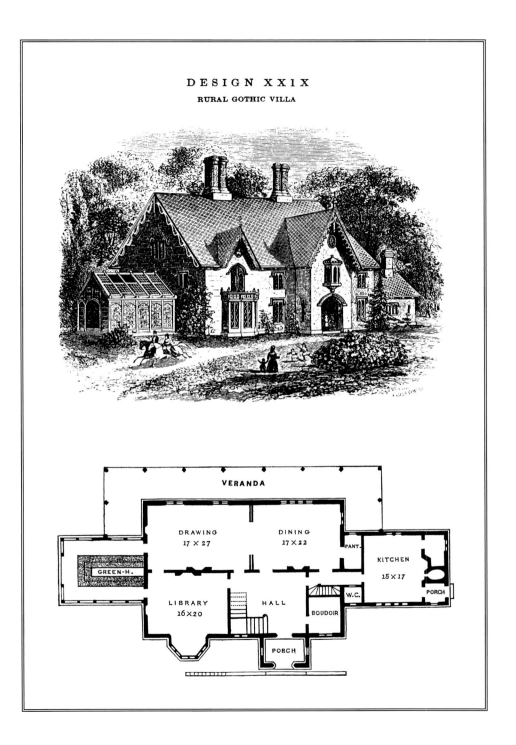

DESIGN XXIX
RURAL GOTHIC VILLA

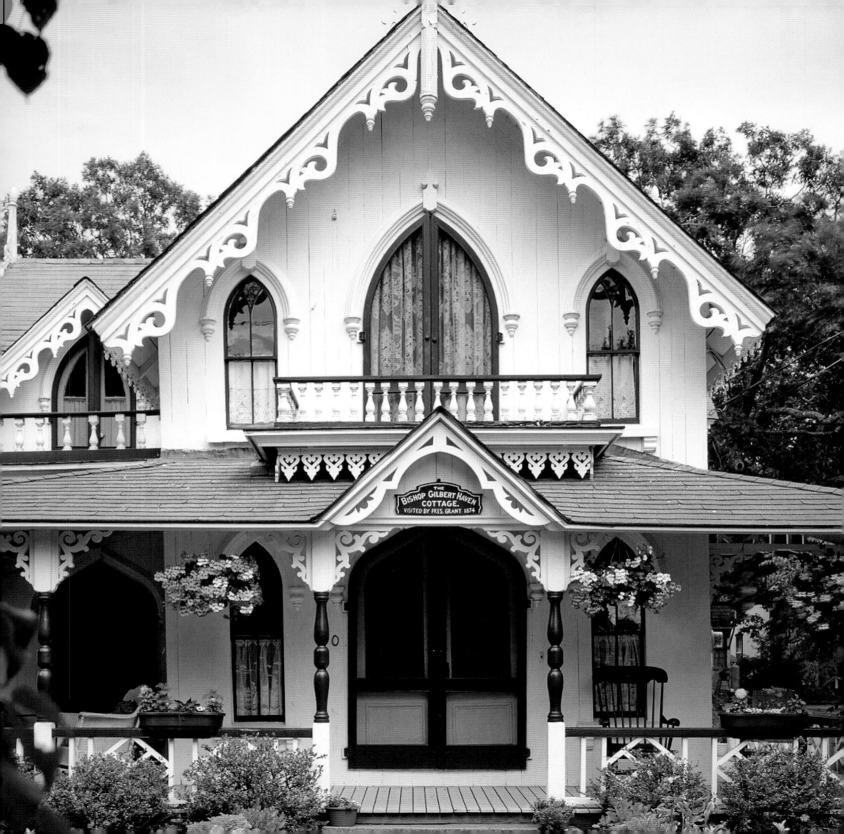

God Is in the Details

THE HALLMARKS OF THE
CARPENTER GOTHIC STYLE

*The veranda is perhaps the most specially American feature
in a country house, and nothing can compensate for its
absence. It may be constructed of lattice in the common way,
or with a little more elaboration... A handsome veranda
may always be made by using posts seven or eight inches in
diameter, and fitting between them brackets or arches.*

*The bay-window is the peculiar feature next to the veranda
that an American rural home loves to indulge in. There can,
indeed, scarcely be too many for the comfort of the house, or
too few for the comfort of the purse.*

—CALVERT VAUX, *VILLAS AND COTTAGES*, 1864

Start with a pointed window, with a hint of tracery at the top, set into the otherwise austere, white board-and-batten siding of a humble farmhouse. In Eldon, Iowa, a diminutive dwelling with such a window became the raison d'etre for Grant Wood's 1903 painting, *American Gothic*. In front of it he depicted "the kind of people I fancied should live in that house." The pointed window that Wood placed at the center of the painting conveys the couple's simplicity and stalwart, God-fearing character better than a thousand other details might.

The architectural details of the Carpenter Gothic cottage—steep gables decorated with scrollwork trim and topped with spires, porches embellished with "gingerbread" spandrels and lattices, and pointed windows—are the first things that catch our eye. These features give these cottages their aesthetic appeal; denuded of its details, stripped of its exterior charms, the Carpenter Gothic house loses its curb appeal. More than any architecture before or since, this and the other romantic architectural styles of the nineteenth century relied on picturesque details.

With respect to the Carpenter Gothic style, it is especially true that "God is in the details," a phrase coined by Sir Christopher Wren in England during the seventeenth century and a fitting one for an architecture that traces its origins to the

PREVIOUS: *Lively details adorn a cottage in Oak Bluffs, Massachusetts.* OPPOSITE: *This modest home in Eldon, Iowa, with its purity of form and simple pointed window, inspired Grant Wood's iconic painting,* American Gothic.

medieval cathedral. The salient elements of the Carpenter Gothic style are steep gables, bargeboards (aka vergeboards) embellished with hand-carved or scroll-work trim, spires, pinnacles, finials, a porch with decorated scrollwork spandrels, pointed windows and hoods, brackets, clustered columns and chimneys, bay and oriel windows, diamond-paned casements, tracery decoration, stained glass, pointed arches, crockets, trefoil and quatrefoil motifs, crenellated battlements, and castellated towers. That's quite a litany: on occasion, it was combined in a single house.

The aim of the Gothic style was to achieve a picturesque effect. But in the aesthetically successful house, this was not achieved by a random piling on of details. Instead, it was the product of a sure and restrained hand. Andrew Jackson Downing made this point more than once. In his description of a design in *The Architecture of Country Houses*, he wrote, "Never introduce in a cottage any elaborate of complex ornament (however beautiful intrinsically or in higher architecture) which is not entirely consistent with that simple,

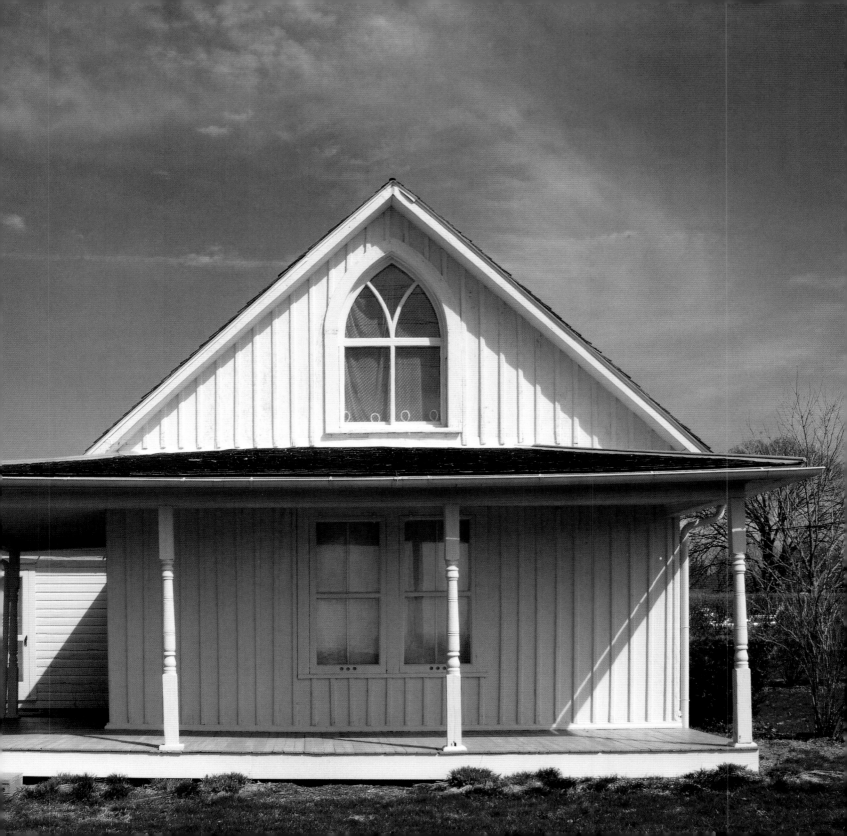

truthful character which is the greatest source of pleasure in Cottage Architecture."

Downing and others pointed out that though the "most economical form for a cottage is a square, and next to that a parallelogram, it is evident that all irregular cottages are more costly than regular ones." As a consequence, many Carpenter Gothic cottages featured a fairly rectangular floor plan with a prominent, steep center gable. This basic form was enlivened by steeply peaked dormers and one or two additional elements. These might have consisted of a projecting section in the front facade, flanked on either side by a porch, a bay window on the first floor, and/or an oriel window cantilevered out from the second

story. Occasionally, the square edges of a parlor were "clipped off" to form a semi-hexagon or semi-octagon. Often, a pointed window on the second floor opened onto the roof of a front porch. Instead of an attic vent, a round "Tudor flower" might be tucked under an otherwise simple gable, like the vestige of a medieval cathedral's grand rose window. Sometimes modest towers or balconies were incorporated into the design. Those who wanted to show off their wealth built homes with more of these elements.

THIS PAGE: *In the Gothic Revival and subsequent styles, residential buildings borrowed from church architecture.* OPPOSITE: *Grace Episcopal Church in Bath, Maine.*

The approach to the rural Gothic residence was important. The drive was to curve, following the contours of the terrain, with trees planted in the areas around which it curved. This afforded a gradual, graceful approach, which hinted at but did not fully reveal the house. Once there, the drive led to the house from an oblique angle, revealing a portion of the side and front facades. The strongest design elements, which gave the house presence as one approached, were the porch, the center gabled section, the varied windows, the rhythm of the dormers, and the chimneys.

Depending upon the means of the owner, the nineteenth-century rural Gothic home could be realized on the grand

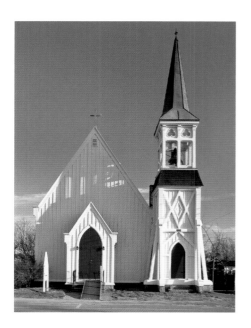

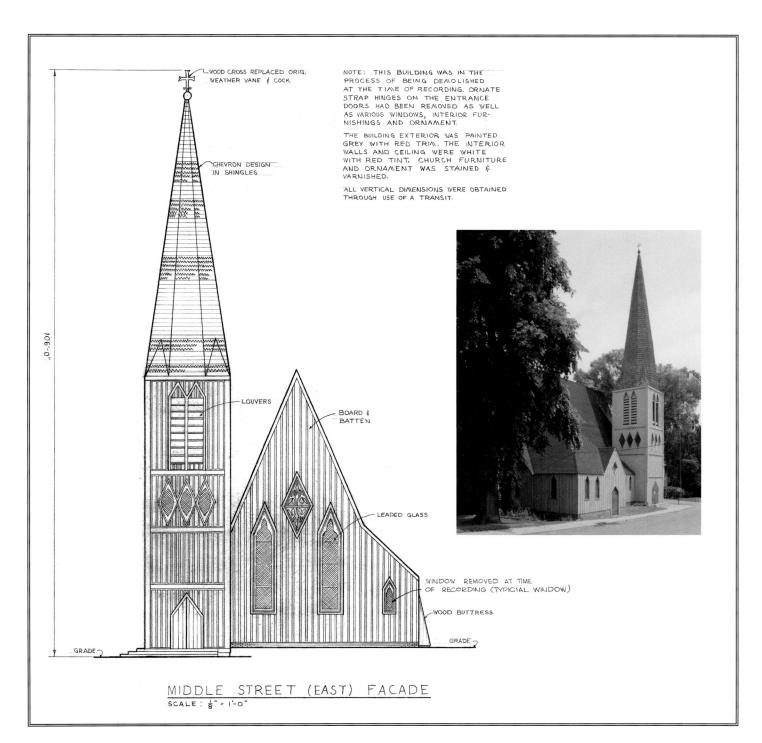

WOOD CROSS REPLACED ORIG.
WEATHER VANE & COCK

CHEVRON DESIGN
IN SHINGLES

LOUVERS

BOARD &
BATTEN

LEADED GLASS

WINDOW REMOVED AT TIME
OF RECORDING (TYPICAL WINDOW)

WOOD BUTTRESS

GRADE

GRADE

106'-0"

NOTE: THIS BUILDING WAS IN THE
PROCESS OF BEING DEMOLISHED
AT THE TIME OF RECORDING. ORNATE
STRAP HINGES ON THE ENTRANCE
DOORS HAD BEEN REMOVED AS WELL
AS VARIOUS WINDOWS, INTERIOR FUR-
NISHINGS AND ORNAMENT.

THE BUILDING EXTERIOR WAS PAINTED
GREY WITH RED TRIM. THE INTERIOR
WALLS AND CEILING WERE WHITE
WITH RED TINT. CHURCH FURNITURE
AND ORNAMENT WAS STAINED &
VARNISHED.

ALL VERTICAL DIMENSIONS WERE OBTAINED
THROUGH USE OF A TRANSIT.

MIDDLE STREET (EAST) FACADE
SCALE: $\frac{1}{8}$" = 1'-0"

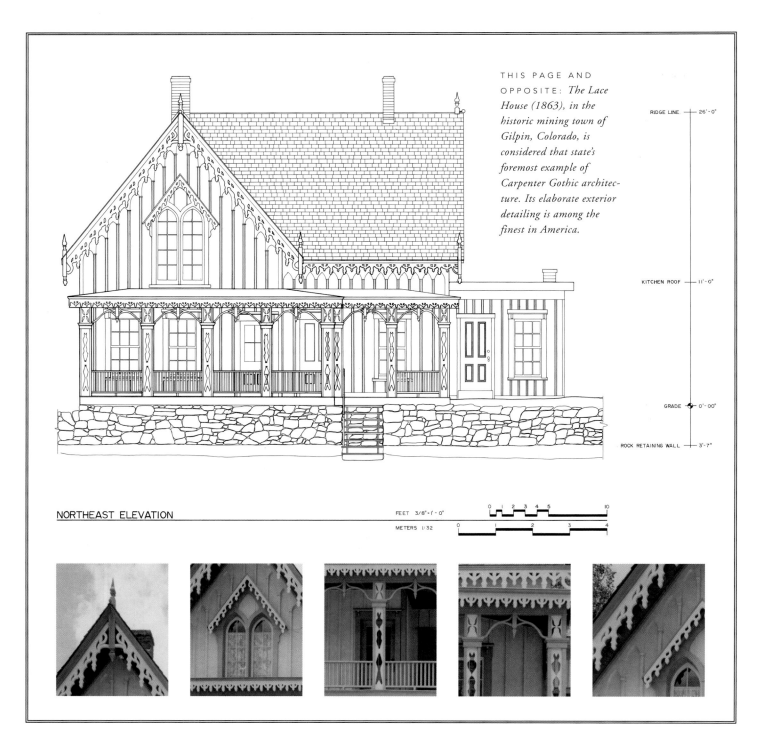

THIS PAGE AND OPPOSITE: *The Lace House (1863), in the historic mining town of Gilpin, Colorado, is considered that state's foremost example of Carpenter Gothic architecture. Its elaborate exterior detailing is among the finest in America.*

RIDGE LINE ── 26'-0"

KITCHEN ROOF ── 11'-0"

GRADE ── 0'-00"

ROCK RETAINING WALL ── 3'-7"

NORTHEAST ELEVATION

FEET 3/8"=1'-0"

METERS 1:32

0 1 2 3 4 5 10

0 1 2 3 4

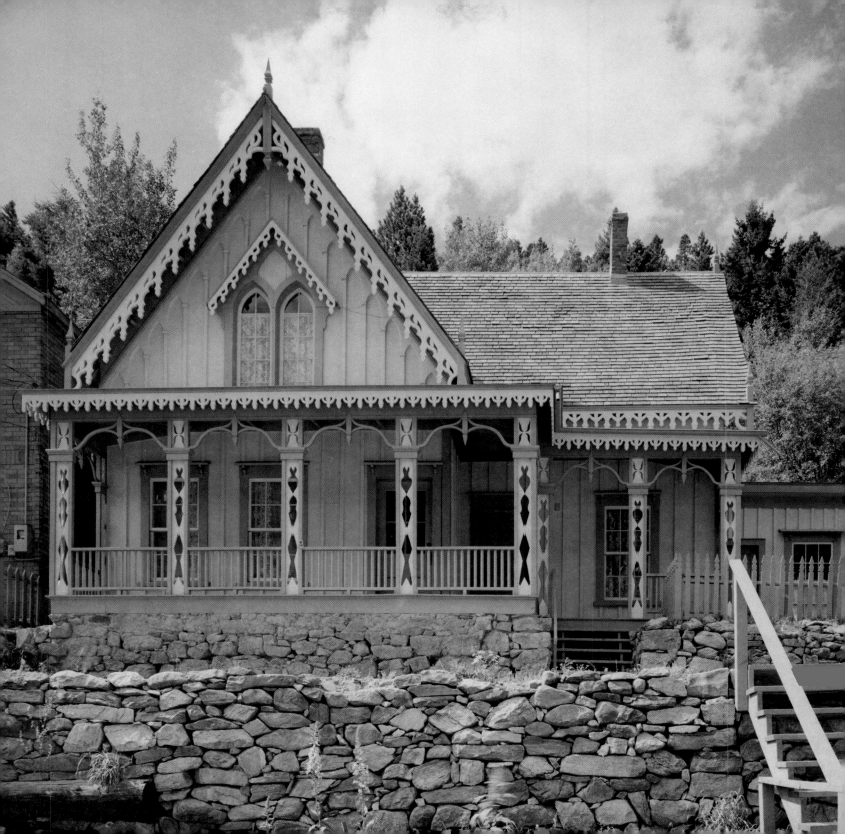

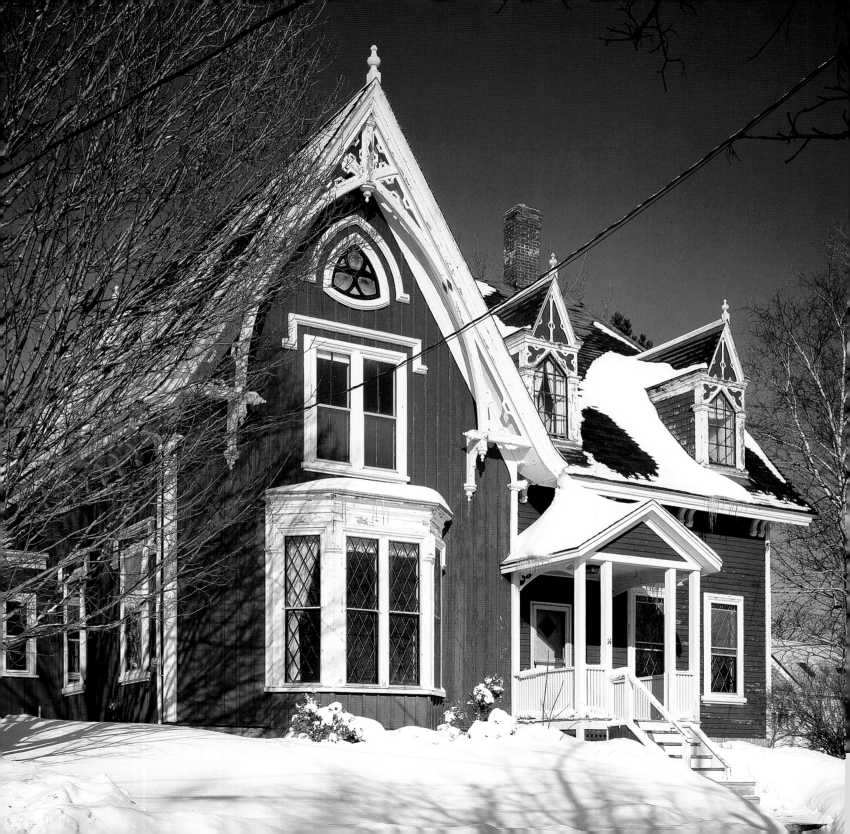

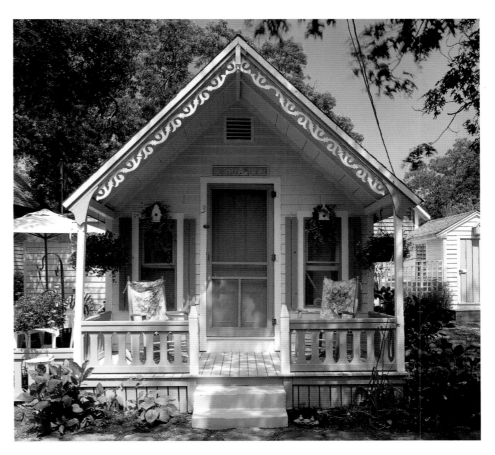

scale of a country villa or on the small scale of a cottage, and the two deployed the same exterior detailing to a greater or lesser extent. As his partner Calvert Vaux observed in *Villas and Cottages*, published a dozen years after Downing's death, cost was a factor, particularly in the cottage of middle-class people and those of modest means. The cottage was the grand villa on a smaller scale, with most of the same features. But, for the cottage, Downing emphasized diamond-paned windows and the pointed gable, "which not only appears in the two ends of the main building, but terminates every wing or projection of almost any size that joins to the principal body of the house . . . [finished] with a handsome moulded coping, or . . . with the widely projecting roof of wood, and verge boards carved in a fanciful and highly decorative shape. In either case, the point or apex is crowned by a finial, or ornamental octagonal shaft, rendering the gable one of the greatest sources of interest in these dwellings. The projecting roof renders the walls always dry."

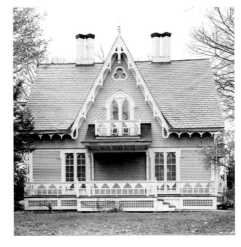

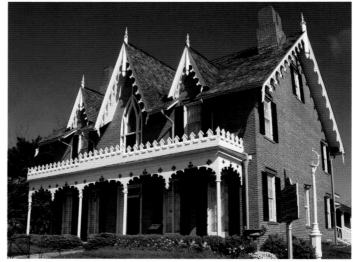

Though wood—being widely available and relatively inexpensive—was the most commonly used building material in the United States, Carpenter Gothic homes were often executed in other materials. Downing advocated the use of stone, brick, and wood, and he liked stucco for its economy and ability to take a variety of tinted finishes. Some large rural villas and cottage-villas were intended to be built of stone, in which case he recommended "stone laid in its natural bed as it comes from the quarry, with rough hand-dressed blocks of somewhat more regular form and size at the angles of the building and round the apertures for doors and windows, [which] would produce a far more pleasing effect than expensively cut work and regular masonry, and would be far more in accordance with the spirit of the style."

THIS PAGE: *Exuberant detailing infuses Carpenter Gothic homes with unique personalities: finials and dark window hoods accent a facade, crockets surmount the porch of a brick house, and a stained-glass window tops an embellished entry porch.* OPPOSITE: *Pastel colors add gaiety.*

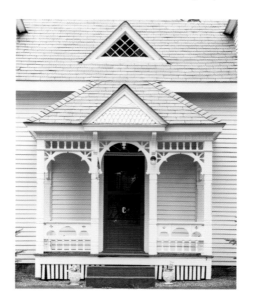

Though clapboard siding was often used in building the Carpenter Gothic cottage, Downing did not present it in his books: exterior sheathing could be of horizontal boards butted together to produce a flat surface, or of vertical board-and-batten siding with the batten either flat or with an ogee profile. Davis was a strong proponent of board-and-batten, and is largely responsible for its popularity. "We greatly prefer the vertical to the horizontal boarding, not only because it is more durable, but because it has an expression of strength and truthfulness that the other does not," Downing noted.

Also recommended for exterior siding were scalloped, "fish-scale" shingles. "This mode of covering wooden houses with shingles is a very durable mode,"

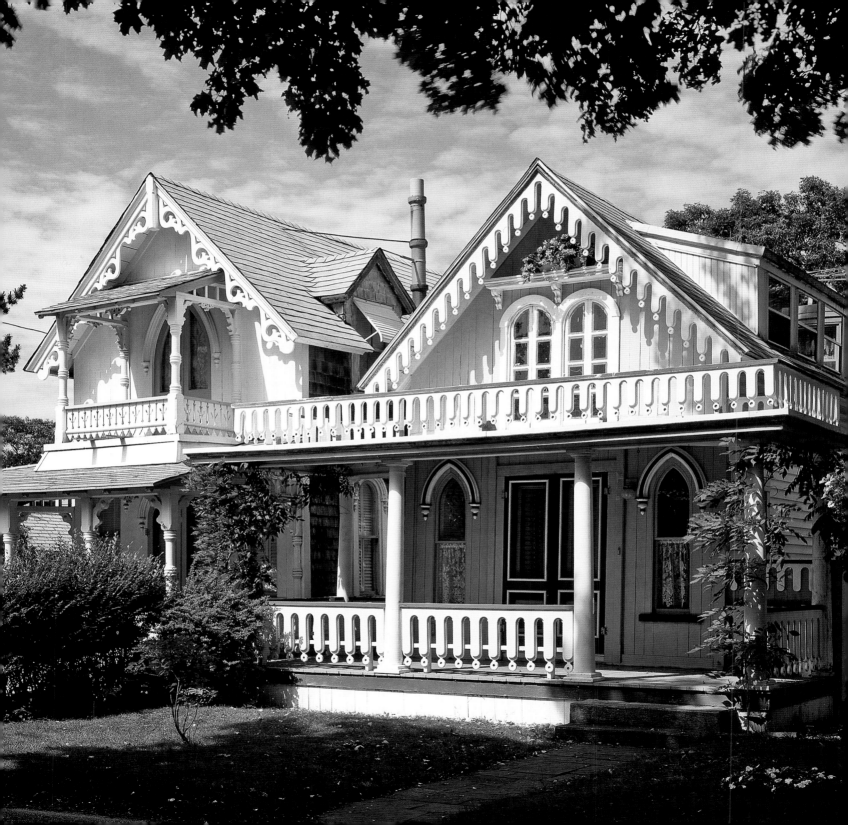

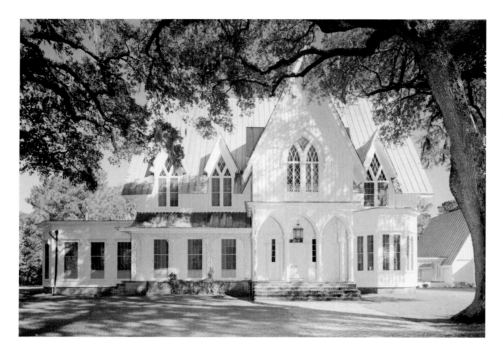

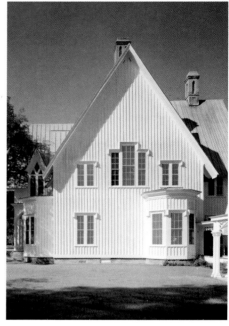

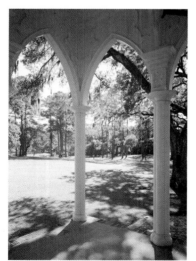

Downing declared, "and, when the shingles are cut in ornamental patterns, it has a more tasteful and picturesque effect than common weather-boarding." The surface with varied shingles, which was much used in later Victorian styles, notably the Queen Anne, and then during the Colonial Revival, originated with the Carpenter Gothic house.

While virtuoso medieval stone carvers created incredibly detailed carvings, the use of wood for exterior trim in Gothic Revival homes opened the floodgates of creativity among rural carpenters. Some hand-carved their work. Others relied on the newly invented scroll saw to achieve

the swirls and curls, trefoils and quatrefoils, for spandrels and other trim details. "*Vergeboards* and *finials*," Vaux observed, "admit of endless variety of design. . . ." Shadows cast by intricate trim on a bargeboard also created a dramatic, picturesque impression.

In construction, quality was a fundamental. Decorative finishes, as Downing noted—and as many later homeowners have learned, sometimes with regret— cost the same whether its components were made correctly or incorrectly. Consequently, he admonished builders to pay careful attention to architectural details such as window and door casings,

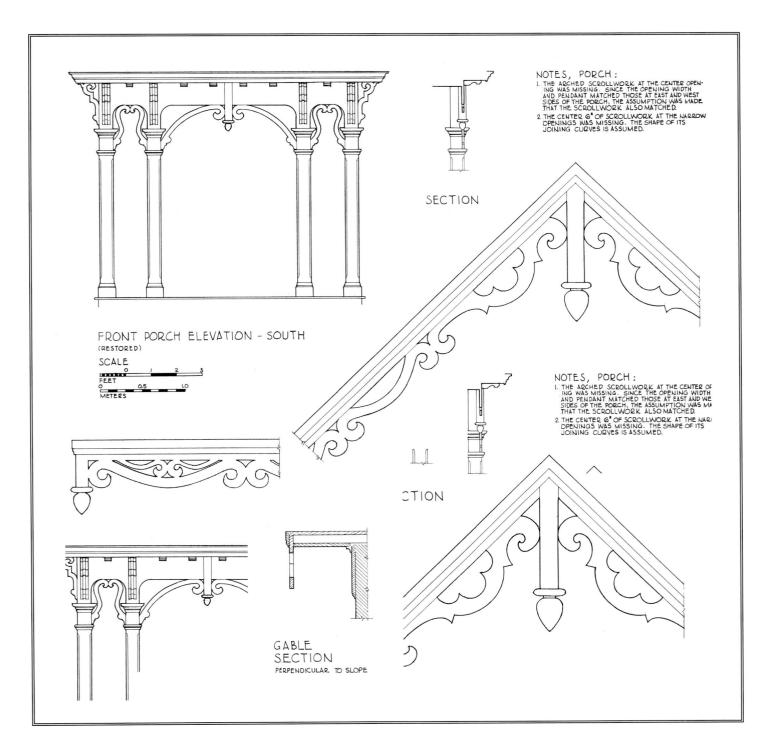

FRONT PORCH ELEVATION - SOUTH

(RESTORED)

SCALE

SECTION

NOTES, PORCH:

1. THE ARCHED SCROLLWORK AT THE CENTER OPEN-
 ING WAS MISSING. SINCE THE OPENING WIDTH
 AND PENDANT MATCHED THOSE AT EAST AND WEST
 SIDES OF THE PORCH, THE ASSUMPTION WAS MADE
 THAT THE SCROLLWORK ALSO MATCHED.

2. THE CENTER 6" OF SCROLLWORK AT THE NARROW
 OPENINGS WAS MISSING. THE SHAPE OF ITS
 JOINING CURVES IS ASSUMED.

NOTES, PORCH:

1. THE ARCHED SCROLLWORK AT THE CENTER OF
 ING WAS MISSING. SINCE THE OPENING WIDTH
 AND PENDANT MATCHED THOSE AT EAST AND WE
 SIDES OF THE PORCH, THE ASSUMPTION WAS MA
 THAT THE SCROLLWORK ALSO MATCHED.

2. THE CENTER 6" OF SCROLLWORK AT THE NAR
 OPENINGS WAS MISSING. THE SHAPE OF ITS
 JOINING CURVES IS ASSUMED.

CTION

GABLE
SECTION

PERPENDICULAR TO SLOPE

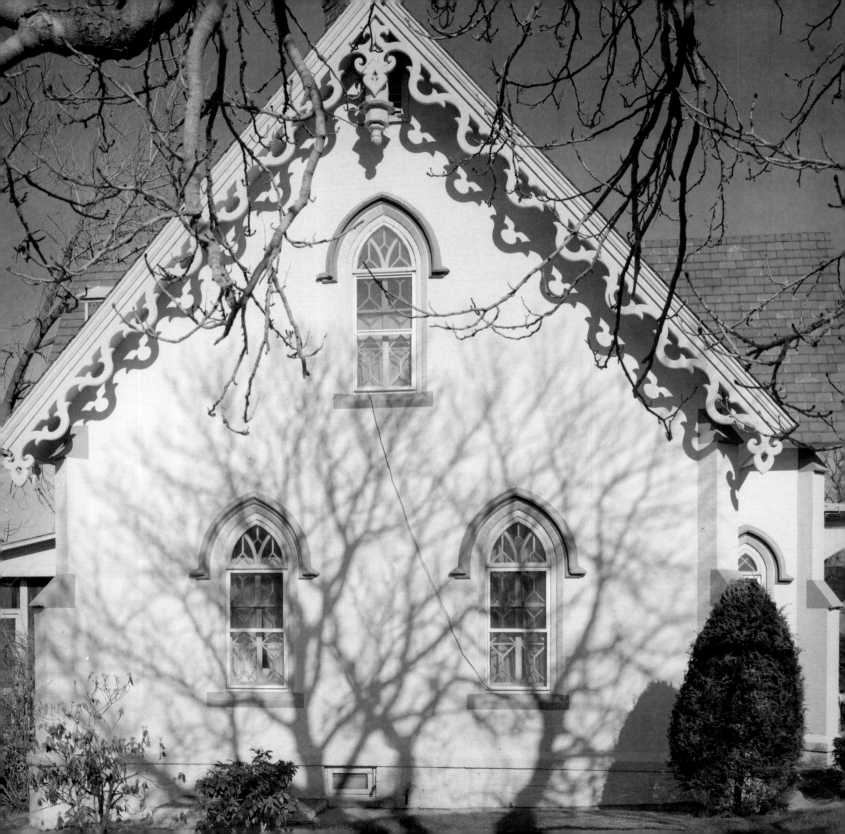

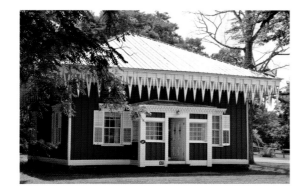

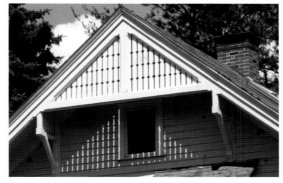

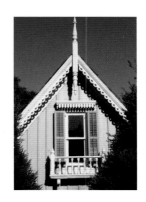

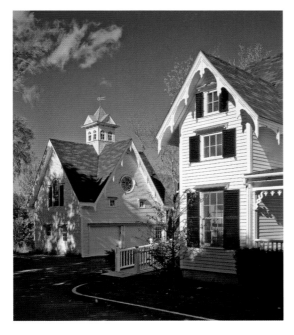

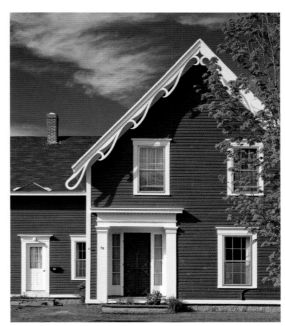

[Fig. 137. Verge-Board]

The shadow cast by the finials and scrollwork trim was a sought-after effect, adding a picturesque air to the simplest of cottages. Excessive gingerbread trim could verge on the saccharine, but used with restraint it could invoke a dignified serenity, as in the non-commissioned officer's quarters (c. 1850), U.S. Military Academy, in West Point, New York (opposite).

cornices and pointed moldings (crafted with the correct wood-working planes), and three-inch architraves and moldings.

"Never attempt any ornamental portions in a cottage," Downing noted, "which cannot be executed in a substantial and proper manner, so that the effect of beauty of design may not be weakened by imperfect execution or flimsy materials."

This was of particular importance, he said, when it came to the bargeboard: "As part of a well-built villa, this verge-board is carefully carved in thick and solid plank, so as to exhibit all the details of outline and tracery boldly to the eye, and so as to endure as long as the house itself." Downing used the term gingerbread, but in a disparaging way. "Now let this be imitated in a cheap cottage," he wrote, "and it is almost always sawn out of

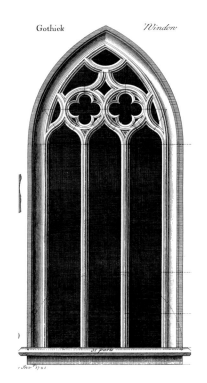

Gothick Window

THIS PAGE: *The trefoil and quatrefoil were popular Gothic motifs.* OPPOSITE: *A quatrefoil embellishes a gable at Rose Cliff, on the Maine coast.*

thin board, so as to have a frippery and 'gingerbread' look which degrades, rather than elevates, the beauty of the cottage. Particularly in the South, cast iron, more durable than wood trim in a hotter, damper climate, allowed the scrollwork on porches to be produced in ornate foliate designs that would otherwise have been possible in only the most accomplished hand-carved wood.

In addition to the trim that embellished the bargeboard and porch, Downing called for ornamentation on the entrance door, the principal windows, the gables, and the chimneys: "The front door and the principal or first-floor windows should be recognized as something more than mere openings, by lintels, hoods, or borders (dressings); the gables by being very simply moulded or bracketed about

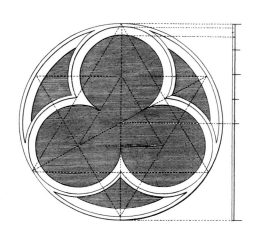

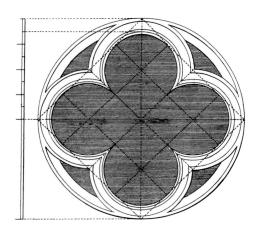

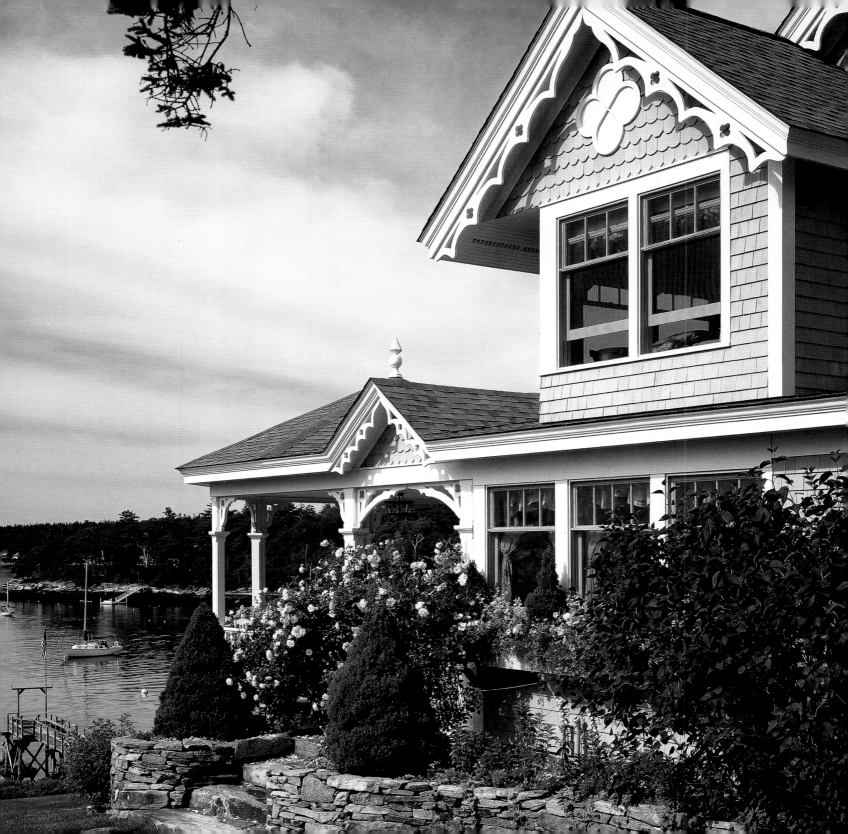

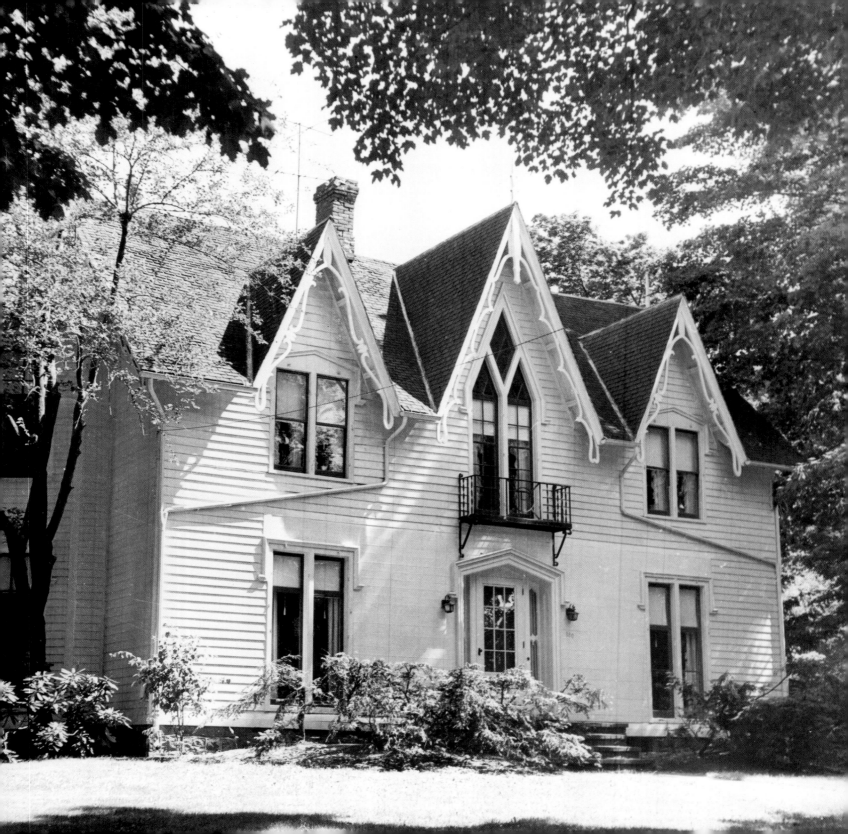

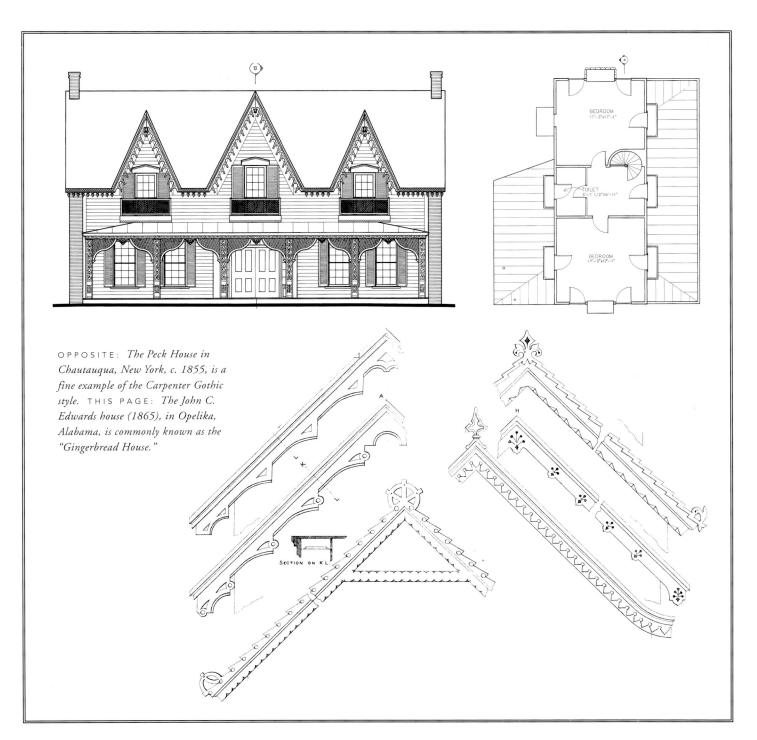

OPPOSITE: *The Peck House in Chautauqua, New York, c. 1855, is a fine example of the Carpenter Gothic style.* THIS PAGE: *The John C. Edwards house (1865), in Opelika, Alabama, is commonly known as the "Gingerbread House."*

BEDROOM
17'–3"x17'–1"

TOILET
5'–7 1/2"x9'–11"

BEDROOM
17'–3"x17'–1"

SECTION ON KL

the junction with the roof; the chimneys, by a pleasing form or simple ornaments, or merely by having the usual clumsy mass lightened and separated into parts."

Another concept Downing emphasized was utility, speaking of the "relative beauty of refined purposes." One element that embodied this was the porch. He wrote, "A *Porch* strengthens or conveys expression of purpose, because, instead of leaving the entrance door bare, as in manufactories and buildings of an inferior description, it serves both as a note of preparation, and an effectual shelter and protection to the entrance. Besides this, it gives a dignity and importance to that entrance, pointing it out to the stranger as the place of approach. A fine country house, without a porch or covered shelter to the doorway of some description, is therefore as incomplete, to the correct eye, as a well printed book without a title page, leaving the stranger to plunge at once *in media res*, without the friendly preparation of a single word of introduction. Porches are susceptible of every variety of form and decoration, from the embattled and buttressed portal of the Gothic castle, to the latticed arbor porch of the cottage, around which festoons of luxuriant climbing plants cluster. . . ." In the back of the house, leading to and from the kitchen, there was often a small porch or stoop.

THIS PAGE: *In the American South, partly because of the warmer, moister climate, cast iron became a stand-in for wooden scrollwork trim, allowing even greater intricacy and refinement.*
OPPOSITE: *A vernacular cottage in New Orleans deploys fanciful woodwork to great effect.*

Given the choice between a feature that was extravagantly ornamental and the one that was gracefully utilitarian, Downing recommended the latter. "A much higher character is conferred upon a simple cottage by a veranda than by a highly ornamented gable," he opined, "because one indicates the constant means of enjoyment for the inmates—something in their daily life besides ministering to the necessities—while a more ornamental verge-board shows something, the beauty of which is not so directly connected with the life of the owner, and which is therefore less expressive, as well as less useful."

In fact, the porch, or veranda, was America's most significant contribution to Victorian and later architecture. It was not used in England where the climate was much damper than in the United States. Though the portico was a feature in classical Greece and Rome, and the colonnade was a standard of Moorish, and, later, Spanish, Italian, and monastery architecture, the porch as a form is thought to have migrated to the southern colonies from the Caribbean, where it was a key element of French and then British plantation houses. Some scholars believe the porch as a form may have been brought to the West Indies by African slaves. Whatever its origins, the porch became a standard feature in American homes during the nineteenth century.

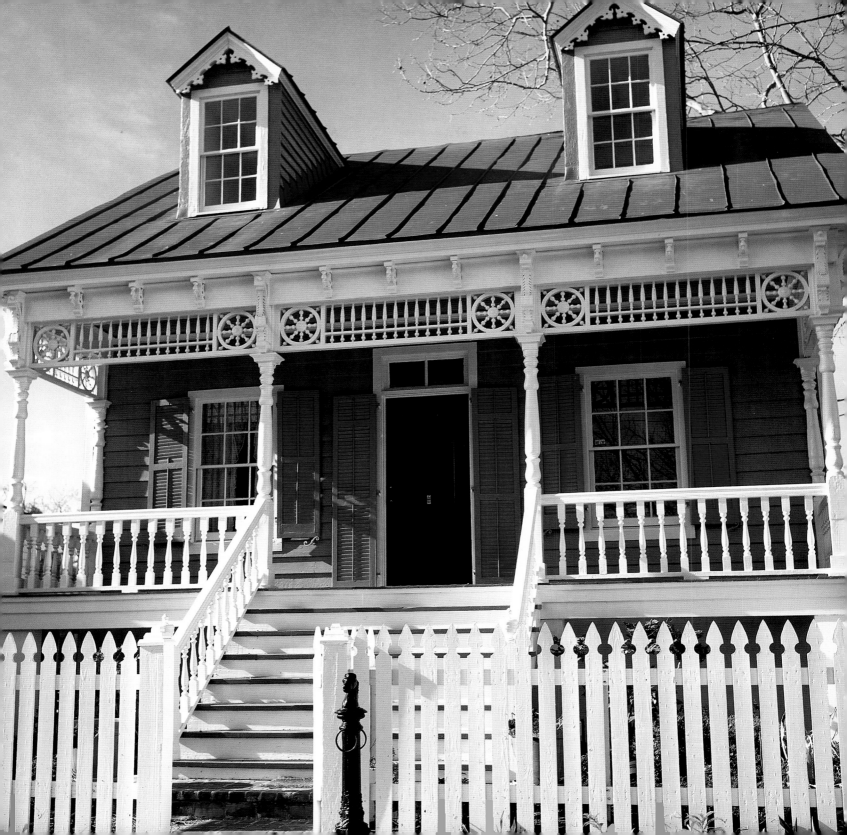

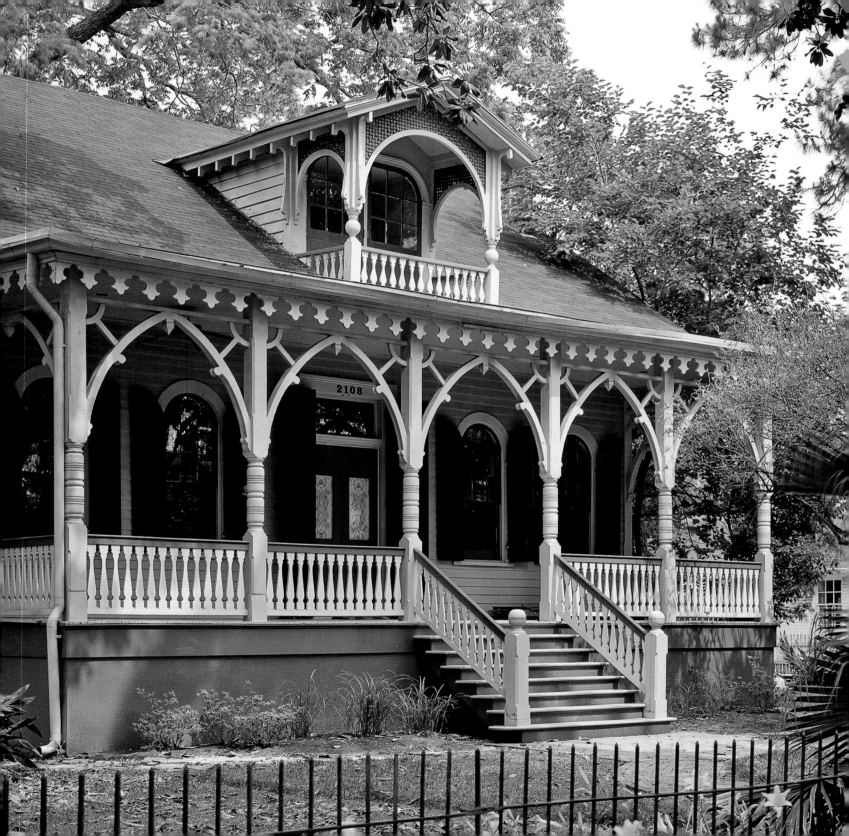

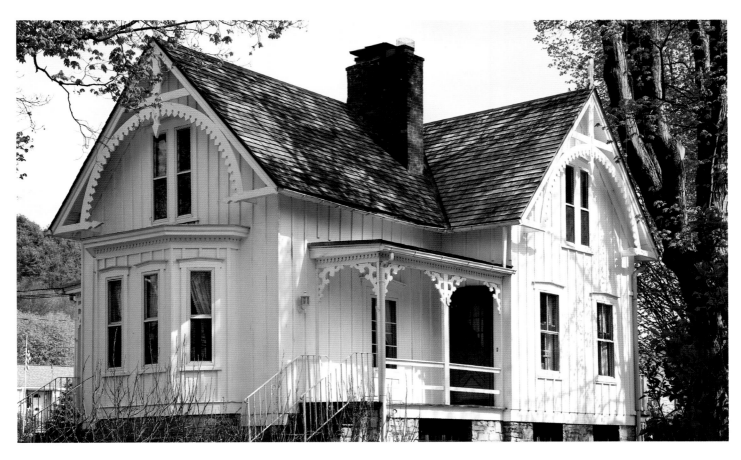

Downing was largely responsible for this. As a landscape designer, he believed rural residences and the surroundings should be visually and physically linked, and emphasized this from the time he wrote his first book, noting that porches, gables, chimneys, and verandas gave a house "some reasonable connexion, or to be in perfect keeping with surrounding nature." The porch mediated between the house and its surroundings.

OPPOSITE: *In this Southern cottage, a varicolored paint scheme emphasizes the pointed arches, trim, and shutters.* THIS PAGE: *A serene white unifies exterior details, such as board-and-batten siding and the scrollwork rimming a semicircular gable screen.*

The porch—as Downing was first to articulate for the public—allowed a flow of space between a home's interior and exterior. Describing a love affair that would continue to the present day, he wrote that

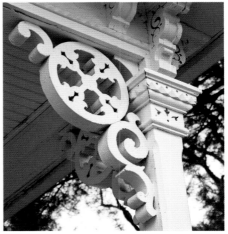

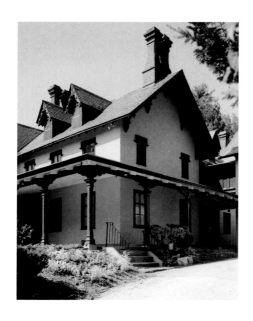

varied decorative designs, reminiscent of those used in columns during the medieval Gothic period when many motifs had a distinctly Moorish look about them. In the Carpenter Gothic cottage, chimneys were often of plain brick, but their arrangement in clusters or pairs gave them a strong presence when viewing the front facade.

Like A. W. N. Pugin and John Ruskin, Downing was a believer in what he termed the honesty of materials—that is, in allowing structural elements to show. "The secret source of the Picturesque," he wrote, "is the manifestation of Beauty through *power* . . . Hence everything that conveys the idea of strength or force in attaining any agreeable form, adds to the picturesqueness of that form. For this reason, in picturesque architecture, the rude timbers which support the roof are openly shown, and in others, bold brackets support the eaves, not only for actual support,

"our hot summers make [the veranda or porch] indispensable to every house . . . [for] shelter, prospect, and an agreeable promenade," and "over almost the whole extent of the United States, a veranda is a positive luxury in all the warmer part of the year, since in mid-summer it is the resting-place, lounging spot, and place of social resort, of the whole family, at certain hours of the day."

Chimneys were also a key feature in the Gothic cottage-villa, "the very first things that catch the eye," Vaux wrote. "They should . . . have a substantial, hospitable look. . . . flues may be grouped together in many different ways. . . ." In larger, more impressive houses, these were clustered, their stacks imprinted with

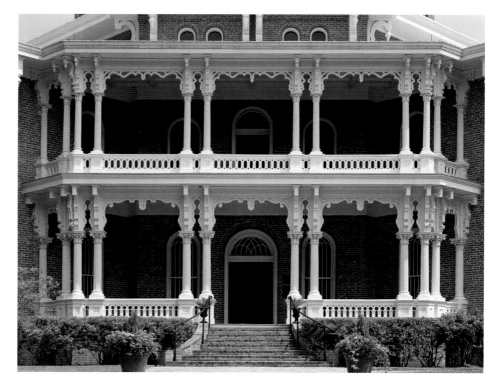

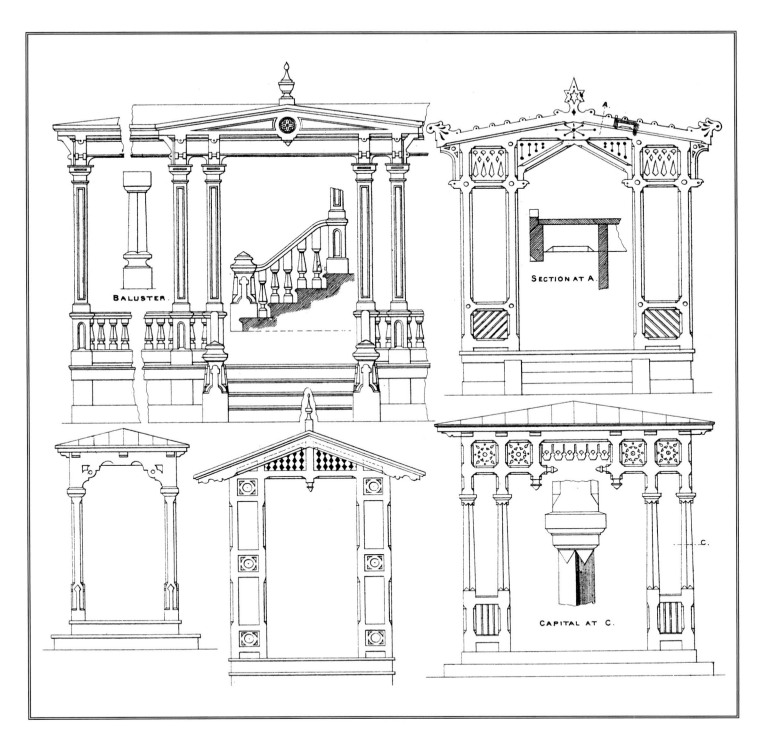

BALUSTER.

SECTION AT A.

CAPITAL AT C.

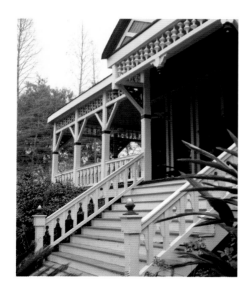

THIS PAGE AND OPPOSITE: *Poplar Grove, in Baton Rouge, Louisiana, by Thomas Sully, was built for the 1884 New Orleans Exposition. Eclectic details include Eastlake spindles and Oriental elements. The Carpenter Gothic style yielded to others, leaving America the porch and an affection for gingerbread trim.*

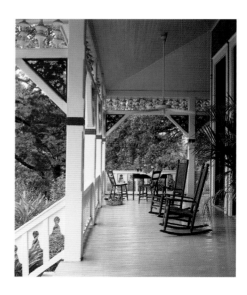

but to suggest the idea of support directly to the eye. . . . There is another way in which projecting roofs convey the idea of power, or heighten picturesque character in a building. They cast broad and deep shadows . . . the most striking and brilliant effects are produced by casting on the walls of a house, in broad sunshine, a dark shadow from the roof which projects two to four feet." As a practical matter, the projecting roof provided shade to upper rooms in the summer and helped keep exterior walls dry, an important consideration in wooden buildings.

It is ironic that this aesthetic emerged just as America was making the transition from post-and-beam construction, which in the interiors of First Period Colonial archi-

tecture was meant to be exposed, to balloon framing, a new, lighter framing method, furthered by steam-powered sawmills that mass-produced lumber of narrower, more uniform dimension. In terms of its lightness and flexibility, the balloon frame, still the conventional method of residential building today, was the nineteenth-century parallel to the lighter construction that had been introduced in the medieval period.

Just as in the original medieval period, when large sections of cathedral walls were devoted to light-welcoming windows, Gothic Revival and Carpenter Gothic houses celebrated sunlight with multiple windows, sometimes extending floor to ceiling, in bay and oriel configurations, single or grouped in pairs or by the threes and fours, always with dormers that brought the light into upper rooms. Small, glazed trefoil, quatrefoil, cinquefoil, and circular openings adorned residential and other types of buildings. And, in imitation of the cathedral itself, sunlight streaming through stained-glass windows turned rooms into prisms of color.

The window design of the Carpenter Gothic cottage descended from the medieval period, through England's Gothic Revival, to America. The pointed, or lancet, window, filled with diamond panes and tracery, and topped with a strongly defined hood of carved stone, was a key feature in the medieval Gothic cathedral. Even when reproduced with wooden frames and sash, the pointed window with a graceful tracery detail at the top imbued the simplest Carpenter Gothic cottage with a distinctly romantic and picturesque look.

Bay and oriel windows were another Gothic Revival convention. A home might have a semi-hexagonal or semi-octagonal bay on the first floor. The oriel window might project, Downing explained, "in a

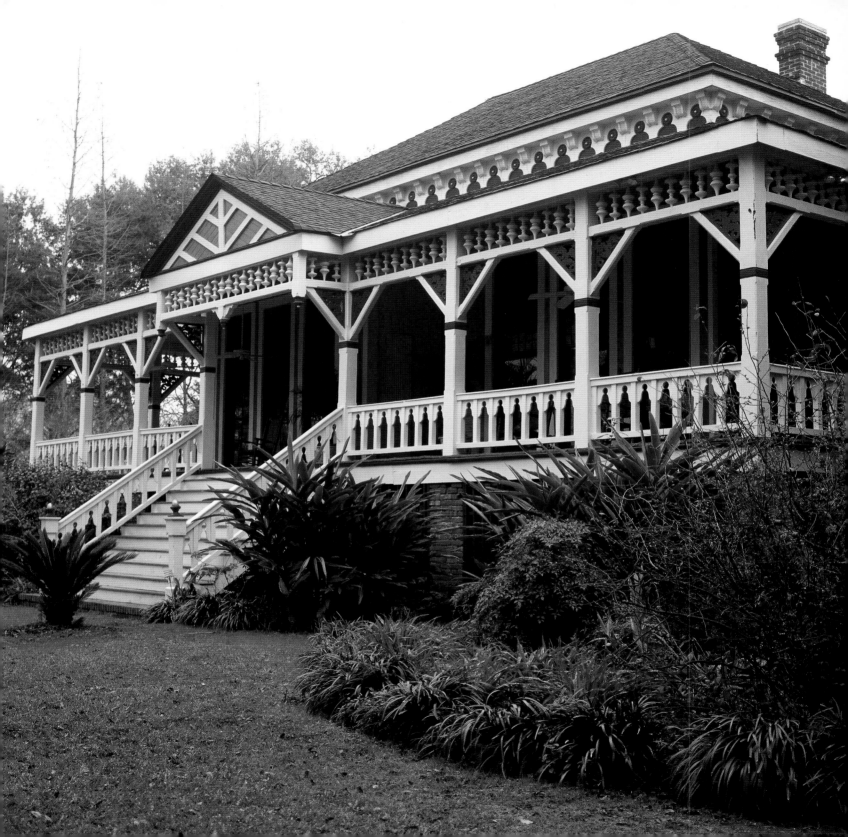

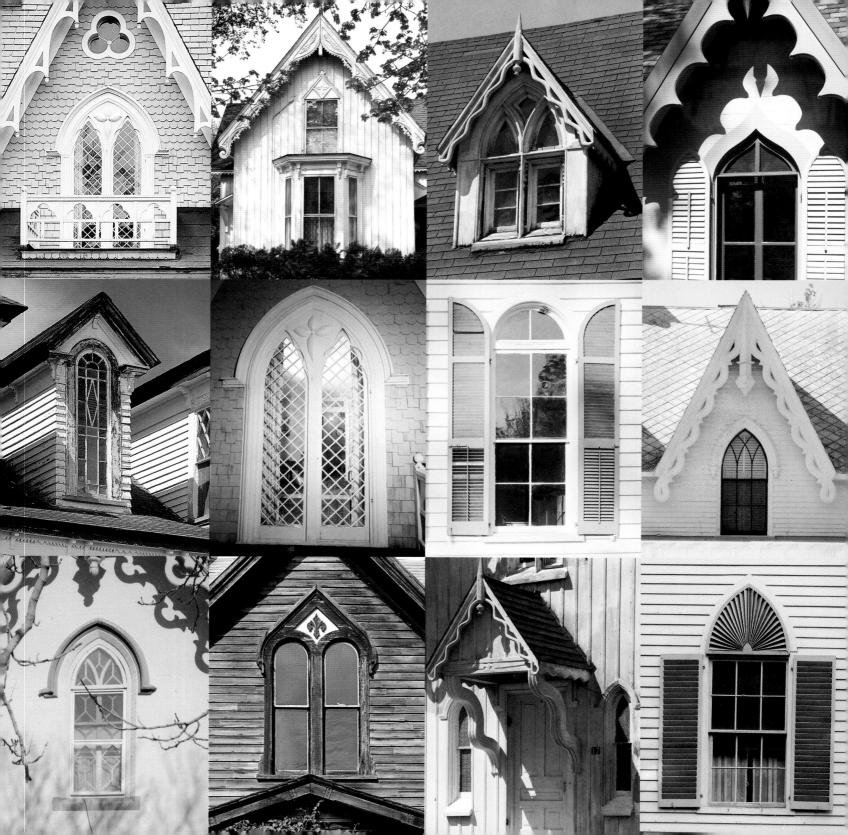

OPPOSITE: *A pride of windows evidences one of the hallmarks of the Carpenter Gothic style.* THIS PAGE: *A rocking chair is decoration enough on this welcoming porch with its pointed French door and windows, and a happy cotton-candy-and-marshmallow color scheme.*

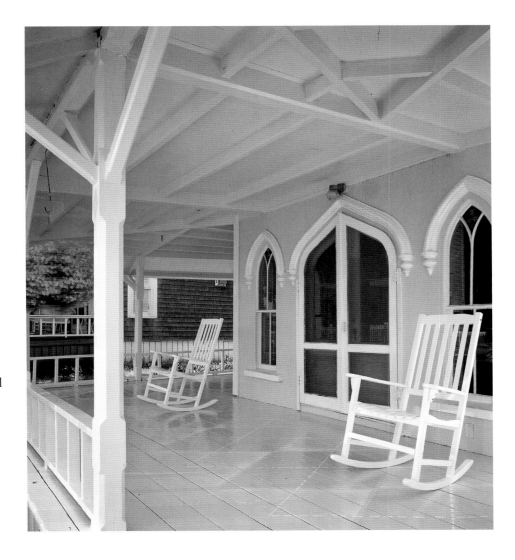

similar manner from the upper story, supported on corbelled mouldings. These [bay and oriel] windows are not only elegant in the interior, but by standing out from the face of the walls, they prevent anything like too great a formality externally, and bestow a pleasing variety on the different fronts of the building."

Casement windows also evoked the medieval period. According to Downing, casements divided into two parallel vertical sections, were "less expensive than rising sashes with weights." Moreover, he noted, a casement allowed for a wide vertical mullion in the center of a window providing a way to "divide closets or rooms by abutting a [single-board] partition [wall] against it." Most important, he opined, "There is something in the associations connected with latticed windows so essentially rural and cottage-like, that the mere introduction of them gives an air of poetry to a house in the country." These were, he said, "most expressive of that simple, rustic beauty, which belongs to . . . cottage life in the country. Anyone who

prefers large panes, set in square sashes, may adopt them instead, but he will sacrifice something of the poetry in order to gain perhaps a little more of utility and economy."

Another important exterior feature of the Carpenter Gothic cottage is, of course,

color. Romantic poet William Wordsworth, in *Prose Works*, said, "A tint ought to be introduced approaching nearer to those which, in the technical language of painters, are called *warm*: this, if happily selected, would not disturb, but would animate the landscape. How often do we

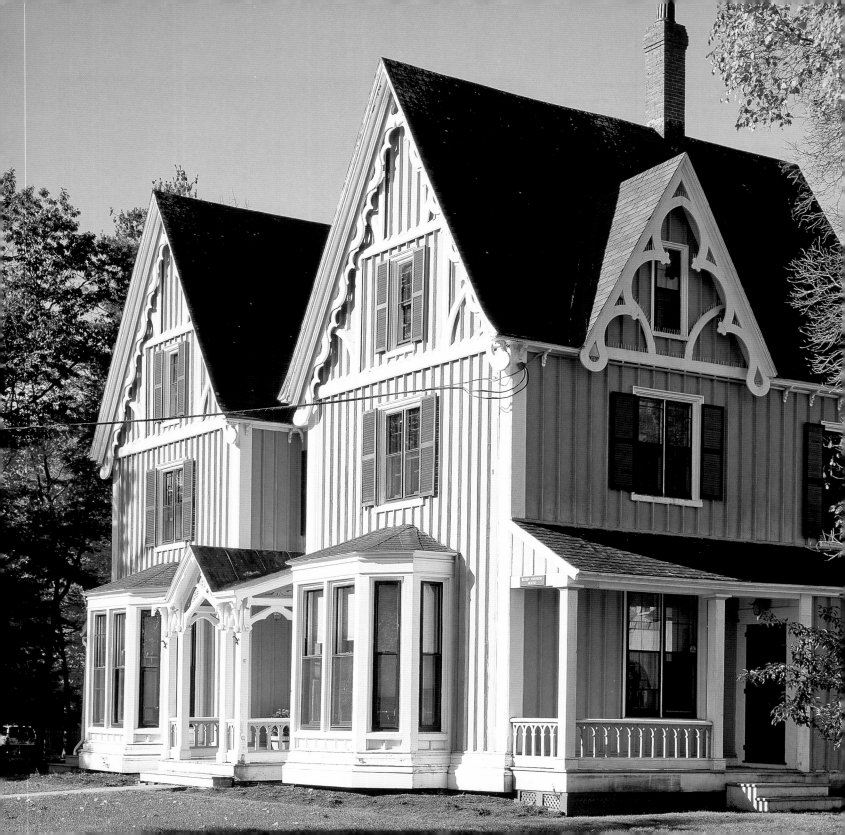

see this exemplified upon a small scale by the native cottages, in cases where the glare of white-wash has been subdued by time and enriched by weather stains! No harshness is then seen; but one of these cottages, thus coloured, will often form a central point to a landscape by which the whole shall be connected, and an influence of pleasure diffused over all the objects that compose the picture."

Though polychrome color schemes were used inside high-style Gothic Revival homes, Carpenter Gothic houses were not "painted ladies" on the outside. Historically, their exterior color was often an earthy gray or tan, mimicking stone. Sometimes it was a dusty, grayed-down pink—a color that imitated marble, was associated with health, and evoked the rose, which was just being hybridized and introduced in many varieties during the nineteenth century. At Roseland Cottage, in Woodstock, Connecticut, designed by New York architect Joseph C. Wells, the body color on the board-and-batten siding was painted a deep rose; chimney stacks were of glazed, rosy-colored stoneware; exterior accents—an oriel window, trellised porches, bargeboards, pinnacles, and crockets—were of dark red; and the trim on the porches was painted white.

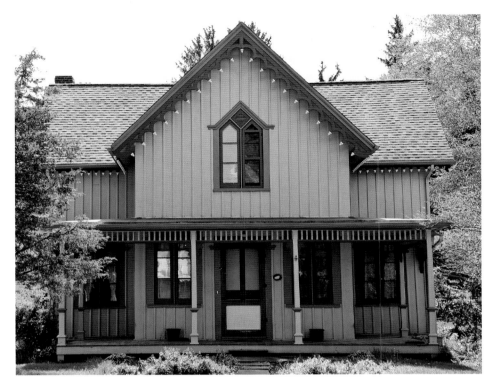

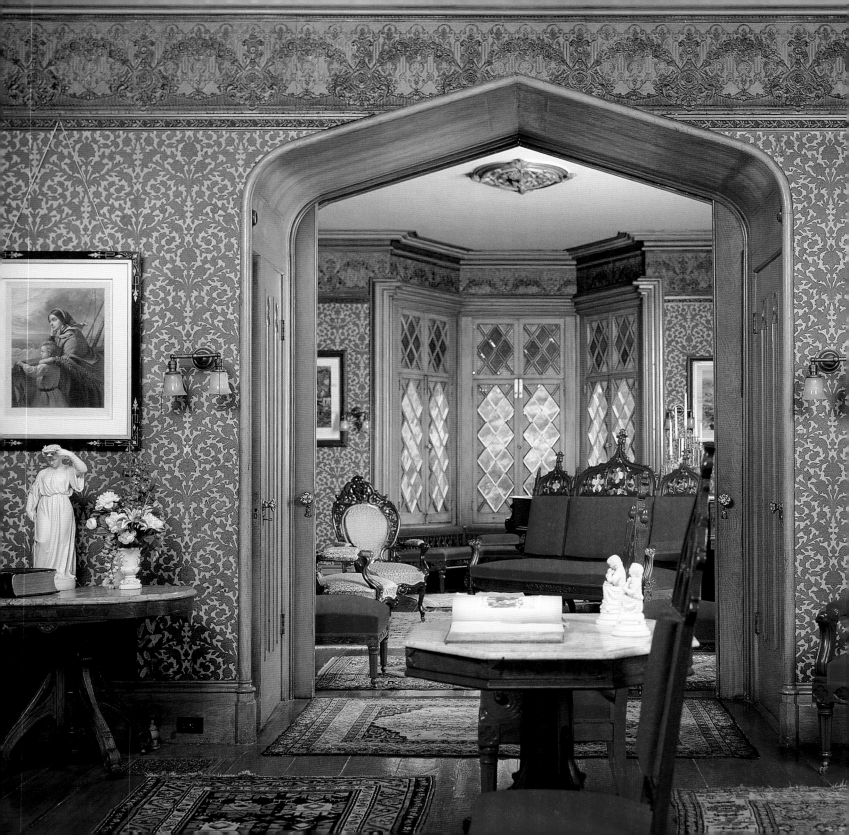

Chapter
Six

The Carpenter
Gothic Room

FURNISHING THE
CARPENTER GOTHIC HOME

*Those who love shadow, and the sentiment of antiquity and repose, will find
the most pleasure in the quiet tone which prevails in the Gothic style.*

—ANDREW JACKSON DOWNING, *THE ARCHITECTURE OF COUNTRY HOUSES*, 1850

"Perhaps the error into which interior decorators are most apt to fall . . . is to render [rooms] too elaborately Gothic," Downing noted. "A more subdued and quiet manifestation is in better keeping with domestic architecture, and, especially, with rural dwellings." What this meant in practice is that few Carpenter Gothic homes were decorated entirely in the Gothic style. One reason for this was aesthetic: then, as now, suites of Gothic furniture in every room seem too over-the-top. Another reason was comfort. Many Gothic chair designs were not all that comfortable. The aim of the rural residence, Downing wrote, was to yield "the greatest amount of comfort and enjoyment to its residents." Whether one's taste ran to Gothic designs in wallpaper, furniture, textiles, silver, lighting fixtures, glassware, or ceramics, nineteenth-century manufacturers answered the call.

The interior design and furniture that emerged during the American Gothic Revival traces its origins to eighteenth-century England. In 1754 Richard Bentley designed Gothic chairs and other furnishings in ebonized beech, fabricated by London cabinetmaker William Hallett, for

Strawberry Hill, the Gothic Revival home of Horace Walpole; the backs of the chairs were modeled on Gothic tracery church windows. Thomas Chippendale showcased Gothic furniture in his important *The Gentleman and Cabinet-Maker's Director*, also issued in 1754. In England, high-style Gothic Revival interiors could be extremely ornate and intricate, and many interiors created for the country homes of the landed gentry during the English Gothic Revival drew their costly details from churches, palaces, and state buildings.

As the style moved to America and took hold a hundred years later, builders and furniture makers picked up some of these details, whether it was a quatrefoil window, or a trefoil, pointed arch, Tudor flower, or tracery that embellished the back of a chair. One wonderful example of this is the stained-glass parlor window (see opposite) at Roseland Cottage, in Woodstock, Connecticut, which was built for Henry Bowen, a wealthy silk merchant, and is now a Historic New England museum property.

One notable reference point for high-style English interiors, including those of Horace Walpole's seminal designs

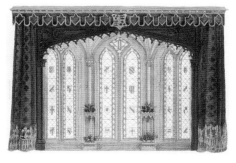

ABOVE AND OPPOSITE: *The church window lent its glory to Gothic Revival homes, as in the example above and in the images opposite: Roseland Cottage (left), Lyndhurst (top), and Fonthill Abbey (bottom).* BELOW: *Chairs illustrated by A. W. N. Pugin.*

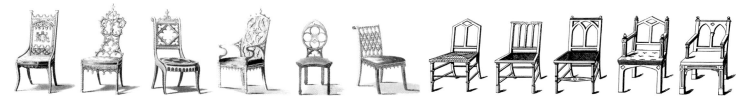

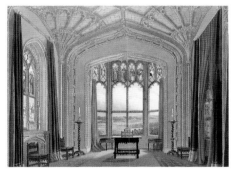

at Strawberry Hill, was the New Palace of Westminster and its Houses of Parliament, with interiors created by A. W. N. Pugin. The son of Gothic Revival proponent A. C. Pugin, he had been a talented prodigy who, in 1835, at the age of thirteen, began illustrating Gothic furniture for Rudolph Ackermann's design magazine, *The Repository of the Arts*, the leading showcase of Gothic design. Among the items Pugin

(continued on page 144)

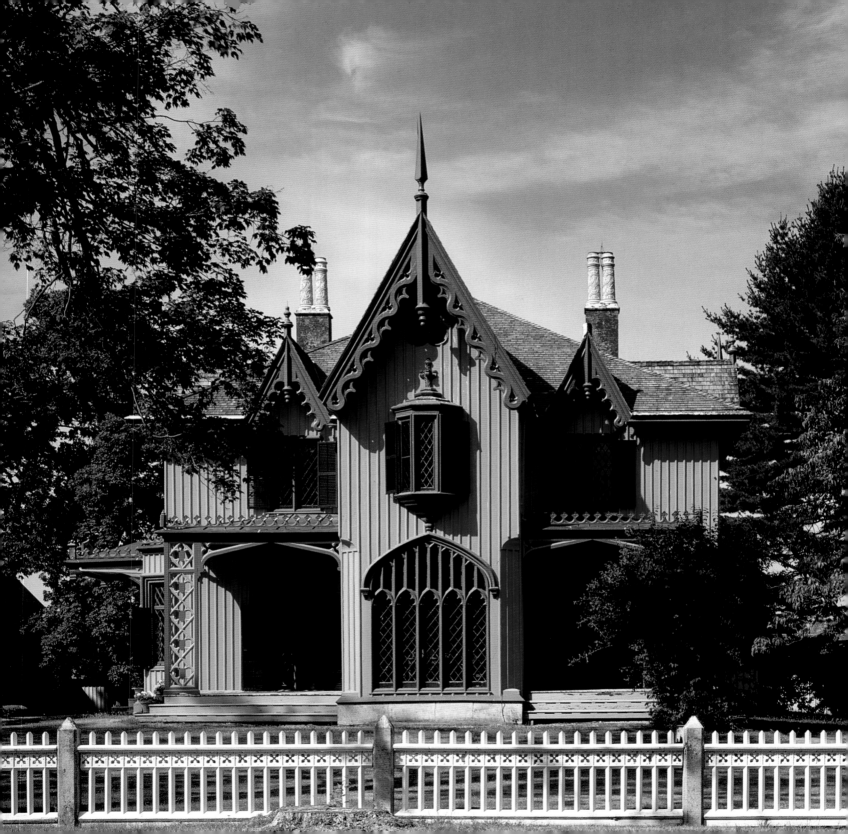

❦ Woodstock, Connecticut ❦

Roseland Cottage, constructed in 1846 by architect Joseph C. Wells for Henry Bowen, is the finest restoration of a Carpenter Gothic home in America. Owned and operated by Historic New England, the property was conveyed to this regional museum with all of its furnishings. Curators revived the home Bowen knew, replacing worn carpets with exact replicas, reproducing original paint schemes, retaining Lincrusta wallpaper, and rearranging furniture according to historic photographs.

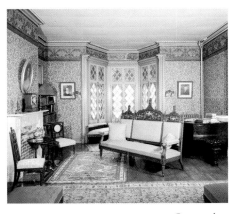

OPPOSITE AND THIS PAGE: *Conveyed with its furnishings to Historic New England, Roseland is the finest museum restoration of a Carpenter Gothic residence in America.*

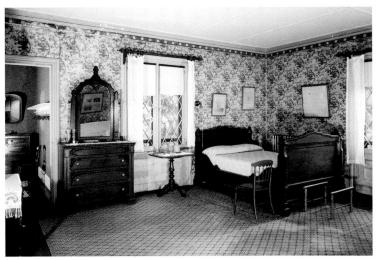

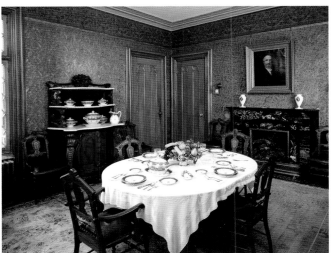

illustrated were pieces by George Smith, including a baby's cradle with tracery and crocketed pinnacles, similar to one Henry Bowen's family had at Roseland Cottage.

At fifteen, the young savant designed a suite of Gothic rosewood furnishings with gilt decoration for the Windsor State dining room: his client was England's King George IV. In 1835, at the age of twenty-three, Pugin issued the authoritative *Gothic Furniture in the Style of the Fifteenth Century*. In the same decade, he remodeled Scarisbrick Hall, a late medieval building, into a more highly ornamented and authentically Gothic residence for Charles Scarisbrick, a prominent antiquarian collector. One of the distinctive pieces in the house is Pugin's first X-frame chair, in oak, which became one of his most influential designs.

Interior woodwork details drawn by A. W. N. Pugin and Brandon & Brandon became popular motifs during America's Gothic Revival.

He also created intricate marquetry designs for tabletops, one of which was showcased to much acclaim in the Medieval Court of the 1851 Exposition—the first world's fair—at the Crystal Palace in London. Of this the *Art Journal Illustrated Catalogue* noted, "The furniture of the Medieval Court forms one of the most striking portions of the Exhibition, and has attracted a large amount of attention."

With his study of original Gothic buildings and paintings of the Middle Ages, his prolific output of designs, and his widely consulted books about medieval design, Pugin was preeminent among those who

approached Gothic Revival design with the sensibility of an antiquarian and scholar. At Westminster, inspired by medieval examples and working in the Perpendicular Gothic style, Pugin created, supervised, and installed resplendent interiors: woodwork of carved oak with elaborate gilt decoration, light fixtures and other metalwork including intricate brass doors with grille-work fashioned to look like tracery, tile flooring, statuary, wallpapers, wall stenciling, carpets, and textiles, which still stand as the most breathtaking decorative accomplishment of the era. Among those who worked on the project with Pugin were Herbert Minton, who made the tiles; builder and sometime furniture-maker George Meyers; metalworker John Hardman; and decorator John Gregory Crace, Pugin's partner in

a decoration firm that also executed several important residential projects. Other influential designers of England's Gothic Revival were Richard Norman Shaw, who designed furniture and decorative arts for the London International Exhibition of 1862, and Bruce Talbert, who promoted this new "Reformed Gothic" style in his popular book, *Gothic Forms applied to Furniture, Metal Work and Decoration for Domestic Purposes of 1867–1868.*

The interiors of the Rotch House (1846), in New Bedford, Massachusetts, designed by Alexander Jackson Davis and photographed for the Historic American Buildings Survey.

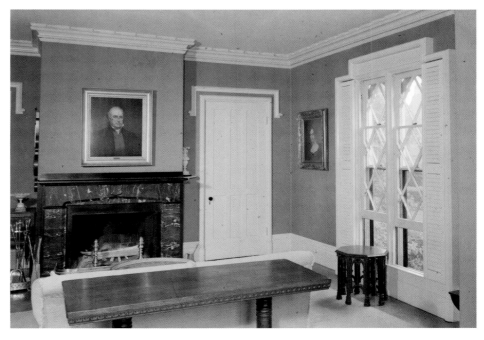

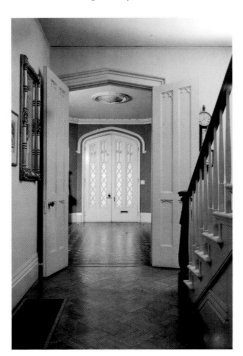

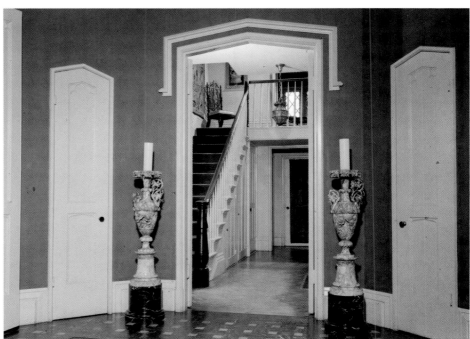

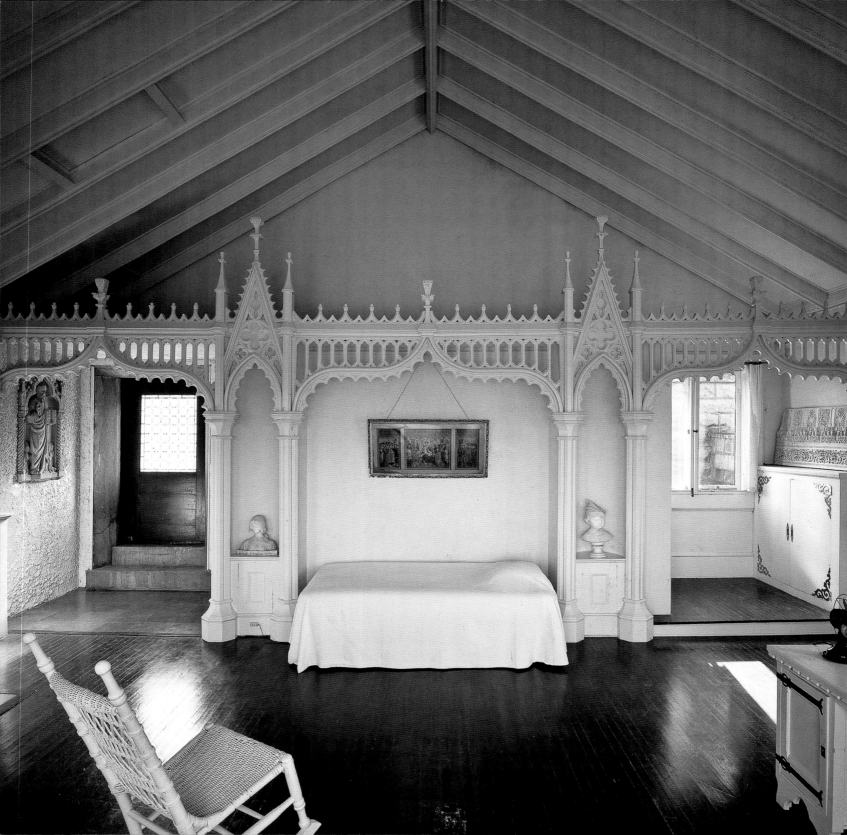

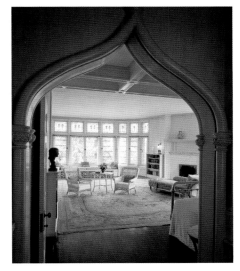

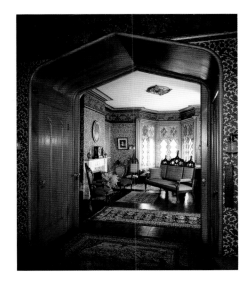

One result of the distillation of medieval Gothic forms during the English revival was a more powerful and primitive iteration of the style, which was a forerunner of the Arts and Crafts movement. In America, its leading proponent was Englishman Charles Eastlake, who released a history of the Gothic Revival in 1872 and whose *Hints on Household Taste in Furniture, Upholstery and Other Details*, published in 1868, was followed by five more editions before 1881. Consistent with the eclecticism of the late Victorian period and with the way the Gothic style had been mixed with the Oriental and others by Thomas Chippendale and other designers since the 1750s, Eastlake combined Gothic motifs with other decorative influences, including Moorish and Greek. Another designer who worked in

OPPOSITE: *Ornate tracery at Yaddo (c. 1844), in Saratoga Springs, New York, recalls the library at Strawberry Hill.* THIS PAGE: *Pointed arches add lyrical elegance to homes including Yaddo (center) and Roseland (right).*

a similar vein was William Morris. Morris's naturalistic, free-flowing designs are generally associated with the Arts and Crafts movement, but because their reference point is in the medieval period, they can be used very effectively in a Carpenter Gothic and more high-style Gothic Revival homes.

The hallmarks of the Gothic style in terms of interior architectural detail were, as Downing put it, the "prevalence of perpendicular lines, and the introduction in all important openings, of the pointed arch, together with the use of the bold

and deep mouldings that belong to its ornamental portions." Arches were a key feature: Downing's illustrations showed both the high, pointed arch of the "ecclesiastical Gothic" and the low, flat arch of the Tudor Gothic style; he advocated the latter combined with square-headed windows, which conveyed "domesticity."

Though many front facades of Carpenter Gothic cottages were irregular, floor plans were often symmetrical. As had been the custom in prior architectural styles, the staircase might ascend just inside the front door. In other plans, a commodious center hall was moved to the rear of the main section of the house, with a less elaborate staircase. It was not unusual to bracket a center hall with a

(continued on page 152)

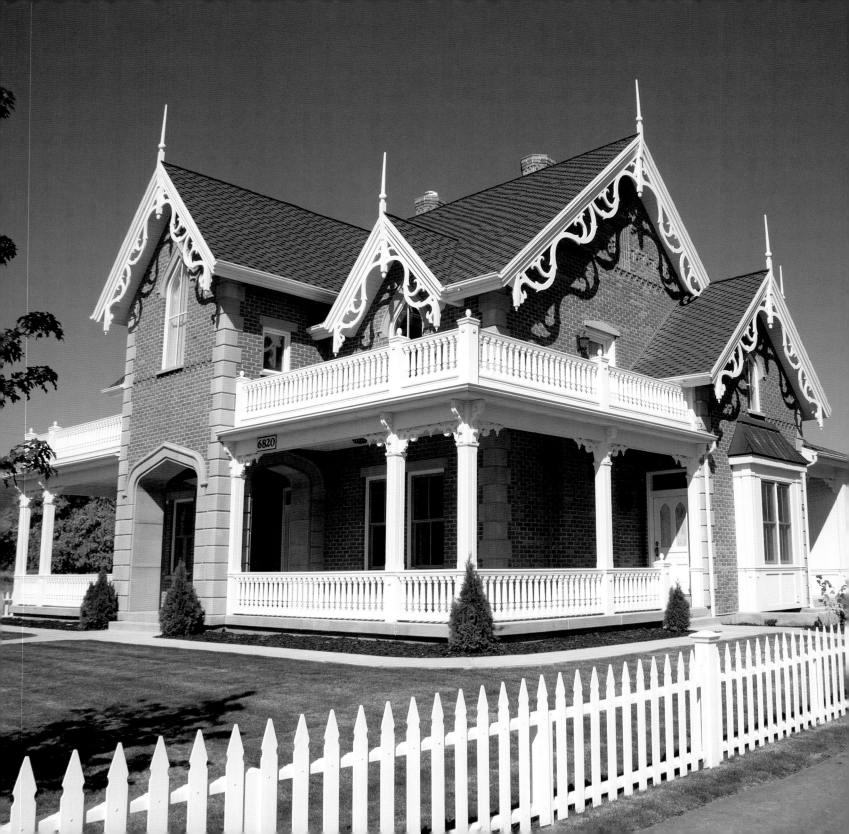

❧ Huntsville, Utah ❧

In any locale, predominant architectural styles correspond to periods of settlement, growth, and prosperity. So it is that in Utah, Carpenter Gothic dwellings proliferated during the nineteenth century. Wanting their home to fit in with the historic ones that surrounded it, a pioneering couple tapped an interior designer, who happens to be an old house aficionado, to work with their architect to create their brand-new house. Every inch of their home is composed of new materials fashioned to look old.

Historic sources inspired the exteriors and interiors. Exterior trim, interior moldings, mantels, paneling, pointed arches, newel posts, and balusters were all custom-crafted. A hammerbeam ceiling creates an overarching statement in one room, while tin ceilings and woodwork bear a quatrefoil motif, which is repeated throughout the house.

Traditional furnishings combine Gothic Revival pieces that make a visual impression with others that bespeak contemporary notions of comfort. With the past as its touchstone, this is decidedly a twenty-first-century home.

OPPOSITE AND THIS PAGE: *Inside and out, this brand-new Carpenter Gothic home, copied from historic sources, was designed to look like a period original.*

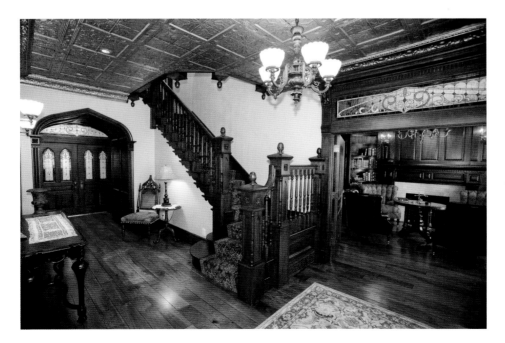

Custom millwork and details, modern systems and conveniences, and traditional furnishings create a comfortable twenty-first-century home.

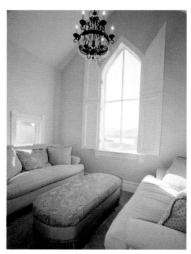

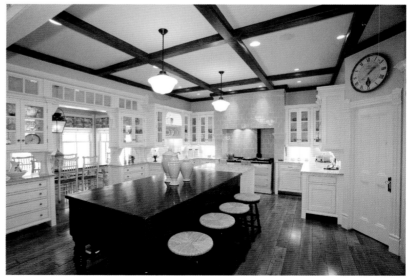

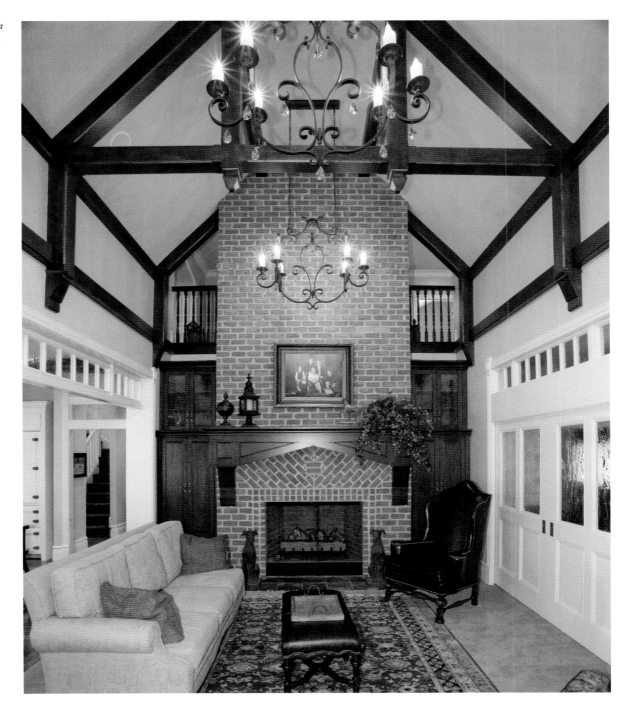

A soaring hammerbeam ceiling, associated with medieval and church construction, infuses the den with Gothic Revival character.

parlor, fronted by a porch on either side. Behind these two parlors there might be two more rooms. These could function as a bedroom and a family living room. The kitchen might be in one, or it might be contained in an ell that extended from the rear of the house.

Design number XXIX, a five-bedroom rural Gothic villa in *The Architecture of Country Houses*, consisted of two stories, with additional space for servants' quarters in the attic. Its projecting entrance was surmounted by a dominant gable; a smaller gable was placed in the facade to its left; drawing and dining rooms measured seventeen by twenty-seven and seventeen by twenty-two feet respectively; and a library was sixteen by twenty feet. The design incorporated a glass conservatory, a rear veranda, richly detailed and varied windows, and "ornamented gables and chimney-tops—all [indicating] the love of refined and artistic forms." Smaller cottages comprised fewer, smaller rooms, but maintained the air of refinement that Downing regarded as essential to the enjoyment of a country home. Even with principal rooms measuring a mere thirteen by sixteen feet, a small three-room Carpenter Gothic cottage derived a sense of spaciousness from windows that opened the interiors to light, air, and views; the flow of space between rooms; and the generous height of the

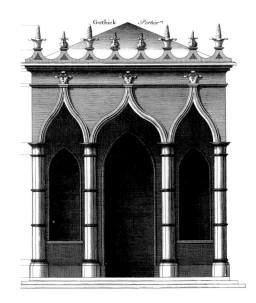

Pointed arches, shown here in Batty Langley's 1742 illustrations, found their way into Carpenter Gothic homes.

ceilings: ten feet on the first floor, and either eight and a half or nine feet on the second floor. Interior finishes and details, including varied woodwork and fenestration, were intended, he observed, to lend each room "a marked and characteristic air."

The hall, Downing wrote, "has a peculiar character of its own, being rather spacious, the roof or ceiling ribbed or groined, and the floor often inlaid with marble tiles." For one of his most expensive designs (XXX: "A Large Country House"), Downing called for a hall ceiling to be detailed with "heavy cross-beams and corbelled supports, and decorated with shields and other appropriate ornaments. . . ." Though as this and common sense suggest, ornamentation in the Carpenter Gothic cottage was much more "chaste," the sense of gracious living pervaded these designs.

For instance, the formal parlor was customary in all but the most modest homes. The parlor was distinct from the family living room in much the same way as today's family room and living room are distinctly different spaces with different functions. As Downing put it, "The American cottager is no peasant, but thinks, and thinks correctly, that as soon as he can afford it, he deserves a parlor, where he can receive his guests with propriety, as well as his wealthiest neighbor. We respect this

feeling entirely, and only object to the parlor when it is brought in, to the exclusion of any other apartment more necessary to the every-day comfort of the family." But, he points out, ". . . in most cheap cottages, the living-room is virtually the parlor. . . ."

Another downstairs room was the ladies' "boudoir"—not a bedroom but a room reserved for sewing, visits, and other women's activities. In design number XXIX in the *Architecture of Country Houses*, Downing showed a massive oak staircase, to one side of which was a ladies morning room, "fitted up in a delicate and tasteful manner, with chintz furniture, the wall papered with chaste Gothic or Elizabethan patterns, or ornamented with small and appropriate pictures or prints."

During this era, and in Downing's view, the library was one of the most important rooms of the house, signifying as it did learning and culture. In these rooms, Gothic-style bookcases were often detailed with columns and with glazed, pointed-arch panels on the doors.

The interior woodwork in the grandest homes during the Gothic Revival boasted oak, mahogany, or walnut linen-fold paneling, while the simpler Carpenter Gothic cottage had a modest pine wainscot that was stained, painted, or grained to resemble a more expensive wood. Trefoils and quatrefoils, ball-flowers, billets

DESIGN XIII.
A SMALL COTTAGE FOR A TOLL-GATE HOUSE.

Fig. 87.

Fig. 88.

DESIGN IV.
AN ORNAMENTAL FARM HOUSE.

Fig. 31.

PRINCIPAL FLOOR

PARLOUR
18 X 20

PANTRY

KITCHEN

WASH

FRONT

HALL

DAIRY

13
BED
18

13
BED
18

WOOD

Fig. 32.

and bird heads, chevrons, cat heads, cable moldings, twining vines, leafy bowers, and acorns were carved or pressed in wood or plaster. Some even boasted expensive veneered finishes in mahogany, rosewood, and walnut.

Moldings were to be "thick and massive and composed of many members, affording great variety and force of shadow. Trefoils and quatrefoils are the simplest forms of tracery for decorating all spaces formed by the intersection of right lines or angles; and 'roses,' 'Tudor flowers,' and a great variety of foliage and flower forms, richly and picturesquely treated, are among the predominant decorations of this style of architecture."

Within rooms, Downing stressed that the "best effect" was produced by "having the ceiling the lightest, the side walls a little darker, the wood-work a shade darker still, and the carpet darkest of all."

For flooring in entrance halls, popular choices included marble tiles in gray or black and white, a scheme that dated from the medieval period. These were laid in a diamond or square pattern: look at a painting by Vermeer as an example—this is what the floors look like in some of his works. Flooring tiles with fleur-de-lis or other designs were another option. Sometimes these patterns had a distinctly Moorish appearance.

THIS PAGE: *A view of the entry hall and a glimpse of the living room in the home in Huntsville, Utah.*

In "better cottages," Downing opined, floors were to be covered in carpet or (straw) matting; contrary to popular modern belief, wall-to-wall treatments had been de rigueur in American homes from the late Colonial period on. But in entry halls and living rooms (a term denoting family spaces rather than formal parlors), there was another option: staining alternate "narrow, matched floor-plank, of good quality" in dark tones to achieve a striped effect.

New floral carpet designs were another option. Large-scale arabesque and architectural designs were also popular. In this new era of mass production, machine-made, flat-woven carpets also came into vogue; popular types were Axminster, Wilton, and Brussels.

Prominent American designer Gervase Wheeler, who wrote the 1852 book *Rural Homes or Sketches of Houses Suited to American Country Life*, thought Gothic Revival floral designs were a ridiculous choice for carpeting, reminiscent as they were of crushing living plants by walking on them.

In England, John Loudon recommended that floors in entries and halls be grain painted to imitate oak. He recommended Scotch or Kidderminster carpets with patterns in a small scale, or, as a less costly alternative, green baize (or drugget), a felt, usually dark green, used as a removable carpet protector under dining tables since the previous century. He also recommended wall-to-wall carpets, tacked down so that the tacks could be easily removed, or, even better, a large area rug that revealed the floorboards along the room's perimeter and could be rotated to ensure that wear was evenly distributed. He also advocated the use of carpeting on the stairs.

Though Downing does not mention it, painted floors were another option. And in functional spaces, such as kitchens and hallways, painted floor cloths and oilcloth were used.

Fireplace mantels were often of heavy black or white marble with center medallions and prominent moldings, sometimes fashioned in a flat arch; mantel shelves were often supported by elaborate brackets and their edges finished with a bold molding. Cast-iron fittings in the Gothic style were placed into these and older fireplaces. If the mantel was of wood, it was supported by colonettes or bunched columns, embellished with tracery and pointed motifs.

(continued on page 160)

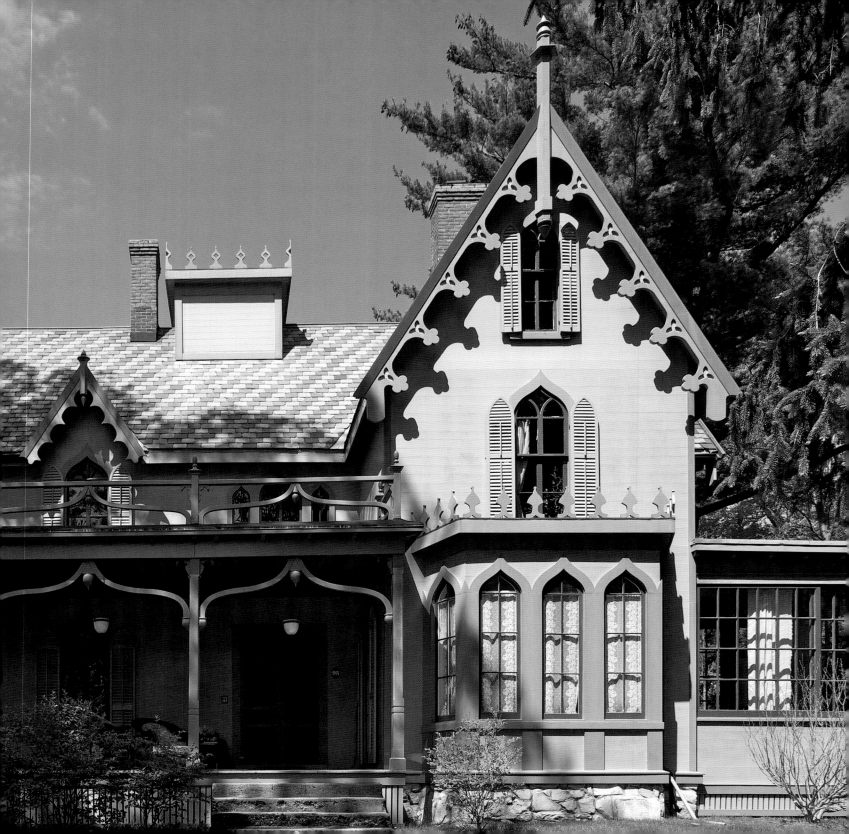

❧ Williamstown, Massachusetts ❧

This venerable residence, built in 1852 and known as the Chadbourne-Bascom house, lost much of its exterior and interior detailing when it was owned by the college that is steps away from it. Restorers relied on historic photographs to reproduce its paneled oak front door, louvered shutters, pointed-arch window surrounds, chimneys, ten-foot gable finials, and nearly three hundred separate pieces of mahogany exterior scrollwork trim.

OPPOSITE AND THIS PAGE: *Completely re-created from historic photographs, the trim and shutters of this stately Carpenter Gothic home were among the restoration challenges that returned it to its original glory.*

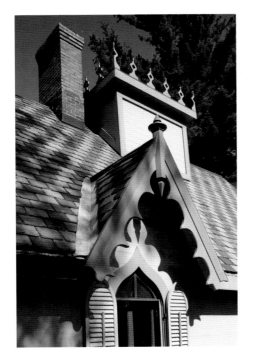

The homeowners, two art historians, one of whom is an expert on the medieval period, were inspired by paint colors, which they saw at poet Johann Wolfgang von Goethe's home in Weimar, Germany, and which extend the hues of the stained-glass windows into the house.

Arts and Crafts furnishings fit perfectly in their current setting—both the Gothic Revival style and the Arts and Crafts movement trace their roots and inspirations to designs and crafts guilds of the Middle Ages.

Arts and Crafts furniture, which also traces its stylistic roots to the Middle Ages, is a fine choice for this Gothic Revival home.

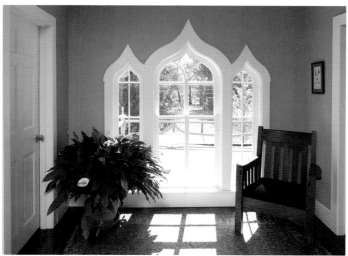

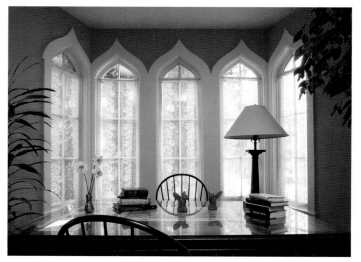

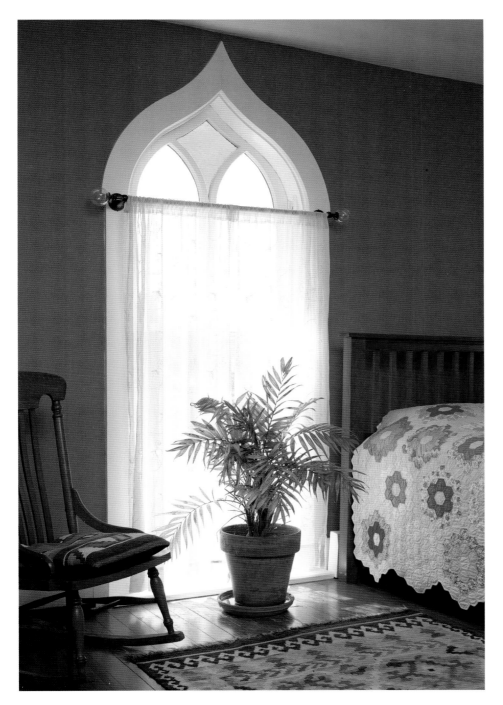

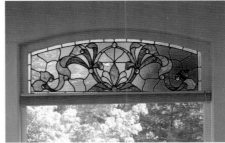

Pointed windows, Gothic fireplace surrounds, and stained glass are some of the defining features of this home.

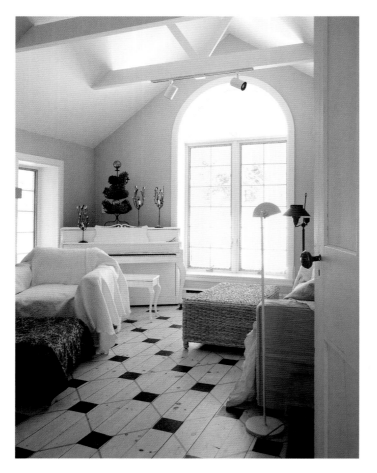

Typically, the parlor mantel was surmounted by a large mirror, the ornate gilt frame of which nearly spanned the breadth of the mantel shelf and nearly reached to the ceiling. These were a popular mid-nineteenth-century decorative device.

Interior walls, composed of smooth lime plaster over wooden lath, allowed a variety of decorative finishes: whitewash (either pure white or tinted), water-based

THIS PAGE: *Black and white checkered flooring is a time-honored treatment with a fresh attitude.* OPPOSITE: *Downing also thought well of the striped floor (top left).*

distemper paint, oil paint, or wallpaper. Prepared, canned oil paints were not commercially available until the 1860s, so the paints that would have been used for original Carpenter Gothic designs would

have been mixed by hand on site, using mineral or synthetic pigments, linseed oil, and white lead.

In parlors and other relatively grand rooms, walls were horizontally divided into three sections: a dado (wainscot), filling (wall area), and frieze (a strip of about one foot or more between the ceiling and the filling).

Downing maintained that color was essential to a successful room. He advised

choosing a principal, unifying color for the room. The hues for the two major planes—walls and carpets—should, he noted, "harmonize . . . if they do not agree in color, they should be selected as to contrast harmoniously." Strong, vivid, overpowering colors were to be avoided; pale and deep colors should be carefully deployed; and bright colors of equal strength—a "confusion of parts"—"should always be avoided." For instance, the pinks of the nineteenth century, whether evoking newly hybridized and immensely popular roses or the color naturally found in marble, were not today's bright, unalloyed bubble-gum hues: they were subdued by adding a drop of gray or black.

The appeal of the Gothic style, Downing said, was in its "homelike expression . . . in the hands of a person of taste. This arises, mainly, from the chaste and quiet colors of the dark wood-work, the grave, though rich, hue of the carpets, walls, etc., and the essentially fireside character [of the rooms]. . . ."

To finish plaster walls, he advocated whitewash, a mix of powdered lime (marble dust) and water, which could be renewed each year, "making everything 'sweet and clean.'" Another alternative, he noted, was to whitewash the ceiling and to create "a delicate neutral tint" for the walls by adding color to white wash or a distemper (water-based) paint. "The addition of

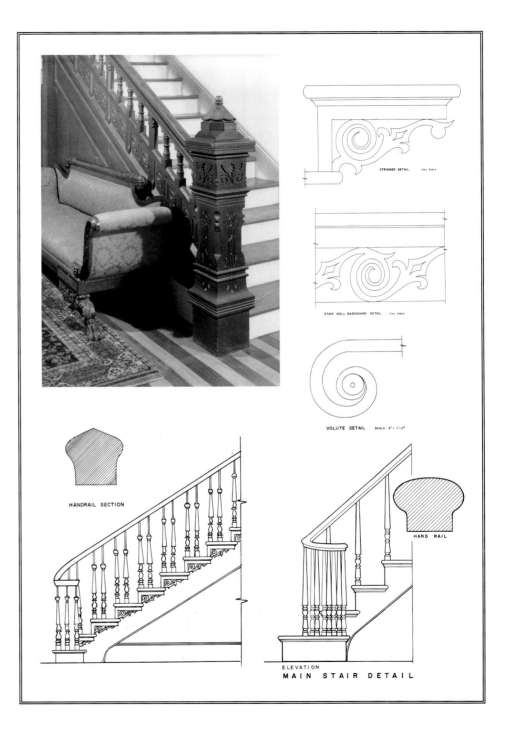

STRINGER DETAIL FULL SCALE

STAIR WELL BASEBOARD DETAIL FULL SCALE

VOLUTE DETAIL SCALE: 3" = 1'-0"

HANDRAIL SECTION

HAND RAIL

ELEVATION
MAIN STAIR DETAIL

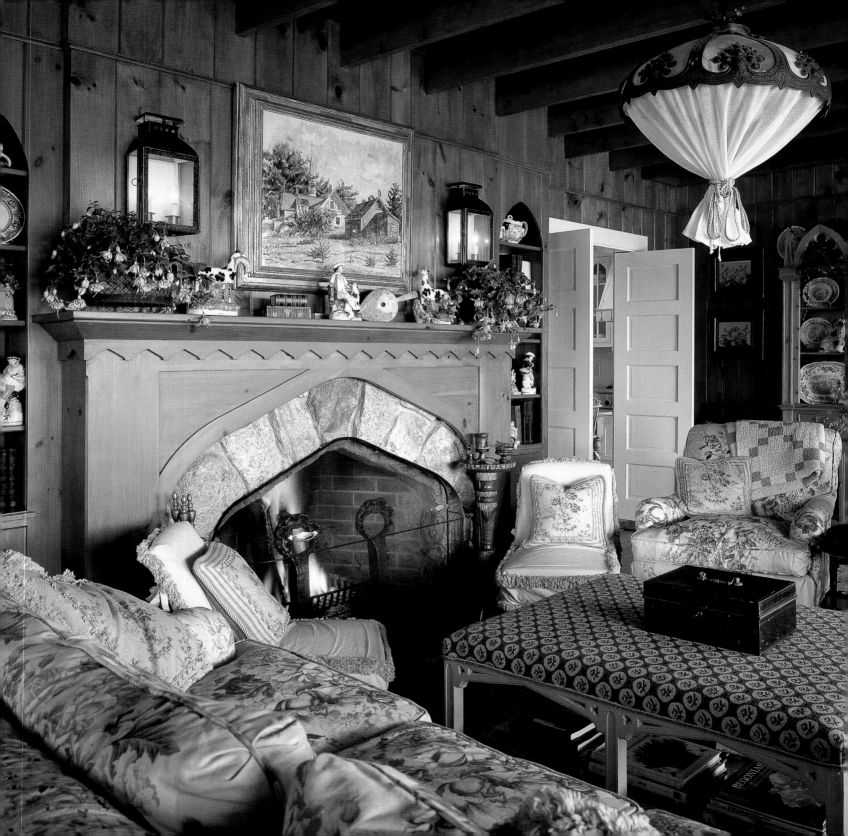

OPPOSITE: *At Rose Cliff, a coastal Maine home that was recently renovated and expanded, a classic Gothic Revival arch adds character to a fireplace.* THIS PAGE: *A sampler of Gothic Revival mantels and treatments.*

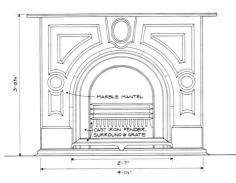

MARBLE MANTEL

CAST IRON FENDER, SURROUND & GRATE

3'-6¼"

2'-7"

4'-1½"

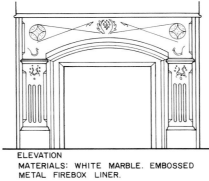

ELEVATION
MATERIALS: WHITE MARBLE. EMBOSSED
METAL FIREBOX LINER.

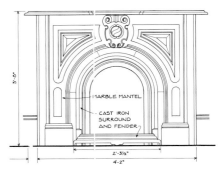

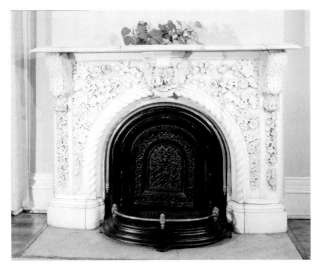

MARBLE MANTEL

CAST IRON SURROUND AND FENDER

5'-6"

2'-3½"

4'-2"

a little blue-black (or very finely powdered charcoal) . . . will produce gray," he noted, while raw umber would produce "a drab; or mix a little blue-black, Indian red, and yellow ochre and you have a fawn color." The first canned, premixed paints were not commercially available until the 1860s, and the range of choices was limited; achieving the right color was part of the skilled housepainter's art.

Entries and hallways, Downing maintained, should be floored in tile and painted in neutral tones of gray, stone, or drab, which would enhance "the richer and livelier hues" of the rooms to which they led.

The drawing room, or parlor, was to be "lighter, more cheerful, and gay than any other room." While ideal for townhouses, "in country houses, gilding should be very sparingly used—and very delicate tints, such as shades of rose, pearl-gray, pale apple-green etc.," were recommended for side walls "relieved by darker shades for contrast."

A dining room should be "simpler in decoration than the drawing room," but "rich and warm in its coloring, and more of contrast and stronger colors may be introduced here than in the drawing room." Wheeler advocated "fallen leaf," a brown or sage green for the dining room.

For the library, Wheeler preferred a rich deep blue, with a painted "diaper pattern," the period term for a small geometric print, such as a diamond motif, in a contrasting orange or red. Downing's choice for this room was "something grave in color. Some shade of fawn or neutral tint for the walls, the furniture of dark oak, or wood like the bookcases, and the carpet selected so as to accord with the severe and quiet tone of the walls and fur-

THIS PAGE:
The dining area of a Carpenter Gothic farmhouse reveals its post-and-beam construction (left), while a Newport Beach, California, home receives whimsical high-style treatment.
OPPOSITE:
Elegance and opulence are the hallmarks in the Lyndhurst dining room.

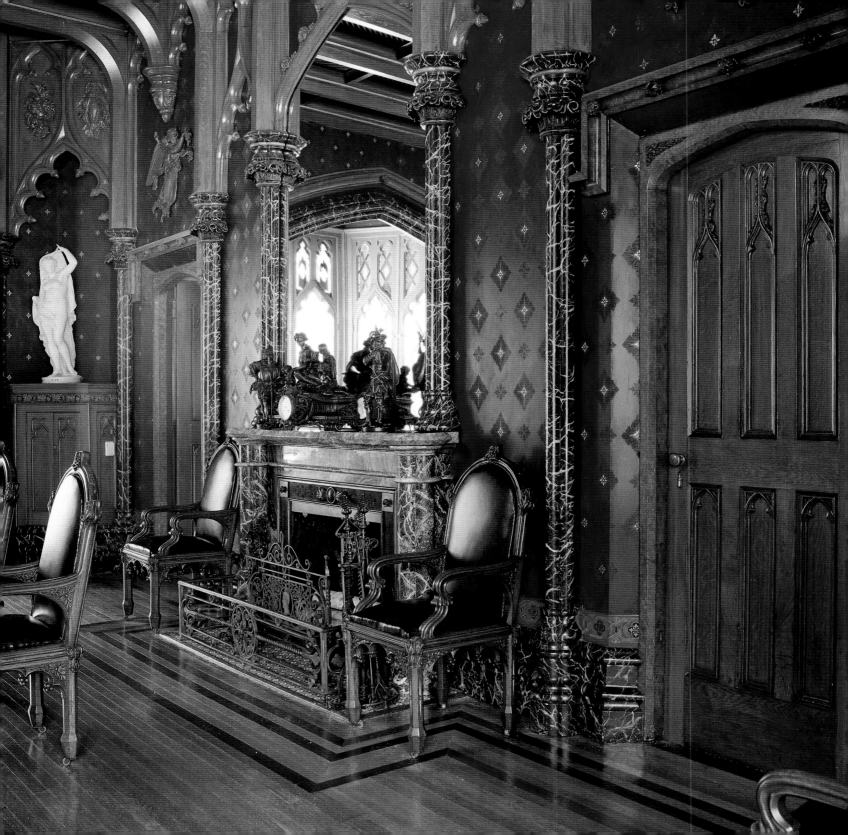

niture. Leather or morocco makes the best and most appropriate cover for the seats of chairs and other furniture."

The boudoir, or ladies' morning room, called for any color the lady of the house chose, "delicate and feminine in its general effect." Bedrooms were to be "light and cheerful" and finished with wallpaper.

While Wheeler favored woodwork that was paler than the wall color, Downing called for it to be painted "lighter or darker than the walls, and generally of a quiet, neutral tint, but never the same color and never white. . . ." In woodwork, as in wall color, Downing considered white too garish for an interior, except in the drawing rooms of formal townhouses where gilt embellishments sparkled in the evening (along with the ladies' diamonds) in the light of gas lamps.

Wainscot, he said, should be made of local woods, such as ash, birch, maple, oak, or black walnut, and varnished; or paint-grained to imitate maple, ash, birch, or oak; or, in the least costly approach, made of cheaper woods and stained to achieve a more expensive effect.

Flat ceilings could be finished with refined beams laid in parallelograms and

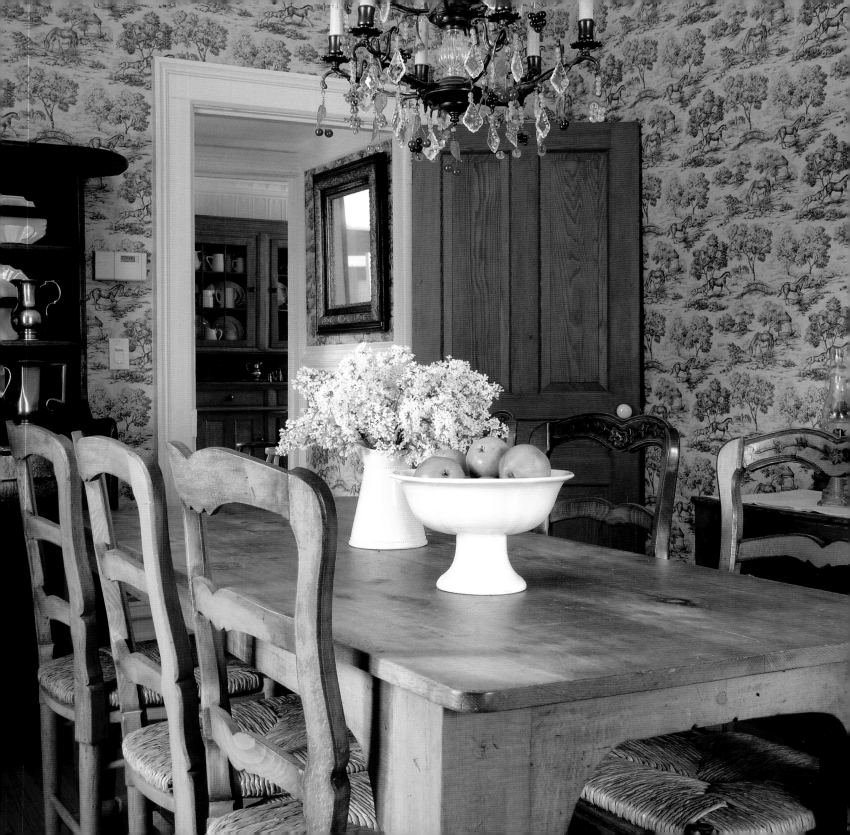

ending in brackets at the edges of the walls, while coved or angled ceilings could feature narrower ribs that extended to the upper edge of the wall. If beams were not of an expensive wood, they could be stained to look like oak, and plaster ceilings could be grain painted to look like oak, too.

Downing was a fan of grain painting—the popular nineteenth-century treatment on woodwork, as well as on furniture—because these surfaces could be easily cleaned with a damp cloth and because the effect compensated, in homes where budget was an issue, for sparse furnishings.

Another treatment for the walls, and the most popular, were wallpapers, or, as they were known in the nineteenth century, "paper hangings." One of the first Gothic Revival style books showing wallpapers was issued in 1742, by English architect Batty Langley, who, with his brother Thomas, was instrumental in popularizing these motifs. In the eighteenth century, floral and naturalistic leaf patterns, swirl and scroll designs adapted from Rococo styles, and beaded edges borrowed from the Neoclassical style, were all part of the Gothic mix. Thomas Chippendale pictured patterns combining the Gothic and Chinese elements in his 1754 book, *The Gentleman and Cabinet-Maker's Director.* By 1761, American wallpaper importers were advertising "stained paper for rooms,

OPPOSITE: *Bucolic toile, which traces its origins to the 1750s, is equally at home in an 1850s interior.* THIS PAGE: *Wainscot topped with a subtle, woodsy wallpaper captures the naturalistic bent of the Gothic Revival.*

in the Gothic and Chinese Taste" and "Gothic Paper Hangings." When Horace Walpole decorated Strawberry Hill, he chose plain papers in crimson and blue; in the hall, he used a Gothic design that replicated the chantry of Prince Arthur in Worcester Cathedral.

Eighty years later, England's leading proponent of the Gothic or "pointed style," architect and designer A. W. N. Pugin, lambasted those who made and

used florid, overly ornamental Gothic papers, calling them "wretched caricatures" because they violated his aesthetic principles, such as the purity of medieval design, the elimination of excessively opulent ornamentation, and the use of "honest materials." These ideas, which English theorist John Ruskin shared and promulgated after Pugin's death in 1852, were the origin of the Arts and Crafts movement of the early twentieth century.

By the 1830s, American manufactur-ers were producing wallpapers by the roll. Though roller printing yielded a product that was inferior to block printing, machine production made wallpaper widely available and affordable. Relatively inexpensive Gothic designs included borders and patterns featur-ing typical motifs of the style—abstract, arched, floral, and foliate designs, pointed arches, trefoils, quatrefoils, crockets, and even representations of rose windows. Ashlar pat-

THIS PAGE AND OPPOSITE: *Gothic Revival wallpapers from Historic New England's extensive database.*

terns imitated stone walls. Another option was to use deeply colored silk and damask textiles on the walls. Confronted with these choices and with new wealth to spend, it's probable that American taste would have offended Pugin's sensibilities.

Concurring with Pugin, Downing maintained, "good taste will lead us to reject all showy and striking patterns," and cautioned that "a good deal of taste is requisite in the choice of paper-hangings. . . . All flashy or gaudy patterns should be avoided, all imitations of church windows, magnificent carved woodwork, pinnacles, etc." Instead, he favored Rococo floral patterns or flocked papers that imitated woven silk or worsted fabric. He also

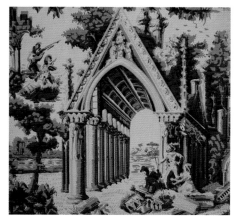

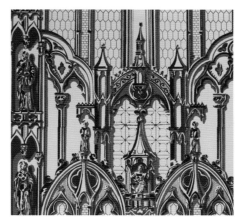

argued for Gothic papers that were "plain, with only panels and cornices printed on them—giving the room in which they are placed a simple and elegant effect." One exception, for the wainscot, was the use of papers that replicated oak grain painting.

For the small rural residence, Downing confessed "a strong partiality for the use of paper-hangings for covering the walls of all cottages," because of "the beauty of effect, and cheerful, cottage-like expression. . . ."

And, he noted, "Paper hangings are largely used for the walls in most of our country houses, and should always agree in general with the furniture in the [rooms]."

As a matter of cost, Downing asserted, "Paper-hangings offer so easy, economical, and agreeable a means of decorating or finishing the walls of an apartment, that we strongly recommend them for use in the majority of country houses of moderate cost." For economy's sake, Gothic borders

could also be paired with plain paper or painted walls.

Beyond this point, with respect to available designs, Downing was silent. He did not picture wallpapers in his books, and, unlike Loudon, with whom he exchanged ideas, he did not reject the use of realistic "picture papers" or advocate the "fanciful compositions of artificial forms and lines, or of plants and animals imagined in imitation of nature's general man-

THIS PAGE: *Carpenter Gothic windows, fitted with shutters or not, are as boldly beautiful inside as out.* OPPOSITE: *Casement window with tracery at Rose Cliff, in Maine.*

ner, but not copied from any of her specific objects," as Loudon did in *An Encyclopedia of Cottage, Farm and Villa Architecture and Furniture*, the first volume of which, *Cottage Furnishings*, was published in 1836.

In deploying papers throughout a home, Downing emphasized their use in drawing, living, and dining rooms, as well as the library and best bedrooms. An 1853 flier issued by one company promoted "Light and Bright" bedroom papers whose "white satin grounds, with figures in brilliant colors, taken from the flower garden, herbarium, &c.," lent bedroom chambers "a sprightly and cheerful look." Anticipating today's vinyl papers, Downing recommended coating wallpaper, after it was

hung, to create a washable surface. Inferior spaces, such as kitchens, corridors, other bedrooms, and servants' quarters, could be finished in whitewash or paint. Lincrusta papers, introduced in 1877 and featuring naturalistic, geometric, and Damask-like designs, may have been used in very late Gothic Revival interiors.

As for lighting fixtures, homeowners had a broad selection of types and styles to choose from, as technology improved and fashion advanced. In the late eighteenth century, Argand oil lamps were introduced; in the nineteenth century, as lighting technology advanced with new inventions and modifications, lamp types included astral (starlike), solar (sunlike), and sinumbra (shadowless). They were fueled by a relatively smokeless camphene-fluid that was contained in a ring-shaped tube within a glass globe. Much brighter than the old whale-oil lamps and candles, these lamps became a standard feature in the parlor, though candles, rush lamps, and grease lamps continued to be used. Kerosene lamps, promoted as being clean and bright, were introduced in 1850, and in 1859 this fuel was hailed as an "absolutely inexhaustible" resource.

Though neither Downing nor Wheeler dealt with light fixtures in their books, Loudon's *Encyclopedia* illustrated a ceiling fixture for the hallway, which was in the form of a hexagonal lantern with three gas outlets, enclosed by glass panels between ornamented columns, and topped with a crocket-decorated crown connected to the terminal by curved ribs. Gothic designs for ceiling and table lamps featured pointed arches, crockets, and trefoils. These accommodated oil, gas, candles, and kerosene. Gothic arches appeared on the cast bases of Argand mantel lamps and chandeliers, outfitted with bulbous cut-glass shades over a chimney and a prismatic array of crystal drops.

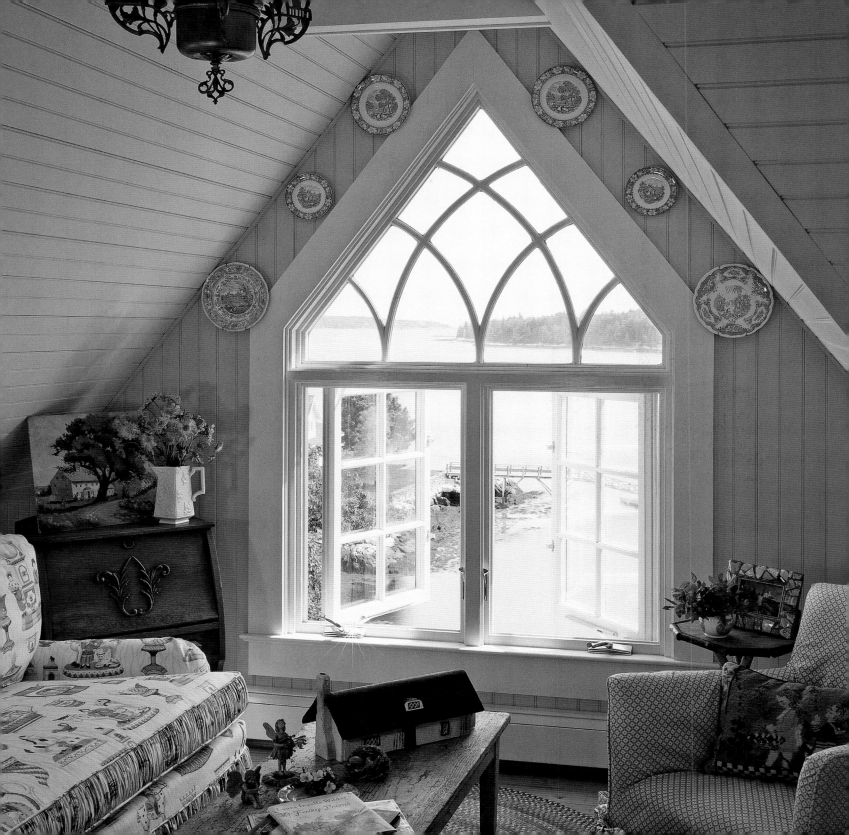

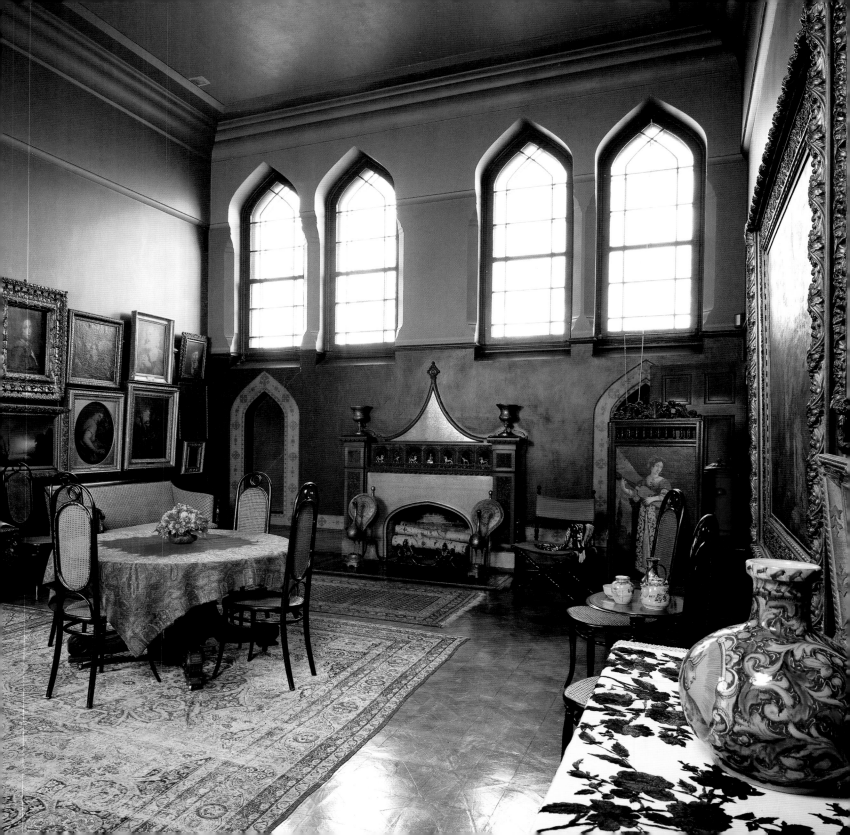

Not everyone liked this bright new world. "We are violently enamored of gas and of glass. The former is totally inadmissible within doors," complained Edgar Allan Poe—the author of the darkly Gothic poem, "The Raven"—in his 1840 book, *Philosophy of Furniture*. "Its harsh and unsteady light offends. . . . The huge and unmeaning chandeliers . . . which dangle in our most fashionable drawing rooms, may be the quintessence of all that is false in taste or preposterous in folly."

One by-product of all this brilliance was how it made diamonds sparkle, igniting a craze for diamonds among wealthy Victorian women.

Window treatments varied, depending upon the importance of the room and upon the type of window to be adorned. Stained-glass and diamond-paned windows were typically left undressed. Bay and oriel windows might likewise either be left unadorned or adorned with draperies, and they could contain conventional furnishings, such as chairs and a table, or window seats.

Treatments in other types of windows might consist of shutters affixed to the interior or exterior of the windows by the builder, roller-blinds of plain beige linen, or draperies, unneeded during the warm months but recommended from December to April when the weather, at least in

the Northeast, was cold, and leafless deciduous trees would not block the harsh glare of the low winter sun. Even when curtains were used, fabric was used frugally; it was generally not sufficient to allow deep folds when closed.

Downing called for curtains to be hung from a cornice with a Gothic molding that projected from the wall above the window. One illustration in the *Architecture of Country Houses* shows a window treatment consisting of a cornice, an inverted U-shaped (arched) valance of dark moreen (a cotton, wool, or wool-and-cotton fabric with a moiré or plain glossy finish) trimmed with a border, and floor-length draperies of a light-colored printed cotton swagged beneath it, on a pair of decorative glass or brass knobs mounted on the window frame. His illustration is virtually identical to one Loudon published in England.

Shaped, flat valances in the Gothic style might be backed with paper or buckram (a stiff linen or cotton fabric).

while heavier fabrics, particularly velvet and wool rep, were often used in dining rooms and libraries. In bedrooms, printed chintzes and lightweight, relatively sheer dotted swiss and lace panels were popular, though in more high-style homes, such as Lyndhurst, velvet bed hangings and window treatments were often fashioned en suite. Kitchen curtains first came into vogue in the mid-nineteenth century; these were often of dotted swiss, checkered dimity (a sheer, lightweight cotton fabric), or cotton muslin.

In keeping with the eclecticism of his day, because "Well-designed furniture in [the Gothic style] is rarely seen in this country," and because furniture could be "too elaborately Gothic" for a simple country home, Downing recommended including Elizabethan, Renaissance,

Other acceptable styles included a French drapery consisting of multiple folds and swags; draperies hung from exposed poles with wooden or brass rings; and draperies suspended from a rod concealed behind a cornice via small rings sewn onto the back of their top hems.

For curtain fabric, Downing liked chintz, printed cottons with separate borders sewn on, or durable, monochromatic moreen in brown, drab, crimson, or blue. Though he does not discuss them, tassels, fringe, braid, and cord were used

for tie-backs and edging for draperies of plain damask, velvet, wool rep, silk, and moreen. Often these were layered color upon color, with an under layer of sheer muslin. In 1849, the newly invented machine-made lace curtain added another option. Another new fabric in this era was light, twilled wool challis; featuring colorful floral patterns, it was used for windows and for upholstery.

The most elaborate window treatments were used in the drawing room or parlor, even in the simple cottage,

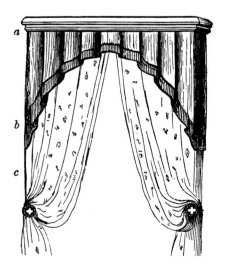

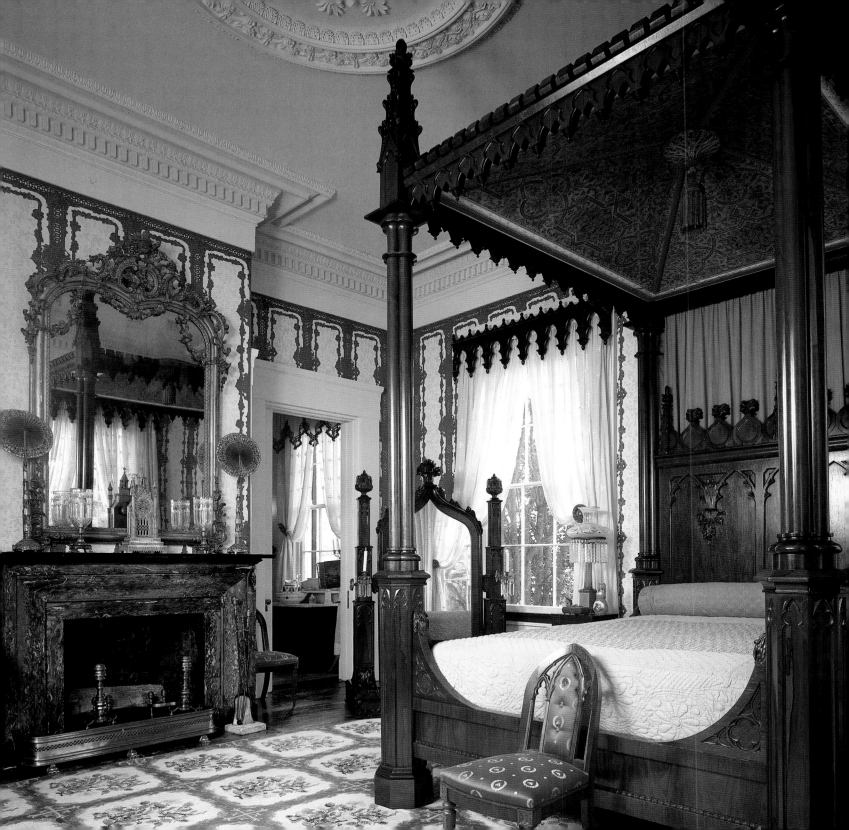

Rococo, and Empire furniture in a Gothic interior. In fact, it's unlikely that many homes were decorated sills-to-eaves in the Gothic style. Instead, homeowners might have created a single Gothic room in a home where different rooms displayed different styles. Or they may have mixed pieces of varied styles in a single room, in which case pedestal tables, cast-iron bedsteads with foliate and arched designs, wooden sleigh beds, upholstered ottomans and couches, whatnots, armoires, varied tables and chairs, daybeds, and newly devised sofa beds were all options. As a practical matter, rural residences were often where homeowners placed furniture of varied contemporaneous styles, along with dated pieces that were no longer fashionable. One piece that was recommended, and that was found in most homes—even those of modest means—was the piano, a mark of refinement and a welcome evening entertainment in this pre-television era.

Whatever decorative style one chose, Downing emphasized that discerning taste was more important than transitory fashion: ". . . furniture remarkable for agreeable and harmonious lines and forms . . . never loses its power of pleasing, but only grows dearer to us by age and association." Arguing for appropriateness, comfort, convenience, simple beauty, and good taste in furniture, as he did in architecture and decoration, he said, "We are thus made to feel that the furniture belongs in a certain house or room, or for one in the same architectural style or character. . . ."

During the English revival, Loudon's *Encyclopedia* recommended the use of Gothic furniture in buildings whose architectural designs were Gothic Revival, but noted that such furniture was expensive. In their *Encyclopedia of Domestic Economy,* another popular nineteenth-century primer, Thomas Webster and Frances Parkes agreed about the cost, criticized imitations of medieval furniture as "miserable," and wrote, "We omit chairs in the Gothic style, as they are never used, except the house itself be in the same style; and we may observe that this style is, in general, very ill adapted for domestic furniture. . . ."

Though Americans drew on English sources prior to and after its publication, the first book in America to focus on Gothic furniture was the *Cabinet Maker's Assistant,* authored by English-born cabinet-maker Robert Conner and published in New York in 1842.

Even in their heyday, most Carpenter Gothic cottages did not feature Gothic furniture en suite. It was common to incorporate Rococo Revival, Empire, and other styles. In fact, Downing, in the *Architecture of Country Houses,* advised against decorating exclusively with furniture in this style, noting "it is too elaborately Gothic—with the same high-pointed arches, crockets, and carving usually seen in the front of some cathedral." In a hallway, or used selectively, Gothic pieces could—and do—have a strong decorative presence. Because of their severe lines and heavily carved backs Gothic chairs tended to be a bit uncomfortable, so their best use might have been as a temporary perch. Ever pragmatic, Downing wrote, "A Gothic character may easily be given to plain chamber furniture by any joiner or cabinet-maker who has tools to make the necessary mouldings."

For more expensive homes, he did recommend Gothic furniture made in New York City by Alexander Roux and by Burns and Tranque. Alexander Jackson Davis also created furniture. For Knoll, in Tarrytown, Davis designed about fifty pieces of furniture, some of which were inspired by Gothic window and tracery designs. With caned seats, a "wheel-back" oak drawing room chair was composed of a round back with a design derived from a medieval rose window, while a hall chair featured a back with a triple lancet design decorated with tracery. Later, when the house was enlarged, made more grand, and renamed Lyndhurst, Davis created pieces that were simpler and weightier, but still incorporated tracery, crockets, and cusping.

Gothic Revival bookcases, cabinets, and chairs display the fine detailing and ornate decoration for which this style is known.

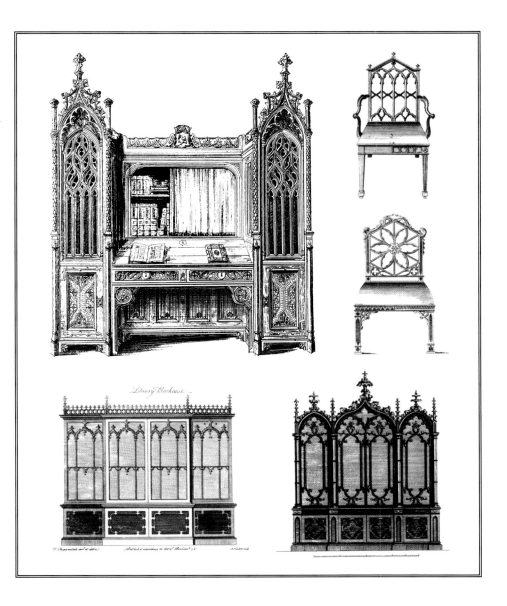

These were by no means the only designers of Gothic furnishings. At Roseland Cottage, for the twin parlors, architect Joseph C. Wells designed matching chairs and a settee to mimic the dwelling's exterior trim; this furniture was made by Thomas Brooks of Brooklyn, New York, who also made pieces for the Bowens' home in Brooklyn Heights.

A factor that Davis and other designers of Gothic Revival seating might not have considered and that the English writers did not mention—but which was important to Downing—was comfort. Expressing an opinion that would continue to influence decorative choices into the twenty-first century, Downing said that furniture in country houses "should be country-like, [uniting] taste, comfort, and durability in the greatest degree. It should be in correct taste, so as to harmonize with the house in which it is placed; it should be convenient and comfortable in the highest degree; and it should be substantially made, so as to unite durability with the capacity of being used without the fear of being spoiled by fulfilling its true purpose." The country gentleman "prefers a comfortable couch or easy-chair covered with substantial stuffs, and not so fine or so frail as to forbid his enjoying it remorselessly at all times. . . ."

Downing depicted Gothic Revival designs for a hall seat, a hat-and-cloak stand, cottage chairs, dressers and bed-steads, bookcases, hanging shelves, formal drawing-room and library chairs, an ornate bedstead with spires, trefoils, and finials, a pedestal dining table, and an elaborate sideboard. He illustrated some upholstered

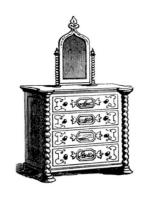
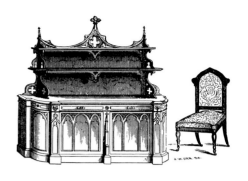

pieces, which, thanks to factory production, became more widely available in this era. Adding a new note of luxury, even to the rural Carpenter Gothic cottage, these featured spring seats and myriad loose cushions. Coverings included horsehair, moreen, wool damask, needlework-embroidered textiles, and even silk for parlor furniture.

For summer furnishings and outdoor use, Gervase Wheeler recommended inexpensive, lightweight, and sturdy rattan—wicker—furniture made in New York City at the House of Refuge, which employed some four hundred boys to make cane seats, or in the suburbs by German entrepreneurs who employed some two thousand girls. Wheeler also favored cast-iron pieces for

High style or low, furniture makers supplied pieces to suit the Gothic taste.

hallway umbrella stands and for bedsteads, insisting that they always be painted black.

Above all, "As regards the furniture of cottages," Downing wrote, "it can scarcely be too simple, too chaste, too [unpretentious]." Consistent with his ideas about what was appropriate, Downing made the distinction that highly carved, ornate Gothic pieces and relatively heavy, decorated Elizabethan pieces were more at home in the urban townhouse or the large country villa than in a simple Carpenter Gothic cottage. Today, however, some of

these pieces—Gothic library cabinets or bookcases, for instance—can be used to make a powerful decorative statement in a rural residence.

The rural parlor, he said, should contain a round pedestal table at its center, small tea tables, upholstered chairs, a whatnot, a sofa and perhaps an ottoman, a ladies' worktable fitted with a silk bag beneath, a portable basket stand, a writing desk, and hanging shelves for books. In the bedroom, elaborate Gothic furniture was rare, he noted. As alternatives, he suggested furniture in the Empire and Elizabethan styles. He applauded the new makers of painted cottage furniture "of pretty forms and at moderate prices."

Though most families of modest means did not own fine art, Downing argued for lithographs or engravings and plaster bas-reliefs of up to two feet in diameter to be hung on the walls. Popular engravings included depictions of romantic medieval ruins, such as England's Tintern Abbey. Americans were also fond of portraits and of landscape and bucolic genre scenes. Pictures might have been hung by a long wire hooked into a picture molding, blind hung from behind, or hung with cords or tassels from a nail.

Loudon suggested that homeowners with numerous works of art place these in a gallery, and unlike Downing, the Englishman didn't stop there. He encouraged cottage owners to collect "other ornaments of smaller description than busts and sculpture, such as curious stones, spars, ores, or other minerals, or coins and objects of art and antiquity." Paralleling the increase in factory production, he noted, in 1842, "The public taste for these articles of this description has improved in an astonishing degree within the last twenty years."

Wheeler's list of desirable decorative accoutrements was longer still. The hall, he said, should contain "a cabinet of dried grasses or other little museum curiosities," along with brackets to display flower vases, a barometer, and a thermometer.

Decorative vignettes recall the Victorians' love of collections, natural curiosities, and books; the raven recalls Edgar Allan Poe's Gothic tale.

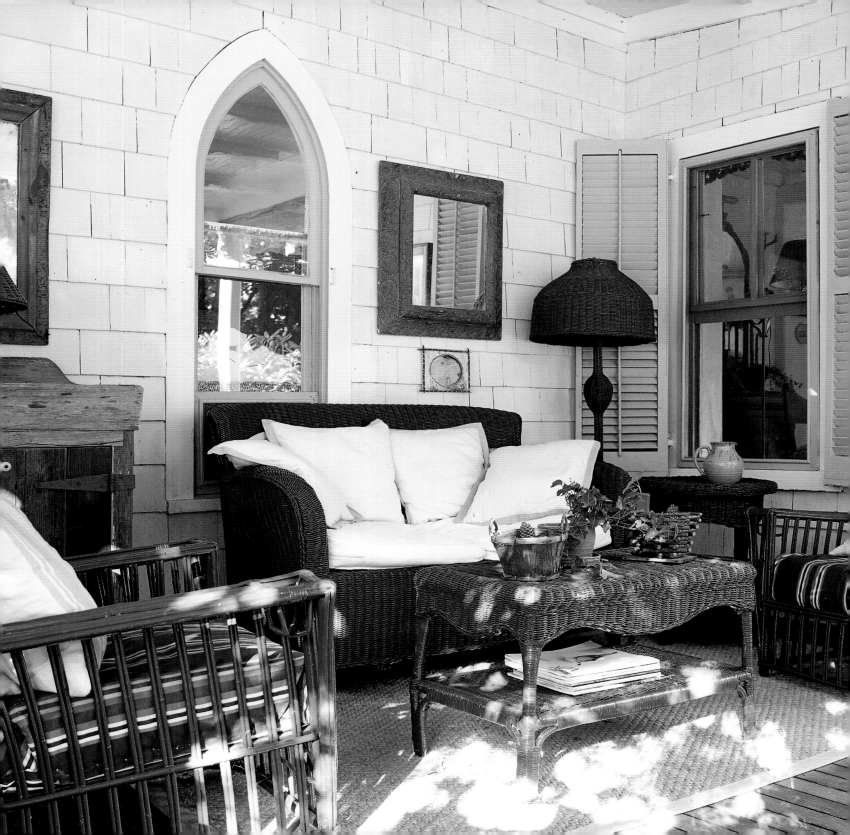

OPPOSITE: *A companionable grouping of vintage wicker creates a place to relax on a Carpenter Gothic side porch.* THIS PAGE: *Gothic treatments decorate a wall outside a mudroom in a country farmhouse.*

The drawing room would not be complete without hanging baskets of flowers and a statue, perhaps, of a little "Fisher Boy," that was "truthfully suggestive of a quiet home life." He suggested Wedgwood vases shaped like flowers, dishes of fruit, items displayed beneath bell jars, and small collections of china. And, for the library, "the magnetic gathering place," he advised conversation pieces: "a thousand tasteful trifles—relics, specimens, objects of art, curiosities, suggestive nothings—which serve to make talk independent of politics, dress, fashion, and scandal."

Upon the newly fashionable étagère, upon mantelpieces, upon myriad hanging shelves were grouped the decorative output of a hundred factories: Dresden and Meissen figurines, Staffordshire cottages, and plaster statuettes. Portfolios of prints were displayed on easels. And by 1860, Gothic motifs appeared on innumerable objects, from cast-iron coal grates to cast-glass pickle bottles, vases, and celery dishes and prie-dieux benches for kneeling.

By the 1830s, kitchens in well-to-do homes were full of new, factory-made

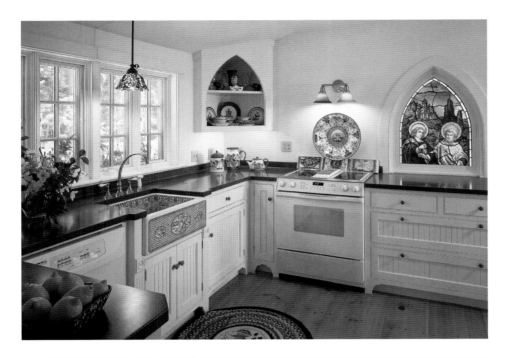

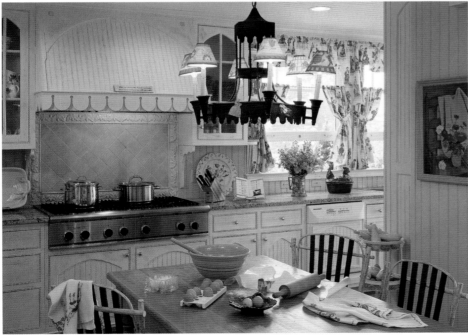

conveniences unknown in the prior century. The iron stove, or range, fueled by wood or coal, was a new option for cooking; it also provided heat. Chest and upright models of the ice box, made of wood with interior insulated walls, were common; these could contain about a hundred pounds of ice harvested from frozen lakes in winter, warehoused and delivered throughout the year to the homeowner's door. Indoor pumps or spigots supplied water to kitchen sinks, which were made of cast iron, soapstone, rough granite, or even wood. Tables for food preparation and eating, hanging and integral shelves, a settee that converted to an ironing board or to a cot for a servant, a tin safe, and a clock were all signs of domestic efficiency. Underfoot, oilcloths and linoleum flooring, composed of fabric soaked in linseed oil and allowed to dry in the sun, which was patented in the early 1860s, provided a surface that was easy to clean. Next to the kitchen, a pantry afforded additional storage for crockery, dishes, and cooking supplies.

Modern conveniences—advances in lighting, cast-iron fireplace grilles, coal stoves,

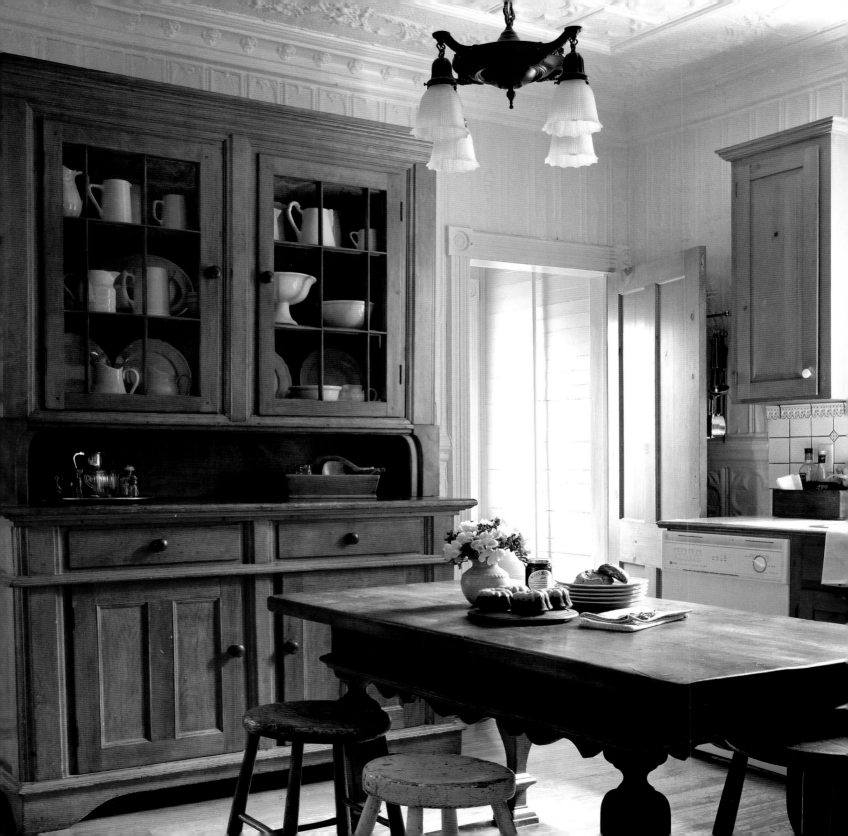

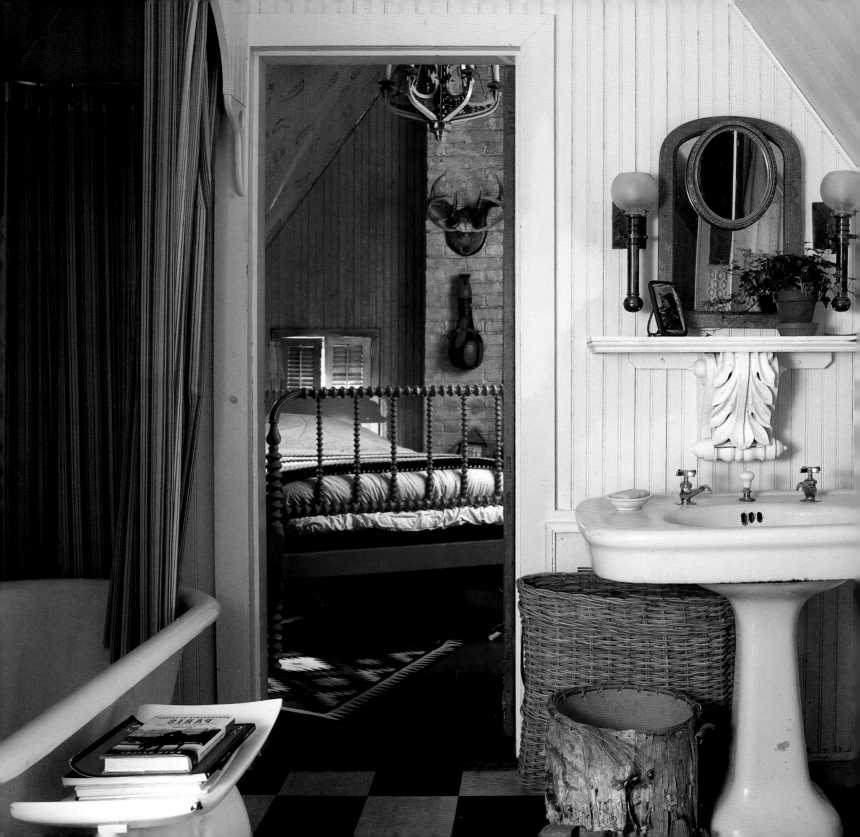

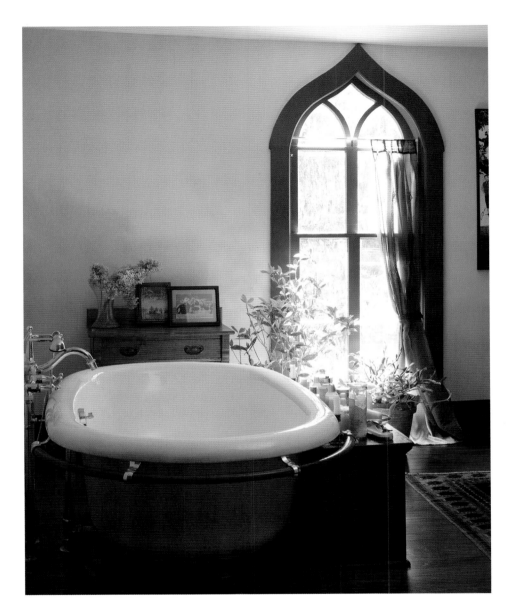

and central heating—ushered in a new era of comfort in rural Gothic residences, as dumb waiters on pulley systems could carry food and dirty dishes from floor to floor.

Though indoor plumbing was introduced in the 1830s, it was only available to the wealthy. In *Country Houses,* Downing showed bathrooms—"water closets"—in several designs, ranging from that on the second floor of a grand country villa costing between six and fourteen thousand dollars to that in the basement of a cottage costing a modest three thousand dollars, where it conferred "a villa-like completeness" upon the little dwelling. Toilets were imported during this period—successful American manufacture of the toilet began in 1873, thanks to Thomas Maddock of New Jersey.

Today, historic treatments are only one decorative option in the Carpenter Gothic home. Rather than adhering to a strict period interpretation with floor-to-ceiling Gothic style in carpet, wallpaper, window treatments, and furnishings, most homeowners are more attuned to the eclectic impulses of the Victorian era. A Carpenter Gothic home in the twenty-first century might incorporate one or two stunning Gothic pieces in an otherwise neutral setting, shabby-chic style with a more rural Gothic sensibility, Mission-style furnishings, or a more eclectic and colorful mix. Whatever its specific furnishings, the interior can combine the lighthearted spirit of the cottage, creature comforts, and personal style and taste.

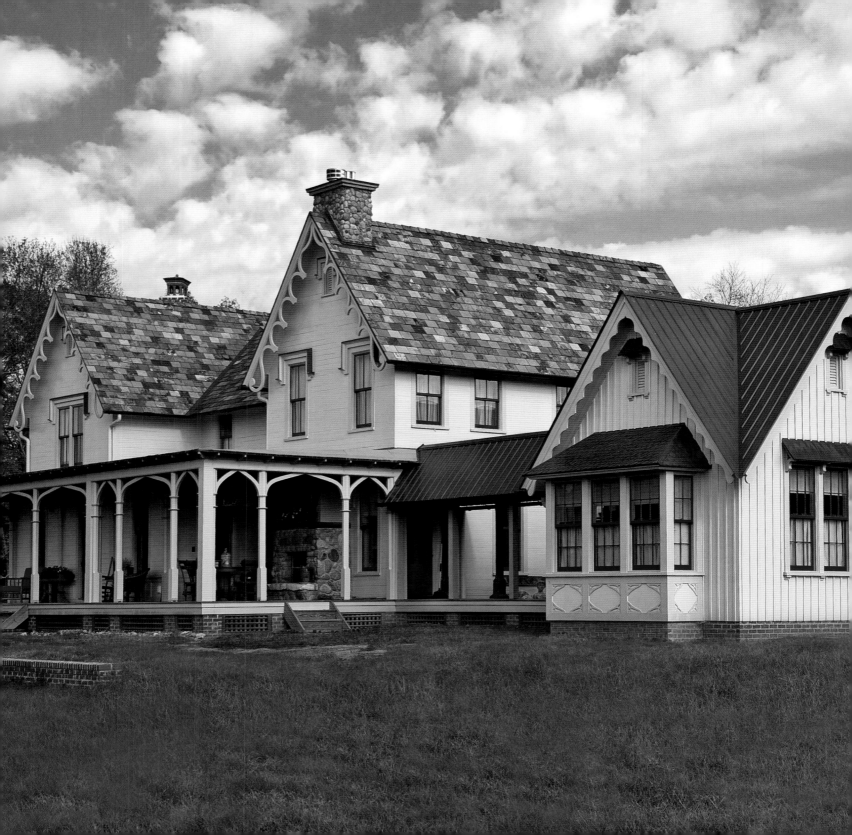

❧ Chapel Hill, North Carolina ❧

Based upon an Andrew Jackson Downing design (see page 104) from *The Architecture of Country Houses*, this new architect-designed home is adapted for modern living. Scrollwork trim, roof brackets, bay windows, pointed arches, a raised-seam metal roof, and porches, one of which has an outdoor fireplace, fit the home's country setting and enhance its rural character.

Inside, the Gothic style receives a new spin, thanks to an international bazaar of salvaged materials that are artfully combined with an eclectic mix of furnishings and decorative accessories.

OPPOSITE AND THIS PAGE: *Porches are a key feature in this new farmhouse, based upon a design by Andrew Jackson Downing.*

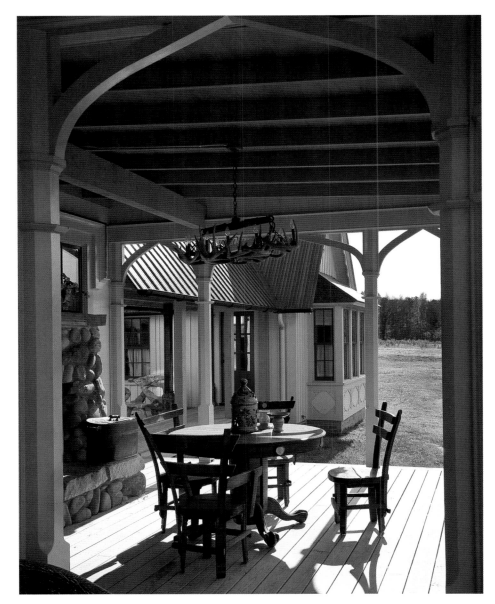

CLOCKWISE FROM TOP LEFT: *In a bedroom, hall, bath, and foyer, homeowners bring a fresh, international point of view to this Carpenter Gothic home.* OPPOSITE: *The living room.*

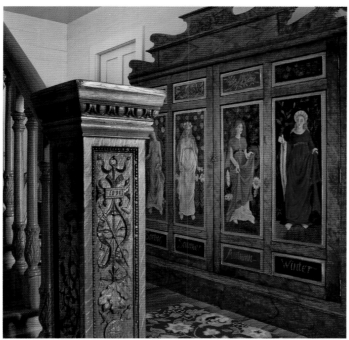

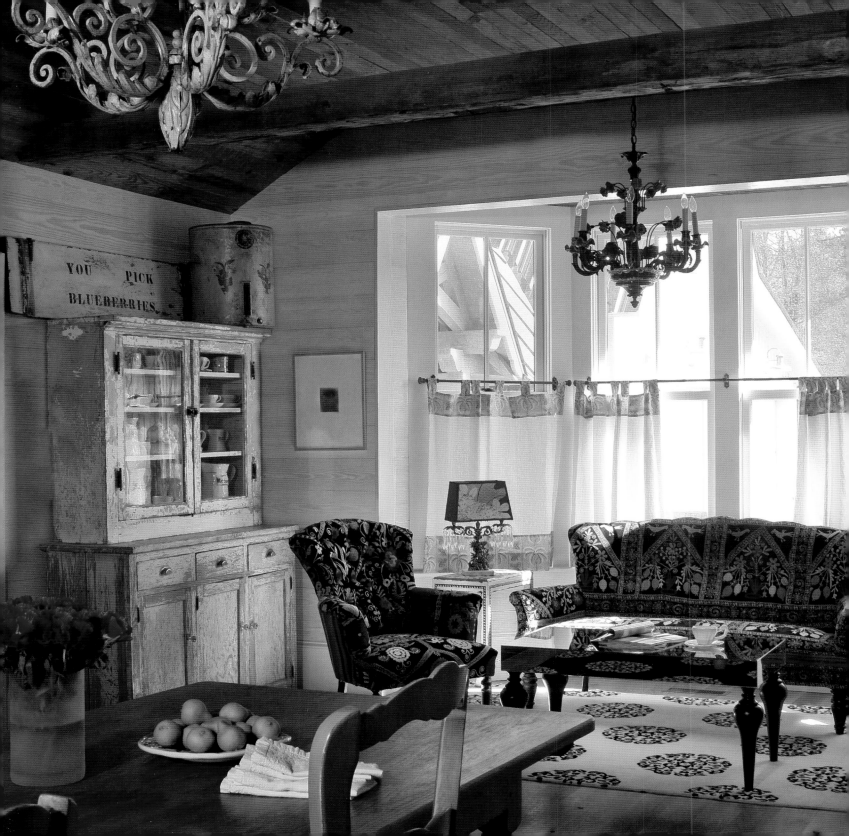

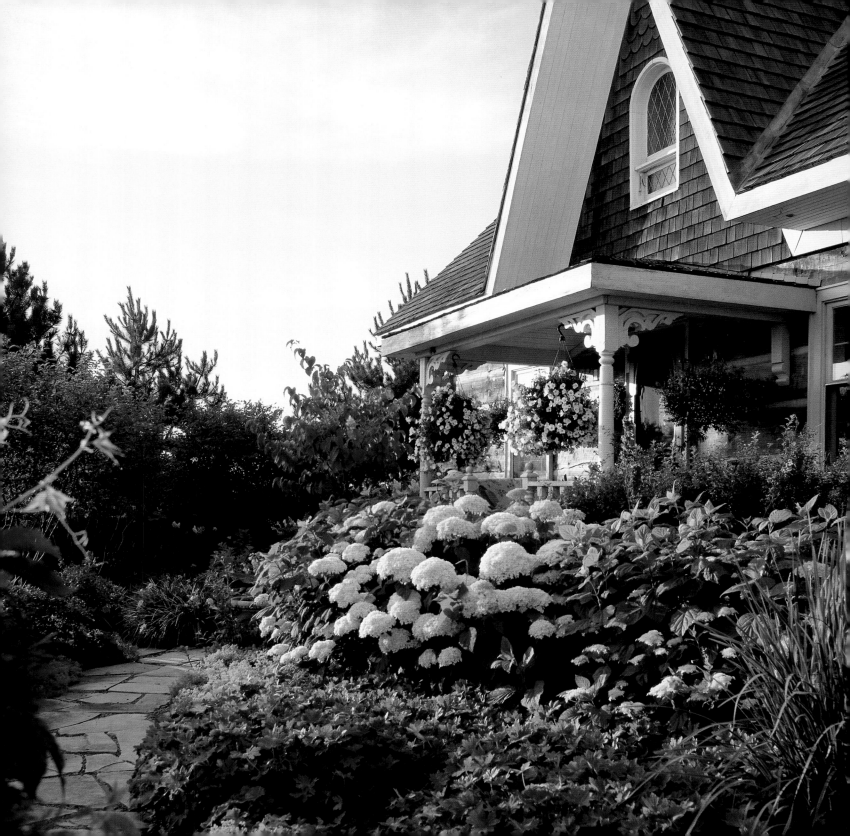

❧ Grand Valley, Ontario ❧

When a floral designer takes up residence in a rural Carpenter Gothic home, roses bloom inside and out, a fitting throwback to the origins of the style, when the vine-covered porch was de rigueur and the newly hybridized varieties of roses were all the rage. Though log construction in this style was rare, some historic examples were built in Canada and the United States.

Of more recent vintage, this small, accommodating house was constructed by the owners, a husband and wife who incorporated salvaged building materials. These include a screen door, wainscoting, windows, reclaimed bricks, and even an entire front porch.

Surrounded by gardens and cohabited by a beloved collie, the house takes its decorative cues from the way its homeowner likes to live, as a creative person who, in summer, spends as much time in the garden as possible. Even in winter, as friends and family gather around the fireplace, interiors blossom with hothouse roses, narcissus, and greenery.

Historical log construction was often concealed by exterior siding and interior plaster, but in this home's interiors, it is revealed, adding extra dimension, rustic texture, and warmth. Relaxed farmhouse decor combines antique pieces, none of which is so precious it can't be used. Comfortable upholstered furniture with light, bright white slipcovers harmonize with the white woodwork and chinking between the logs.

OPPOSITE AND THIS PAGE: *Log construction and salvaged architectural elements combine in a new Carpenter Gothic home.*

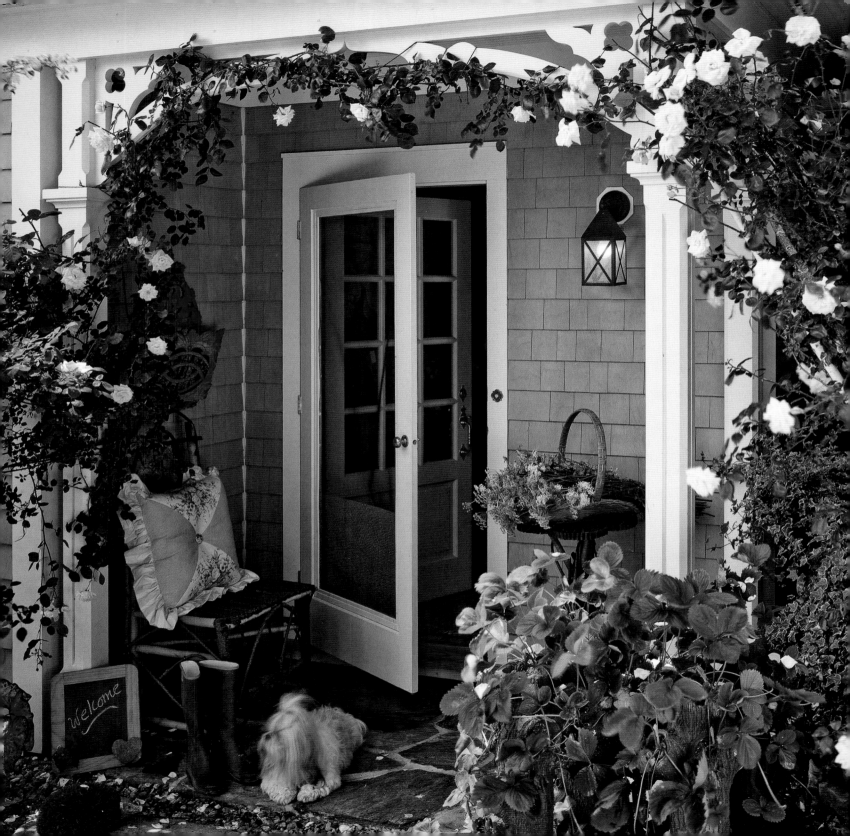

Chapter
Seven

The House
in Its Grounds

THE CARPENTER GOTHIC GARDEN

The principles of landscape gardening, like those of every other art, are founded on the end in view.

—John Claudius Loudon, *Encyclopedia of Cottage, Farm, and Villa Architecture*, 1833

A collection of pictures . . . is comparatively shut up from the world, in the private gallery. But the sylvan and floral collections—the groves and gardens which surround the country residence of a man of taste—are confined by no barriers narrower than the blue heaven above and around them. The taste and treasures, gradually, but certainly, creep beyond the nominal boundaries of the estate, and re-appear in the pot of flowers in the window, or the luxuriant, blossoming vines which clamber over the porch of the humblest cottage by the wayside.

—Andrew Jackson Downing, *The Theory and Practice of Landscape Gardening*, 1841

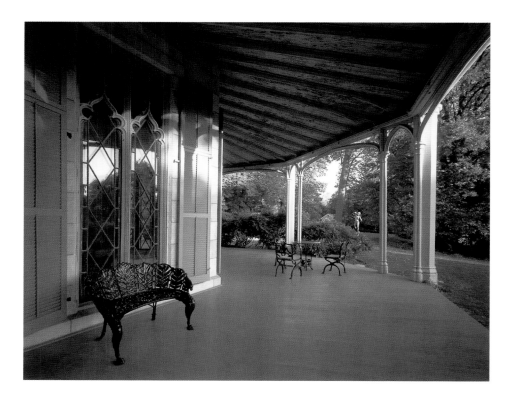

The landscape surrounding a rural Gothic cottage or villa was intended to be composed as one would compose a painting. This idea arose in England, where, in the eighteenth century, during the Regency period, Lancelot "Capability" Brown, followed by Humphrey Repton, and later by John Loudon, developed for the landed gentry on the great Georgian country estates, a style that modified nature, rendering it more harmonious and more beautiful, creating what they called "a fine prospect" when viewed from the house. These three men transformed hundreds of

properties, and among the garden structures they deployed were pavilions in the Gothic style, because they were so highly picturesque.

In 1751, Gothic Revival style-setter Horace Walpole said of the grounds at Warwick Castle, "The castle is enchanting; the view pleased me more than I can express, the river Avon tumbles down a cascade at the foot of it. It is well laid out by one [Capability] Brown who has set up on a few ideas of [architect William] Kent and Mr. [Philip] Southcote," who was known for the "decorative farm," or *ferme*

ornée he had established at Woburn Farm, in Surrey. In his 1785 *Essay On Modern Gardening*, Walpole enumerated three types of naturalistic gardens: "the garden that connects itself with a park, . . . the ornamented farm, and . . . the forest or savage garden." These concepts were later echoed by America's first professional landscape designer, Andrew Jackson Downing, who described two types of grounds: the beautiful and the picturesque.

"The perfection of landscape gardening consists in the four following requisites," Repton wrote in his 1803 *Observations on the Theory and Practice of Landscape Gardening* (a title that Downing later almost exactly reprised in America): "First, it must display the natural beauties and hide the defects of every situation. Secondly, it should give the appearance of extent and freedom by carefully disguising or hiding the boundary. Thirdly, it must studiously conceal every interference of art, however expensive, by which the natural scenery is improved, making the whole appear the production of nature only; and fourthly, all objects of mere convenience or comfort, if incapable of being

PREVIOUS: *Climbing roses entwine a porch.* THIS PAGE: *The veranda at Lyndhurst, designed by Alexander Jackson Davis, affords a place to take the air, stroll, and enjoy a fine prospect overlooking the Hudson River.*

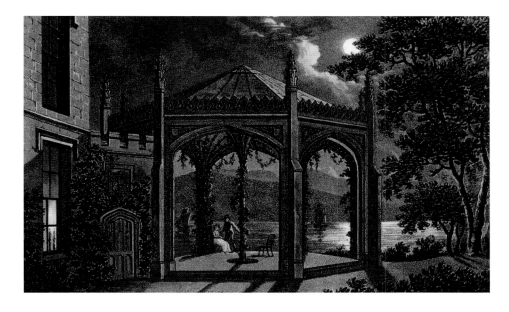

A period etching evokes the mystery and elegance of a veranda in the moonlight.

made ornamental, or of becoming proper parts of the general scenery, must be removed or concealed."

In other words, nature was to be subdued and made more beautiful by artifice. "In landscape gardening everything may be called a deception by which we endeavour to make our works appear to be the product of nature only," Repton wrote. "We plant a hill to make it appear higher than it really is, we open the banks of a natural river to make it appear wider, but whatever we do we must ensure that our finished work will look natural or it would fail to be agreeable."

Loudon took this concept one step further. His *Encyclopedia* defined landscape gardening as "the art of arranging the different parts which compose the external scenery of a country residence so as to produce the different beauties and conveniences of which that scene of domestic life is susceptible." This task, Loudon said, required someone with the combined sensibilities and skills of the architect, landscape painter, and horticulturalist. Placing the landscape gardener above the landscape painter as an artist, Loudon concurred with Repton that it was the task of

the former "to select and to apply whatever is great, elegant, or characteristic" and to "discover and show all the advantages of the place upon which he is employed; to supply its defects, to correct its faults, and to improve its beauties." It was also important, Loudon noted, "never to lose sight of common sense."

"Any creation to be recognized as a work of art must be such as can never be mistaken for a work of nature," Loudon declared. From this perspective, which would become the viewpoint of Andrew Jackson Downing, the seminal figure in landscape design in America, the landscape was not a celebration of nature as one found it, but a revision of nature to conform to an artistic aesthetic: "subjected to

a certain degree of cultivation of improvement, suitable to the wants and wishes of man." Invoking the ideas of foreground, middle ground, and distant scenery that were well established in the composition of landscape paintings, Loudon emphasized the importance of the view from the principal rooms of the house, particularly the drawing room.

Following this lead, Downing cautioned, "Care should be taken in planting not to intercept any fine views or vistas, but in such points (if any boundary plantation must be made) to compose it of shrubs or low-growing trees. Shrubs, trees, and grass with a few walks, gracefully and naturally curved, are the materials with which a pleasing little landscape may be

created in any site, when the soil is such as to favor the growth of vegetation; and it will generally be found that the more simple and natural the arrangement, the more pleasure will be derived from it." Repton, and later Loudon and Downing, believed in establishing a curving approach to the house that revealed picturesque views containing key focal points. This could be accomplished, Repton said, "by collecting the wood into larger masses and distinguishing the lawns in a broad masterly manner without the confused frittering of too many single trees . . . by the interesting line of road winding through the lawn, . . . by the introduction of cattle to enliven the scene; and . . . by the appearance of a seat on the knoll and a part of the house with its proposed alterations displaying its turrets and pinnacles amongst the trees." In towns such as Newburgh, along the Hudson, where Downing focused most of his attention, he recommended that villas be sited on promontories overlooking the river—an ancient convention that has become new again with the practice of feng shui. Like Loudon, he maintained that, for privacy, a villa should be set back from the public road, with a long, curved drive leading to the front of the house.

The key factors in good landscape design, according to Loudon, were symmetry, balance, order, proportion, appropriateness, and congruity. Arrangements of flowerbeds, assorted shrubs, and intermingled species of deciduous and evergreen trees led the eye from the foreground through the middle ground to the larger landscape. Trees should never, he scolded, be planted to obscure the view or the front facade of the house.

Loudon also illustrated architectural elements and garden structures that connected the house to the wider landscape: terraces descending from the house, "green-houses or conservatories, architectural seats or loggias, covered or open connecting verandas, sundials, vases for flowers, basins for fountains, architectural baskets, and other mural compartments for plants or flowers; and to mansions of a certain size, there may even be architectural watch houses (gazebos)."

The work of Repton and Loudon had a profound influence on the development of ideas in the United States, where their leading accolade was Andrew Jackson Downing. The idea that a house should harmonize and be mutually complementary with its landscape is commonplace now, but in Downing's day it was a relatively new notion among the general public and newly affluent individuals who were building rural Gothic homes. As a practical matter, colonial American kitchen and herb gardens—which came

A meandering stone path leads through perennial gardens to a pointed Gothic arch.

to be called "dooryard gardens" during the Colonial Revival—had always been located near the house. On great estates, such as George Washington's Mount Vernon and Thomas Jefferson's Monticello, modeled on the English plans set forth by Repton and Loudon, sweeps of lawn and pasture led to the wider view, while kitchen and farm gardens were placed at a remove from the gentleman's house. Drawing upon this tradition, Downing codified the principles of landscape design for a newly well-to-do generation of Americans, and he took them a step further.

In 1841, at the age of twenty-six, Downing released his first book, *The Theory and Practice of Landscape Gardening.* "By landscape gardening we understand not only an imitation in the grounds of a country residence, of the agreeable forms of nature, but an expressive, harmonious, and refined imitation," he wrote. Downing shared the view that landscaping was an art. We must, he said, "preserve only the spirit, or essence [of nature] . . . and by heightening this expression . . . give our landscape gardens a higher charm than even the polish of art can bestow." Downing's was not the nation's first book about

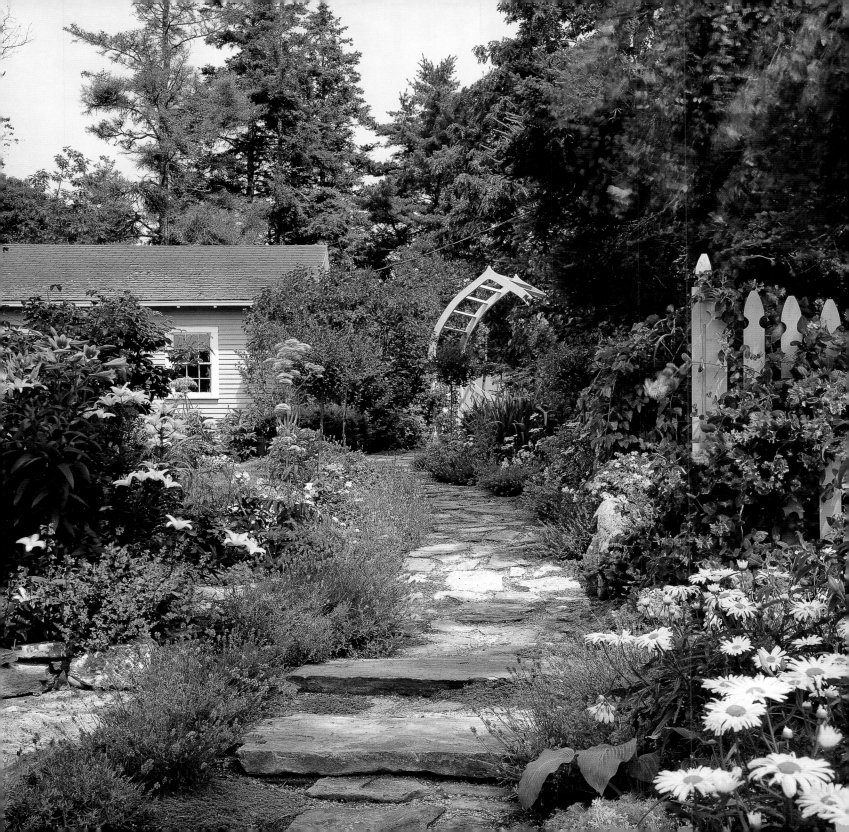

gardening—that was the 1806 *American Gardener's Calendar* by Bernard McMahon of Philadelphia—but it was the most influential of the nineteenth century. From this beginning, his fame and influence spread: he was asked to design the grounds of the U.S. Capitol, the White House, and the Smithsonian Institution, with its original building designed by James Renwick in the Norman Gothic style.

"The true beauty of a country cottage consists in . . . good form, simplicity of details, and the rural embellishment of vines and foliage," Downing noted. "A little flower garden, or, at least, a *parterre* of flower beds, may be laid out and managed by the mistress of the cottage."

Downing distinguished between two fundamental types of landscape design: the formal and the picturesque. The formal, geometric plan descended from classical French and Italian gardens; relied upon symmetry, regularity, and precision;

was characterized by parterre or knot gardens near the house, sculpted trees leading to the distance, and shapes that echoed the geometric forms of the building it complemented.

A higher level of art, he believed, was to take a more naturalistic approach. This was achieved in one of two ways. The first was the beautiful—a highly groomed version of nature—distinguished by refined, flowing, and harmonious compositions and forms, wide carpets of lawns edged by lofty trees, and a single, graceful, manicured pond. The alternative was the picturesque style, identified by its rough, wild, "striking, irregular, spirited" appearance and incorporating bold rock outcroppings, deeply shaded thickets, overgrown vines and foliage, decayed and broken trees, and rollicking streams. In each case, the governing principles were unity of composition, harmony, and variety.

Downing defined the beautiful as "nature or art obeying the universal laws of perfect existence (i.e. Beauty), easily, freely, harmoniously, and without the *display* of power," while "[t]he picturesque is nature or art obeying the same laws rudely,

Andrew Jackson Downing distinguished two types of landscape: the harmoniously beautiful (left) and the wildly picturesque (right).

violently, irregularly, and often displaying power only." To illustrate this point, he significantly invoked images from the paintings of Claude Lorraine, which he admired for their beauty—"graceful and flowing forms in trees, foreground, and buildings . . . emanating from a harmonious soul, and inspired by a climate and richness of nature and art"—and the picturesque "vigorous landscapes" of Salvator Rosa with their "bold rocks and wild passes . . . [displaying] a romantic and vigorous imagination. . . ."

A large property could combine the two sensibilities in different areas, but in a small property, Downing recommended that only one inspiration be used. While he said that the Gothic style was ideally suited to the picturesque landscape, his illustrations showed Carpenter Gothic cottages with gentler surroundings. This began with the greenery planted at the porch. "Something of a love for the beautiful . . . is always suggested by

the vine-covered cottage. . . ." This was the perfect "domestic expression," Downing opined because "vines are never planted by architects, masons, carpenters, or those who build the cottage, but always by those who live in it, and make it truly a home, and generally by the mother or daughter, whose very planting of vines is a labor of love offered up on the domestic altar . . . [so that] vines on a rural cottage always express domesticity and the presence of heart."

In the design of "A Cottage for a Country Clergyman," the veranda and trellises that formed open exterior bays on the windows were constructed with rustic work consisting of bark-clad cedar twigs, a feature that was later used by Frederick Law Olmstead and Calvert Vaux in their designs for pavilions in New York City's Central Park and Brooklyn's Prospect Park, and that later became a distinctive element of Adirondack architecture. These,

Downing explained, were "intended for vines—though not merely as supports for vines, but rather as giving an air of rural refinement and poetry to the house without expense . . . to be added [after the cottage was constructed] by the clergyman himself, aided by some farmhand expert with the saw and hammer."

In addition to the use of plantings, and again following Loudon's lead, Downing recommended that architectural

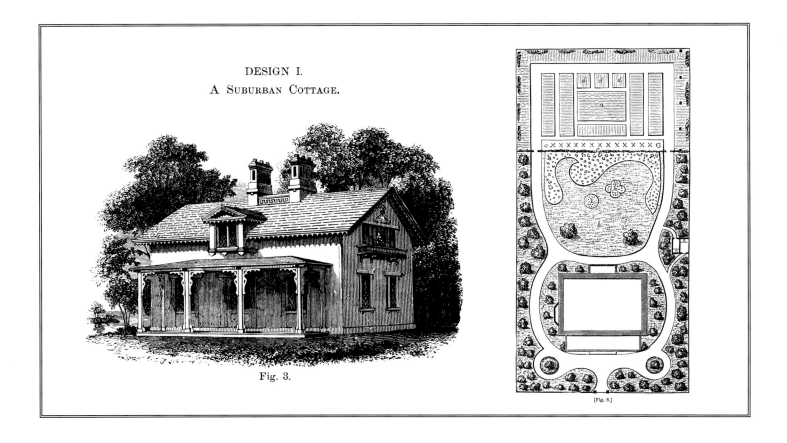

DESIGN I.
A SUBURBAN COTTAGE.

Fig. 3.

[Fig. 8.]

elements, set into the garden and landscape, be used to create a "harmonious union" between a house and its setting. "There is felt to be something incongruous in a highly finished house set down, as we sometimes see it, without the least reason or preparation, in the middle of a green lawn; but let the base of the house extend itself by a handsome terrace, and let the characteristic forms of the building be occasionally repeated nearby, in the shape of a few pedestals, with vases or other sculptured objects, and there is at once produced a harmonious union between the architecture and the landscape, or, in other words, between the house and the grounds."

An example, in *Landscape Gardening*, is the cottage residence of a Mrs. Camac, near Philadelphia, as "a picturesque cottage, in the rural Gothic style, with very charming and appropriate pleasure grounds, comprising many groups and masses of large and finely grown trees, interspersed with shrubs and plants; the whole very tastefully arranged." He gave special mention to the owner's greenhouse, a structure invented by Loudon: the "conservatory attached to the house, in which the plants in pots are hidden in beds of soft green moss, and which, in its whole effect and management, is more tasteful and elegant than any plant house, connected with a dwelling, that we remember to have seen."

Largely thanks to Downing, the porch, or veranda, became a distinguishing feature of American architecture during this period, as an open room that mediated between the home's interior and exterior space. Another means of achieving this was the terrace, "[a]n object of utility, . . . a most comfortable and agreeable feature, affording a firm, dry, and secure walk, sunny and warm in the mid-day of winter, and cool and airy in the mornings and evenings of summer. From it, in many situations, access is had to the flower garden, the luxuriant creeping and climbing plants of which, enwreathing gracefully here and there the balustrade or hanging in clusters of rich blossoms about the sculptured vase, increase the harmony growing out of this artistically contrived union of nature and art."

In *Cottage Residences*, published in 1842, Downing translated the principles he had set forth in *Landscape Gardening* into landscape plans for his architectural designs. The illustrations in that book show many houses in their settings. Near the house, he suggested a colorful and fragrant border containing "a few choice

THIS PAGE AND OPPOSITE: *Among flourishing perennial beds, rustic garden structures recall a favorite picturesque element of historic Gothic Revival landscapes.*

shrubs, or roses [such as Baronne Prévost], selecting such as are remarkable for beauty of leaf and flower, or for their fragrance; as from the nearness to the windows, the latter may be enjoyed in the summer, while the windows are open. . . ." This idea began a new era in the use of foundation plantings, which had not been the norm prior to this period.

To be placed near the house, Downing identified several types of flower gardens. The *architectural* style contained "regular lines and forms"—circular, octagonal, or square beds that echoed the geometric composition of the house. The *old French* comprised "regular and intricate" parterres containing low-growing plants and outlined in low boxwood hedges, which Downing illustrates as a single multi-sectioned medallion. Another approach was what he called the "*modern or English* flower garden," which was fashionable at the time; in these gardens, he noted, "the beds are either in symmetrical forms and figures, or . . . by irregular *curved* outlines," and he illustrated an array of jigsaw-puzzle shapes bordering a central lawn. In the English style, each bed was planted with only one or two varieties of flower, so that "each bed in its season presents a mass of blossoms, and the contrast of rich colors is more striking than in any other arrangement."

The veranda at Montgomery Place (1861), in Annandale-on-Hudson, New York, was designed by Alexander Jackson Davis; grounds were by Andrew Jackson Downing.

For the rural Gothic cottage, Downing favored the *irregular* form, which is more consistent with the design that probably holds the most appeal for owners of Carpenter Gothic homes today. This consisted of beds of varied shapes, casually laid out and surrounded by copses of trees, and lent itself well to intermingled flowers, creating "a general admixture of colors and blossoms throughout the entire garden during the whole season of growth." In advice still pertinent to gardeners everywhere, he invoked, and perhaps was one of the first in America to articulate for the public, two rules—still confusing to beginning gardeners—that plants should be arranged "so that the taller and coarser growing shall be the farthest from the front of the border, the smallest near the walk" and "the collection should consist

of a due proportion of plants blooming in the different months through the whole season." For constant color, he suggested petunias, portulaccas, and herbaceous plants, such as the double white campanula. In well-to-do homes with the means to maintain a gardener and a greenhouse, he advocated the use of exotic plants; these included potted palms to be used outdoors in the summer, along with verbenas and geraniums, "which in their many varieties, their brilliant colors, and their power of withstanding heat and dry weather, have done more to give an air of perpetual beauty to our flower gardens than all other plants together."

The parterre garden was the convention of the day. These were composed of geometrically shaped beds, set into the lawn, bordered by low boxwood hedges, and traversed by paths of gravel or turf. Downing preferred the latter, particularly in the hot summer months, when foliage failed revealing naked "beds of earth" and "walks of gravel that only reflect the glare and dryness of the parched soil." According to Downing, in *Cottage Residences*, in the beds of the parterre garden, flowers, of six to twelve inches in height, should be planted "in *masses*—sometimes filling a whole bed . . . with the same flower. This produces a brilliancy of effect quite impossible in any other way; and as the object of a flower

An Umbrello for the Centre or Intersection of Walks, in Woods, Wilderness's &c Plate LV

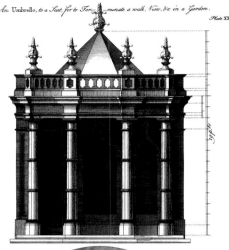

An Umbrello, to a Seat, for to Ter——minate a walk, View, &c in a Garden. Plate XXXI

garden is gaiety, this *bedding* or *massing* of flowers is certainly the most complete and beautiful way of attaining it."

Downing illustrated a small circular parterre with a center sundial surrounded by a dozen elliptical or lozenge-shaped beds, and a border separated into four parts, each in a different color: white, pink, purple, and scarlet. Six beds within this border would be filled with bulbs and annuals: crocuses and grape hyacinths inter-planted with Gillia tricolor, portulaca, sweet alyssum, Collinsia bicolor, and Eschscholtzia, among others. Alternating with these, he recommended that two beds be planted with dwarf red Tom Thumb geraniums, two with variegated, and two with purple petunias. Though he doesn't make the comparison, the overall effect to the modern eye is that of a blooming rose window.

He also borrowed plans from Loudon, and suggested other more elaborate parterres, illustrating an especially noteworthy

ABOVE: *In 1742, English architect Batty Langley published these designs for "umbrellos," or gazebos, to be placed as part of the scenery on grand estates.*

BELOW: *Langley designs celebrated Gothic motifs including spires, crockets, pointed arches, and quatrefoils.*

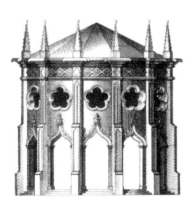

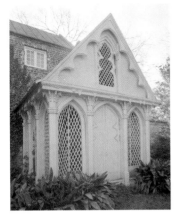 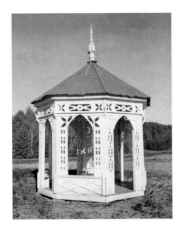 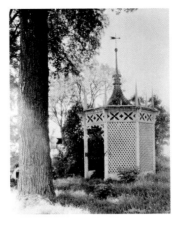 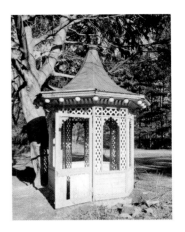

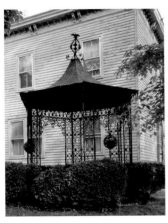 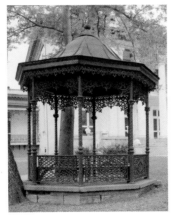 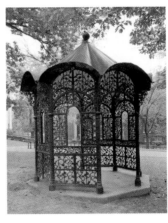 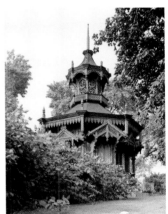

 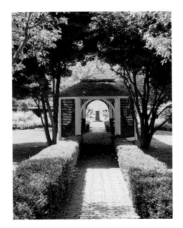

OPPOSITE: *A modern gazebo is screened and furnished for entertaining in the garden.* THIS PAGE: *A selection of images from the Historic American Buildings Survey shows eighteenth- and nineteenth-century American gazebo designs in wood and cast iron.*

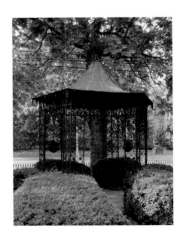

European example from Vienna, Austria. This plan comprised a large rectangle with rounded corners, set into the lawn and divided into two main sections, each a mirror image of the other. A running circular knot garden formed its border; inside each main section a central circle was surrounded by five more or less trapezoidal beds of varied size. "Of course," Downing wrote, "each bed should be planted with a single kind of flower, or, what is still better, with one kind of flower for the bed, but a border or margin of another kind—when the bed is wide enough to permit it. When the beds on opposite sides of the figure correspond in shape, they also produce a better effect when the same colors are introduced into such opposite beds—and even the same plants." For the outer beds,

he suggested ever-blooming roses in white, red, pink, and "creamy, fawn, or shaded (such as Souvenir de Malmaison). By keeping each color distinct, we get a marked and striking effect, entirely unattainable by mixing all colors together; and by using only ever-blooming roses, the beds are always in ornamental condition." For the smaller beds, he favored verbena, red geraniums, "or any other dwarf and showy flowers."

Roseland Cottage, with a house, outbuildings, and grounds designed by Connecticut nurseryman and landscape gardener Henry A. Dyer, boasts historic parterre gardens in their original, mannered configuration. Bowen, a silk merchant who founded *The Independent*, the antislavery newspaper, was an avid amateur horticulturalist. His parterre, enclosed by a

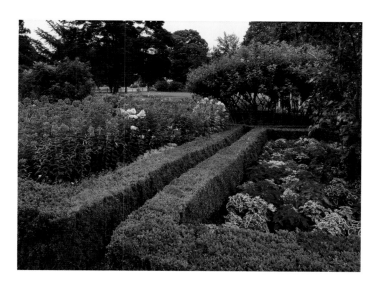

THIS PAGE AND OPPOSITE: *The parterre garden at Roseland Cottage (1846), the Historic New England property in Woodstock, Connecticut, restored to its original design.*

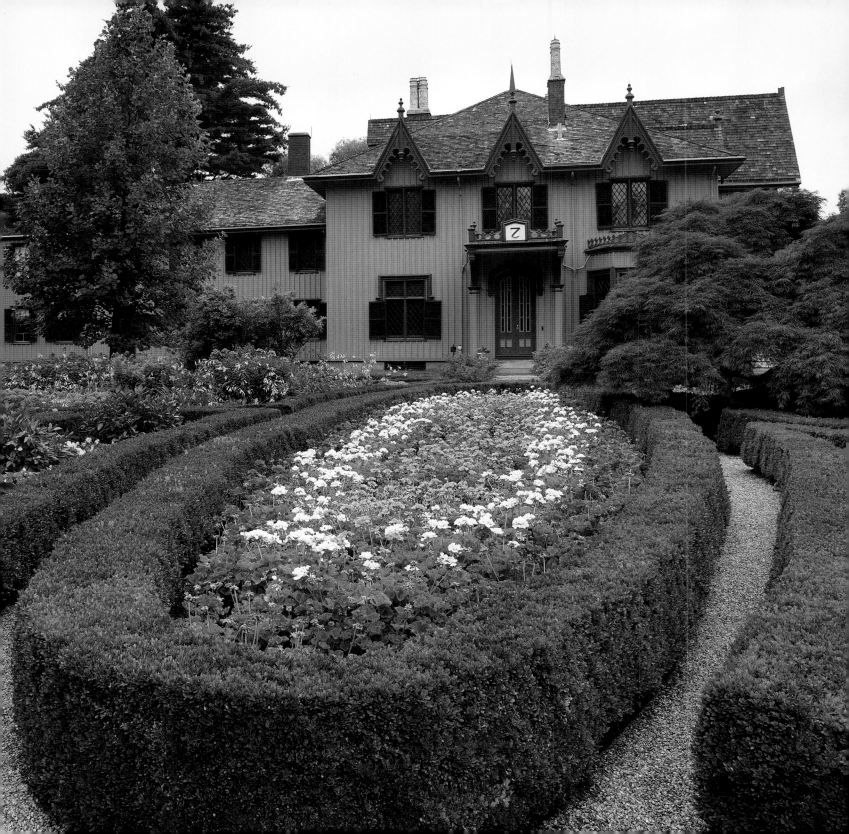

lattice fence and with a large semicircular design, occupies a footprint larger than that of the house. Within the semicircle, twenty triangular beds are bordered by low boxwood hedges and separated by gravel paths. Bowen was an active customer of the Connecticut and Long Island nurseries that stocked his garden, ordering flowering shrubs, bulbs, perennials, and eighteen-hundred linear feet of dwarf boxwood for edging. In fact, he began planting trees on the property before the house was completed, including Scotch larch, tulip, willow, fir, and hundreds of arborvitae. A home orchard and arbors contained apples, cherries, currants, grapes, nectarines, pears, peaches, plums, and quinces. Though sales receipts for the flowers Bowen ordered survive, the plants themselves are long gone. However, his flower selections were based upon *The Flower-Garden*, authored by Joseph Breck and published in 1851, and they included dianthus (pinks), Canterbury bells, sweet William, Turk's cap, hollyhocks, geraniums, and wild and Madonna lilies. Though Breck thought them unattractive

and malodorous, Bowen also planted the dahlia, which had been newly introduced from Mexico.

The nineteenth century was the era of the ever-blooming rose, and Downing was among the foremost in singing the praises of "the greatest ornaments to the flower garden." Best in the Northeast, he suggested, were "China roses . . . Bourbon, Bengal, and Noisette . . . [which would] thrive well in open beds, if very slightly covered with straw or branches of evergreens in the winter." He particularly praised the Bourbon for its hardiness and beauty; these required "rich, loamy soil, where they will bloom in profusion all summer, and until winter frosts overtake them. The Bourbon roses are especially remarkable for their size, and the abundance, fragrance, and the

beauty of their blossoms." In the South, he recommended adding tea roses, "the most lovely and delicious flowers in the world," especially when planted in single-color masses in circular beds separated by turf, and pegging them to the ground "so that the entire surface of the soil in the bed shall be covered by foliage and bloom." One might be tempted to achieve a similar effect today with multiflora roses, if it were not for the fact that this is an invasive species that should be avoided.

At Roseland Cottage, Bowen was also fond of roses, and chose from among the offerings featured in manuals published in the 1840s. One was by Robert Buist, a Philadelphia seed and plant dealer, who imported roses from England and France; another was authored by William Robert

Prince, who offered 1,630 different varieties for sale. While the newly introduced Noisette and China roses did not winter well in the Northeast, the Bourbons were much sturdier. Even hardier and more prolific than these were the new hybrid perpetuals introduced in the 1840s and 1850s. Among the roses Bowen chose were Baronne Prévost, which Downing mentioned and which were new to the market in 1842; Stanwell Perpetual with fragrant, double pink blooms; and General Jacques-Minot, with a brilliant red color that became the standard by which red roses were judged for decades to come. Bowen also had moss roses and damasks, such as

NORTH ELEVATION
SCALE · 1/2" = 1'-0"

WEST ELEVATION
SCALE · 1/2" = 1'-0"

Crested Moss, Maiden's Blush, Harrison's Yellow shrub rose, and Madame Hardy, with its lemony scent, white petals, and clear chartreuse eye. There were also climbing roses, such as the purplish-crimson Elegans, a Boursault rose, and the striped Queen of the Prairies. Both Downing and Edward Sayers, the author of *The American Flower Garden Companion* (1838) suggested placing standard or pillar roses as centerpieces in beds of low-growing plants. This, Downing said, had a "wonderfully brilliant" effect; his favorite for this purpose was Rivers's George the Fourth, a dark crimson bloom introduced in 1830.

Though we often think of the groomed lawn as being a product of the 1950s, its roots go much deeper: Americans had always loved the lawn, a tradition that came to the United States from England. "The first point," Downing declared, "in the smallest place as well as in the largest, is to get as much of an expanse of green lawn as possible." He insisted that nothing set a house off better than manicured grass, with frequent mowing to "insure that velvet-like appearance." The mechanical lawnmower wasn't invented until 1871—but grass could be groomed prior to that with a scythe working in damp grass. The lawn was to surround the house. At the front or on the side, it was to frame a parterre of flowerbeds cut into the turf, while at its edges, shrubs and trees would define "a picturesque, irregular natural-looking boundary."

Flowering shrubs could be planted in the beds or used in irregular groupings on and around the lawn. They, trees, or the wings of the house itself could be used to conceal the service buildings and areas behind it. "Neat kitchen and fruit gardens . . . in the rear . . . are so arranged as to give all the convenience without marring the beauty of the scene; and a back entrance allows access to the kitchen yard, outbuildings, kitchen garden, etc., without being seen from the more elegant parts of the ground," Downing said. It was convenient, he noted, to place the kitchen garden near the stable and its supply of manure for fertilizer. In the orchard, he suggested a picturesque grouping of trees rather than an arrangement of rigid rows. In no case should the trees be planted too close to the house or where they would obscure the front facade. He recommended oak, elm, tulip, cedar, yew, spruce, fir, white pine, larch, hemlock, weeping ash, weeping cherry, horse chestnut, European linden, Osage orange, umbrella magnolia, weeping and purple beech, and silver maple. For more formal villas, particularly those in the Italian style, the Lombardy poplar

The grounds at Blithewood (1836), in Annandale-on-Hudson, New York, designed by Andrew Jackson Downing, for a house by Alexander Jackson Davis.

was recommended, and as ornamental focal points in an expansive lawn, he favored trees with rounded growth habits.

For instance, at Blithewood, in Annandale-on-Hudson, New York, Downing notes, "one of the most charming villa residences in the Union. . . . [is] 'enchanting' in its combination of 'softness and dignity' . . . The smiling, gently varied lawn is studded with groups and masses of fine forest and ornamental trees, beneath which are walks leading in easy curves to rustic seats, and summer houses placed in secluded spots, or to openings affording most lovely prospects."

As mentioned previously, a key concept in landscape design, borrowed from the art world, was that of foreground, middle distance, and the long view. Downing described outdoor scenes as being composed of light (lawn) and shadows (trees). He instructed that a long view could be foreshortened by planting dark trees at the outer boundary, while a shallow property could be visually expanded and lengthened by planting trees near the house and having a meadow extending toward the horizon.

Picturesque Gothic garden buildings and seats were a key convention as a focal point in the landscape from the beginnings of the English Gothic Revival and had been used on the grounds of well-to-do American homes since the eighteenth century. One thing Downing does not address is the design of the gazebo, or "architectural watch house" mentioned by Loudon.

Sometimes combining fanciful Chinese and Gothic features, these might have featured exaggerated hipped roofs topped with pinnacles, gingerbread trim, and latticework. Others were constructed of cast iron shaped into naturalistic vine motifs or graceful arabesques—that medium's iteration of the carpenter's scrollwork. Still others were given a

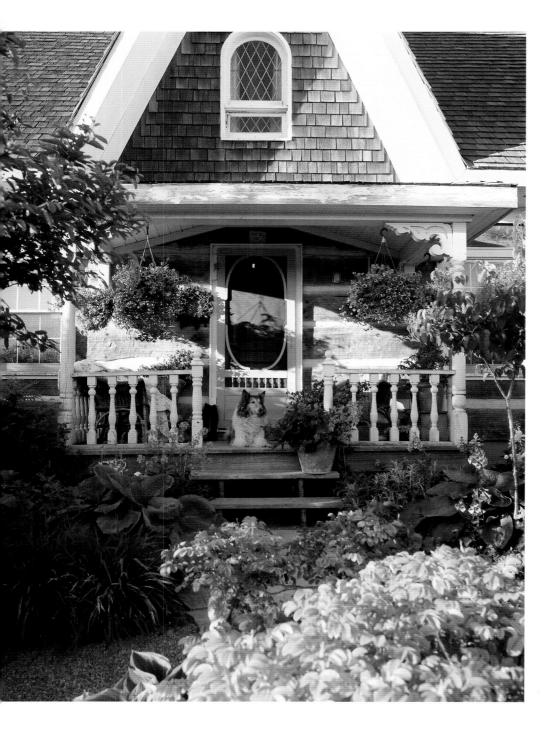

woodsy, rustic look via their use of twig-work trim.

Downing's home, a Gothic villa on a hill above the Hudson, in Newburgh, New York, was fronted by formal gardens that segued to a generous lawn. This sloped to the nursery grounds and to the river. Set into the lawn, flower beds laid in ara-besque patterns contained "roses, gerani-ums, fuchsias, *Salvia patens, Salvia fulgens,* and *Salvia cardinalis,* to be turned out in pots in the summer season after being wintered in greenhouses or frames." There were ornamental trees and arborvitae-screened service buildings; a Gothic-style sundial, potted palms, and "rustic baskets" were artistically arranged as focal points.

Though the nostalgic image of the vine-covered cottage is so ingrained in our culture as to be almost a stereotype, today's idea of the cottage garden is very different from what it was in the mid-nineteenth century. With the Colonial Revival of the late nineteenth and early twentieth centu-ries, landscape gardeners, such as Charles Platt, Beatrice Farrand, and Ellen Biddle Shipman, rejected the rigid parterres of the

Victorian era for lush flowerbeds overflowing with perennials, which provided a variety and sequence of color throughout the season. Retaining elements of the classical Italian and French garden plans, they enclosed their garden "rooms" within tall hedges, fences, or walls; threaded paths between beds; introduced open spaces to sit; and punctuated these spaces with classical elements, such as urns, statues, benches, large pots, and fountains.

This is the style homeowners usually embrace for the present-day cottage garden. Each room or area might be defined by a hedge, a tall fence, or wall that encloses a flower-filled space with pathways and an open spot in which to sit, read, sip a cup of tea or glass of wine, or dine al fresco. Accents and focal points with Gothic details introduce the light, romantic spirit of the style, without its heavy-handed formality. Roses are de rigueur—though today's preference might be for climbing or lush shrub varieties rather than historically accurate victims pinned unnaturally to the ground.

Even if the design of the contemporary Carpenter Gothic garden is different from what it might have been in the nineteenth century, Downing's advice is worth heeding: "There is no error so frequently committed as to suppose that beauty, whether in houses or grounds, depends on *variety* and *expense*. Chasteness, good proportions, agreeable and expressive arrangement of simple forms—these are the elements of the beautiful, which are always captivating to persons of pure and correct taste, whether that taste be natural and intuitive, or whether it has been refined by the long familiarity with all that is most satisfactory in nature or art."

More casual and much freer than the rigid patterns of the parterre, today's gardens can achieve the fanciful, picturesque spirit of the Gothic Revival by playing with layout and with decorative Gothic elements. They might include a parterre of herb and more casual flower gardens, twining paths, garden antiques and pieces of architectural salvage such as cast-iron fencing, vine-laden trellises, a gate or arbor with a pointed arch, fence posts finished with spires, a playhouse or doghouse with scrollwork trim, or a steeply gabled garden shed. A stone bench, a fountain with a pointed or trefoil Gothic motif, urns, potted palms, a gargoyle or a "green man" poised on a wall, cast-iron outdoor furnishings, a grape arbor, or a pergola or open area in which to sit, read, or dine al fresco—these are some of the ways to bring the Gothic style into today's residential garden.

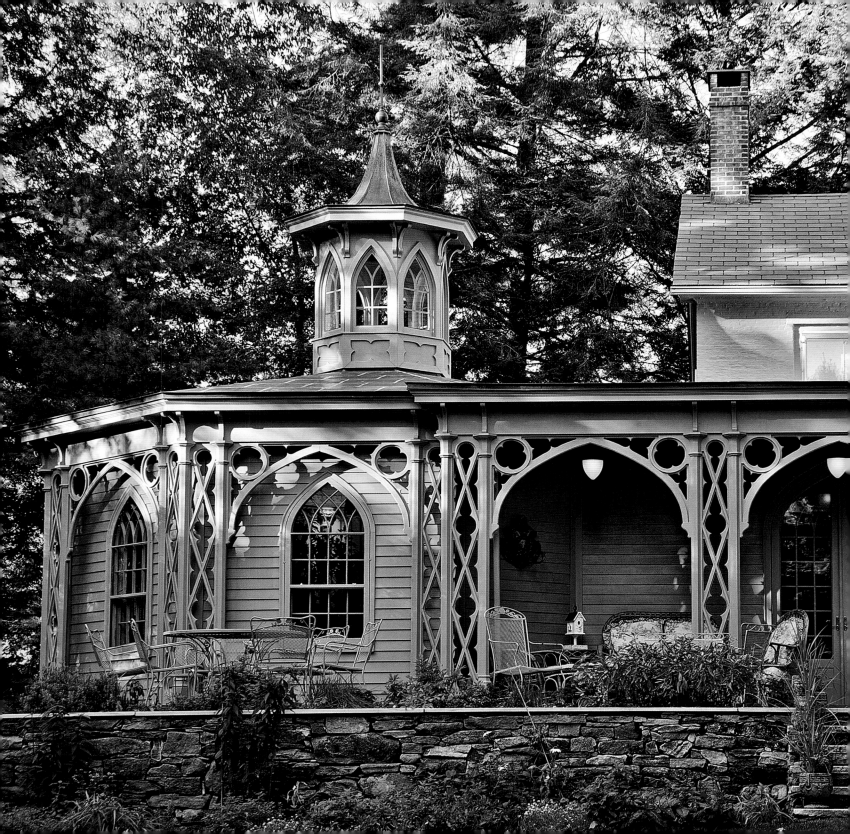

❧ Stockbridge, Massachusetts ❧

For this conservatory addition, the polygonal form of the gazebo was the ideal choice. The brainchild of erudite homeowners, who appended it to their Greek Revival home, its design was based upon historic sources. Affording a garden view, this sophisticated yet fanciful setting represents the work of an architect, a set designer in theater and film, a master carpenter, and a trompe l'oeil artist.

Inside, Travertine marble flooring features a multi-hued center medallion, while fool-the-eye elements include interior columns of painted PVC pipe topped with capitals salvaged from Warner Brothers Studios, and a ceiling that unfurls tromp l'loeil constellations and rises to the cupola.

The Gothic Revival chandelier and furnishings, including Heywood Wakefield wicker, are antiques, while the bookcase in the anteroom was created for the space.

OPPOSITE AND THIS PAGE: *A new conservatory addition took its cues from historic precedents, including this circa 1742 sketch by English architect Batty Langley.*

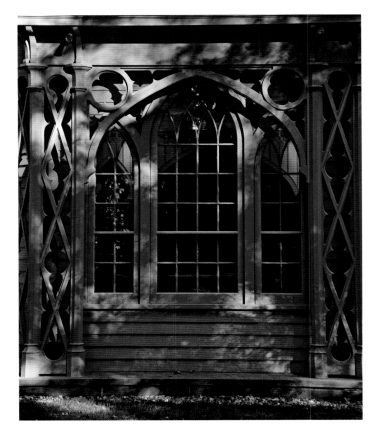

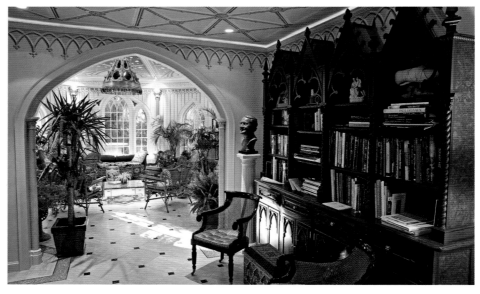

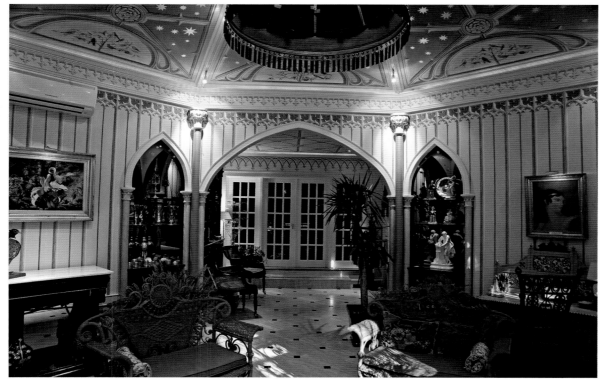

THIS PAGE AND OPPOSITE: *An alchemical blend of elegance and whimsy, the new conservatory is just the "plaything" that Walpole's Strawberry Hill was, a gilt-y pleasure, with its faux painting, rich detailing and coloration, and shimmering canopy of stars.*

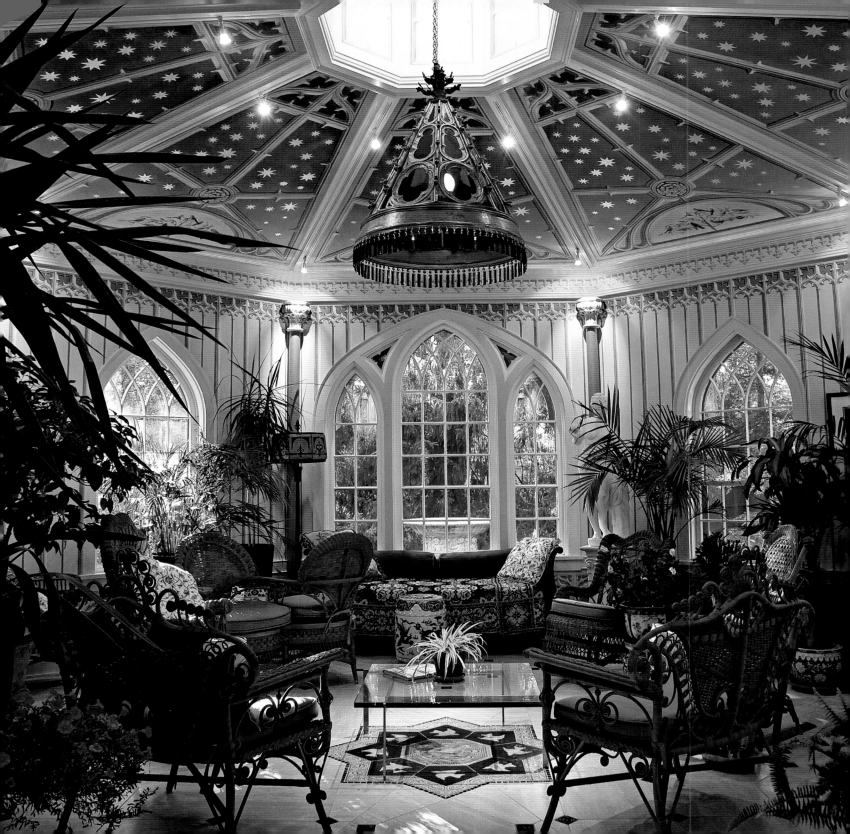

❧ Photo Credits ❧

Avery Architectural and Fine Arts Library, Columbia University in the City of New York: 70 (right)

Brandon and Brandon (Dover Publications): 140 (top), 144 (top far left, near left, and middle; bottom second from right)

Brian Vanden Brink: cover, 6, 38, 39, 44, 52–55, 62, 67 (bottom right), 85, 88, 106, 110 (left, right), 114, 115 (top), 116 (top left, bottom), 117, 121 (middle row), 122 (photo), 123, 128, 129 (top), 130 (bottom), 134 (top row: middle left; middle row: left; bottom row: middle left), 135, 136, 146, 147 (left, middle), 162, 167 (bottom), 173, 184, 194, 199, 213

Bridgeman Art Library, Courtesy Board of Trustees, Victoria and Albert Museum: 12, 13, 173

Thomas Chippendale: 179 (chairs and case pieces, bottom)

Robert Conner: 180 (top: second from left)

Alexander Jackson Davis (color drawings): 11, 49, 70, 86, 212

Andrew Jackson Downing (Dover Publications): 75 (drawing), 87, 90–93, 99–102, 104, 105, 121 (drawing), 153, 154, 180 (top left, middle, near and far right; bottom), 200, 201, 204

Courtesy of the Friends of Strawberry Hill: 18 (Killian O'Sullivan), 23 (Richard Holttum)

Giammarino & Dworkin Photography: 188–191

Geoffrey Gross: 72

Gross & Daley Photography: 17, 67 (bottom left), 74 (left), 76, 78, 82, 83, 115 (bottom right), 121 (top row: left), 127, 129 (bottom), 132, 133, 137 (top), 141 (top), 165, 211 (top)

Historic American Buildings Survey: 35, 37, 45–48, 49 (top), 56 (photos), 57, 63 (Jack E. Boucher), 65, 66 (drawings), 67 (top), 68, 69, 73, 81 (drawing), 84, 86 (b/w photos), 103, 110 (middle), 111 (photo: Gerda Peterich), 112, 113, 115 (bottom left), 118–120, 124, 125 (top), 130 (top), 134 (b/w photos), 143 (b/w photos), 145, 161, 163 (b/w images), 172, 207, 211 (bottom), 215

Courtesy of Historic New England: 138, 141 (left), 142, 143 (color photos: Aaron Usher), 147 (right), 170, 171, 208, 209

Treve Johnson: 71

William Kent and Inigo Jones: 71 (left)

Batty Langley: 20, 21, 122, 152, 205, 217 (drawing)

Keith Lanpher, courtesy of Historic St. Luke's: 34

The Lewis Walpole Library, Yale University: 28

Steve Marsel: 9, 16 (photo), 137 (bottom)

Glade McComb, courtesy of Martineaux Homes: 148–151, 155, 167 (top)

Metropolitan Museum of Art: 49, 86 (color drawing)

Gladys Montgomery: 121 (top row: middle and right; bottom row: left)

Bret Morgan, courtesy of Lyndhurst, a property of the National Trust for Historic Preservation: 196

New-York Historical Society: 74 (drawing)

A. W. N. Pugin (Dover Publications): 14 (top), 22, 121 (drawing), 140 (bottom), 144 (top: far and near right; bottom: far and near left, middle, and far right), 179 (top left)

Thomas Rickman: 25

Paul Rocheleau: 2, 8 (right), 66 (photos), 75, 80, 81 (photo), 126, 134 (top row: right), 156–159, 163 (color photos), 174, 176, 177, 187

Royal Institute of British Architects: 70 (left)

Carl Rutbert, courtesy of Alice Austen House Museum: 121 (bottom row: right)

James R. Salomon: 94–97

Edward Shaw (top): 16

Samuel Sloan: 56 (drawing)

Kevin Sprague: 216, 217 (color photos), 218, 219

Stapleton Collection, London: 29, 31, 140 (Ursus Prints color drawing), 141, 197

Statz & Ungewitter (Dover Publications): 15

Tim Street-Porter: 58–61, 164 (right), 175, 182, 186

Robin Stubbert: 8 (left), 160, 164 (left), 166, 168, 169, 181, 183, 185, 192, 193, 202, 203, 206, 210, 214

Richard Upjohn: 46

Alexander Vertikoff: 109

Victorian Housebuilder's Guide (Dover Publications): 50, 51, 125 (details, bottom), 131

John Werry: 14 (bottom), 32 Alan Wigton, courtesy of Oak Hill: 116 (top right)

Woodruff & Brown Architectural Photography: 40–43

❧ Acknowledgments ❧

At Rizzoli, thanks to editor Tricia Levi for her attentive edits and steady hand on the tiller; to designer Lynne Yeamans for combining diverse visual materials, tackling a new architectural vocabulary, and creating a format suited to it; to the production department; and to Charles Miers, publisher.

I am grateful to Tom and Michelle Bignell, Tom Fallon, Gordon and Carole Hyatt, Keith Moxey and Michael Holly, Marta Morse, Brian and Jana Watts, Larry and Judy Willets, John and Diane Woodruff, and other homeowners. Kudos to designers and builders: in Chapel Hill, North Carolina, architect Sandra Vitzthum and DiRienzo Builders; in Huntsville, Utah, interior designer Derek Mecham, Habitations Architects, and Martineaux Homes; in Stockbridge, Massachusetts, architect Kristine Sprague, art director Carl Sprague, tromp l'oeil artist Richard Haas, and carpenter Michael Costerisan; in Williamstown, Massachusetts, project manager Robert Crosky; and in Maine, the Knickerbocker Group Builders and Coastal Designers and Consultants.

At museums, I appreciate the assistance of Carl Rutbert at the Alice Austen House; Susanna Crampton, Jeanne Gamble, and former chief curator Richard Nylander of Historic New England; Cami Brooks at Historic St. Luke's; director Jack Braulein and Stephanie Brown at Lyndhurst; Eileen Sullivan at the Metropolitan Museum of Art; John Dumville at the Morrill Homestead, Vermont; Alan Wigton at Oak Hill, Ohio; and Susan Seagrave of the Friends of Strawberry Hill.

Heartfelt thanks to the photographers and institutions listed in the photo credits, and for photo sourcing to Jennifer Belt, Nicole Contais, the heroic Jason Crain, Thomas Haggerty, Joanne Rees, Elaine Rocheleau, Robin Stolfi, and Dana Stubbert. Also, to Googlebooks for offering out-of-print volumes online and to Dover Publications for its reprints of Downing, Pugin, Woodward, and other historic sources.

I am fortunate to have earned my stripes during a golden age of publishing and am grateful to the professionals with whom I have had the privilege of working. With respect to this book, I especially want to thank Janet Mowat at Harris Publications, and editor Patricia Poore and art director Inga Soderberg at *Old House Interiors*. Thanks, too, to publisher Michael Zivyak and editor-in-chief Seth Rogovoy at *Berkshire Living*, which published my article about the Williamstown home. Lastly, thanks to you, gentle readers, for buying books and keeping those who write, photograph, edit, and design them teetering uncomfortably but hopefully on the brink of solvency.

GLADYS MONTGOMERY
West Stockbridge, Massachusetts

❧ Index ❧

DOOR DETAIL SCALE FEET 1/2" = 1'-0" PORCH DETAIL

WINDOW DOWNSTAIRS SCALE FEET 1" = 1'-0" WINDOW UPSTAIRS

TRIM DETAILS SCALE FEET 1" = 1'-0"

MATERIALS:
FOUNDATION: ASHLAR/BRICK/STONE
B) WALL: TOUNGE & GROOVE
ROOF PRESSED TIN/STANDING SEAM METAL

WEST ELEVATION

BEDROOM
17'-3"x17'-1"

TOILET
5'-7 1/2"x9'-11"

BEDROOM
17'-3"x17'-1"

MATERIALS
WALLS - PLASTER
CEILING - PLASTER
FLOOR - WOOD

SECOND FLOOR PLAN SCALE FEET 1/4" = 1'-0"
METERS 1:48

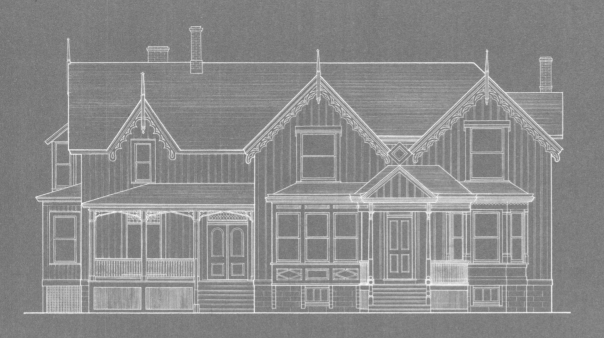

- BOARD AND BATTEN SIDING
- PORCH TRIM AND DECORATIVE FEATURES ARE OF WOOD
- SCORED PLASTER OVER GRAVEL CONCRETE OR OVER BRICK FOUNDATION

EAST ELEVATION

SCALE 3/16"=1'-0"

5' 0' 5' 10'

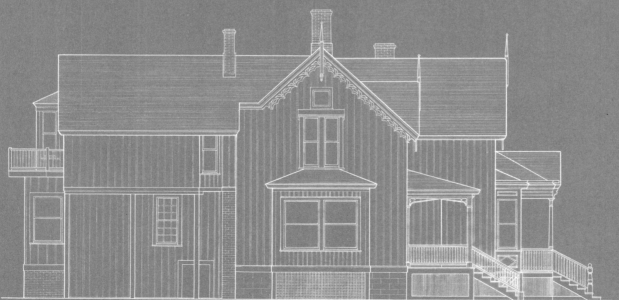

SOUTH ELEVATION